Art of ancient
greece

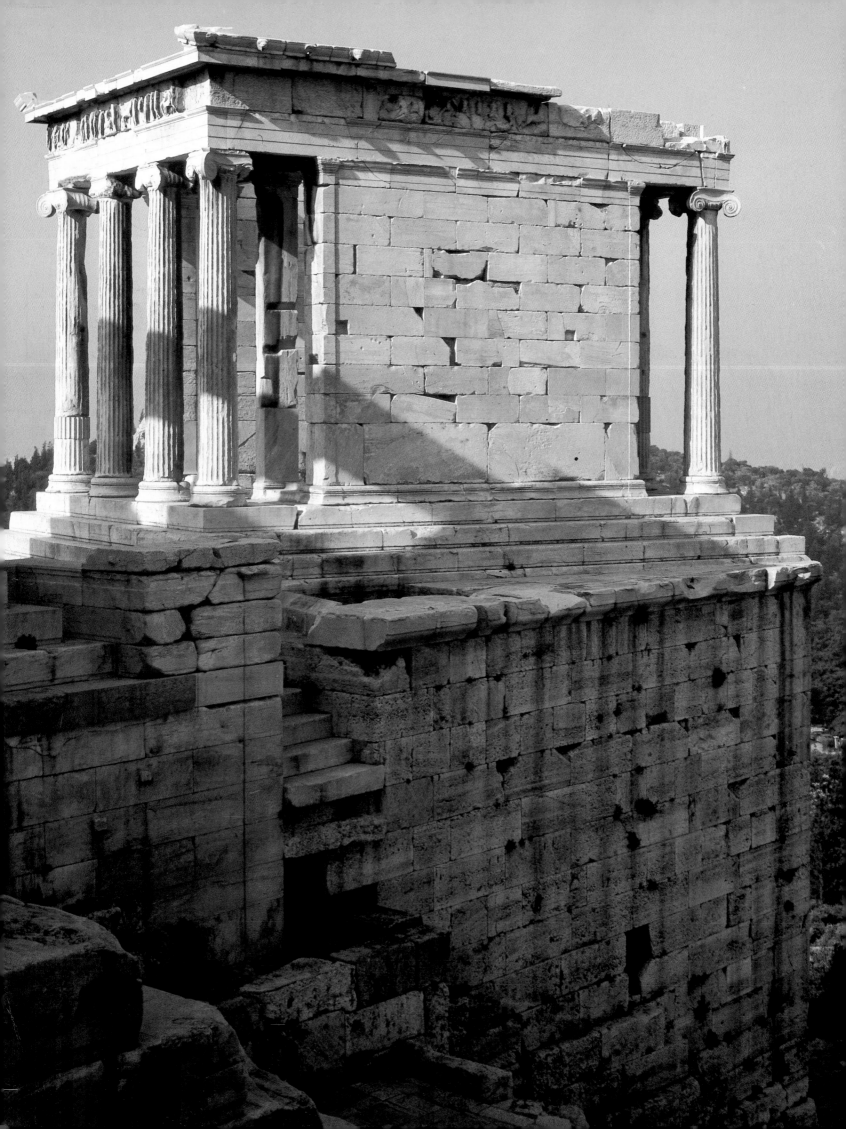

Art of ancient greece

PAINTING
SCULPTURE
ARCHITECTURE

CLAUDE LAISNÉ

·TERRAIL·

Cover illustration

Temple of Juno

Fifth century BC.
Agrigento Archeological Site, Sicily.
Photo. G. Dagli Orti.

Previous page

Temple of Athena Nike

Fifth century BC.
Acropolis, Athens.

Opposite

Head of a Warrior

Marble, from Aegina.
490-480 BC.
National Archaeological Museum, Athens.

Page 6

The Erechtheum

Fifth century BC.
Acropolis, Athens.

Editors: Jean-Claude Dubost and Jean-François Gonthier
Cover design: Gérard Lo Monaco and Laurent Gudin
Art director: Marthe Lauffray
English adaptation: Jean-Marie Clarke
Editing: Aude Simon and Malina Stachurska
Iconography: Christine de Bissy
Composition: Graffic, Paris
Filmsetting: Compo Rive Gauche, Paris
Lithography: Litho Service T. Zamboni, Verona

English edition, copyright © 1995
World copyright © 1995
by
FINEST S.A./EDITIONS PIERRE TERRAIL, PARIS
A subsidiary of the Book Department
of Bayard Presse S.A.
ISBN: 2-87939-011-7
Printed in Italy

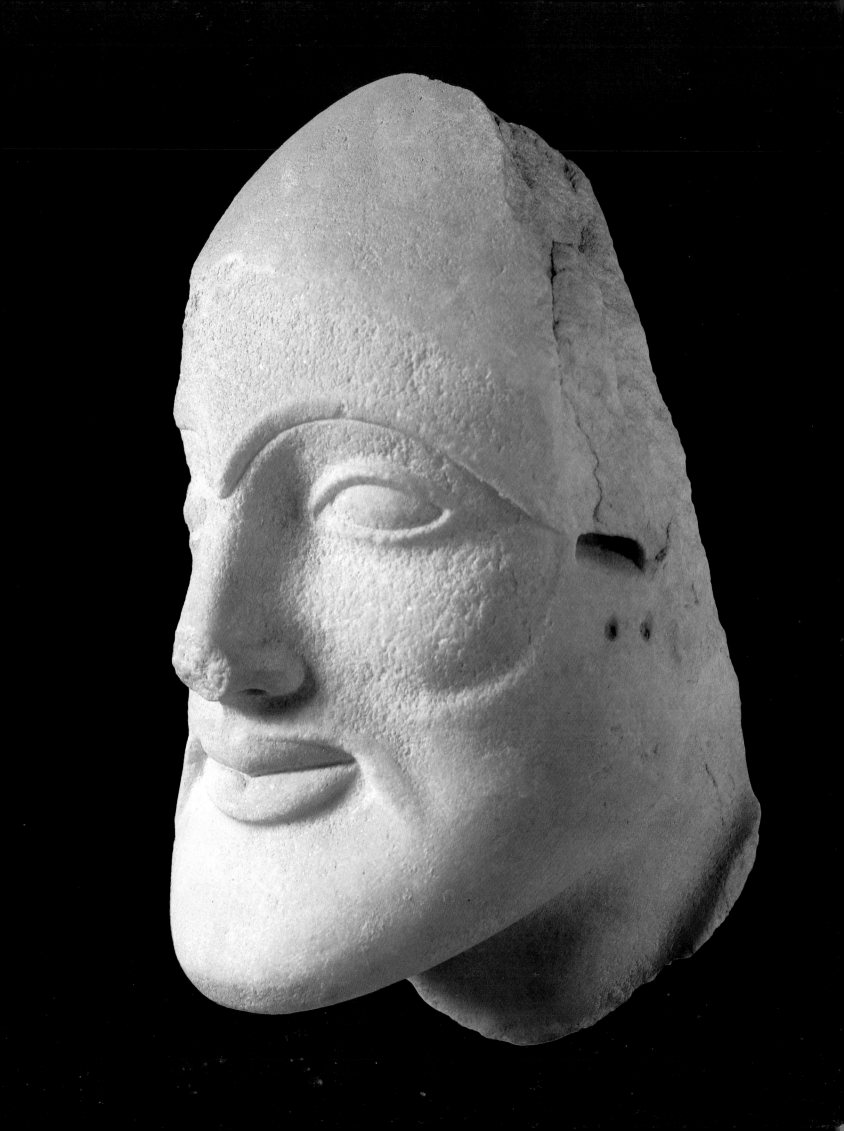

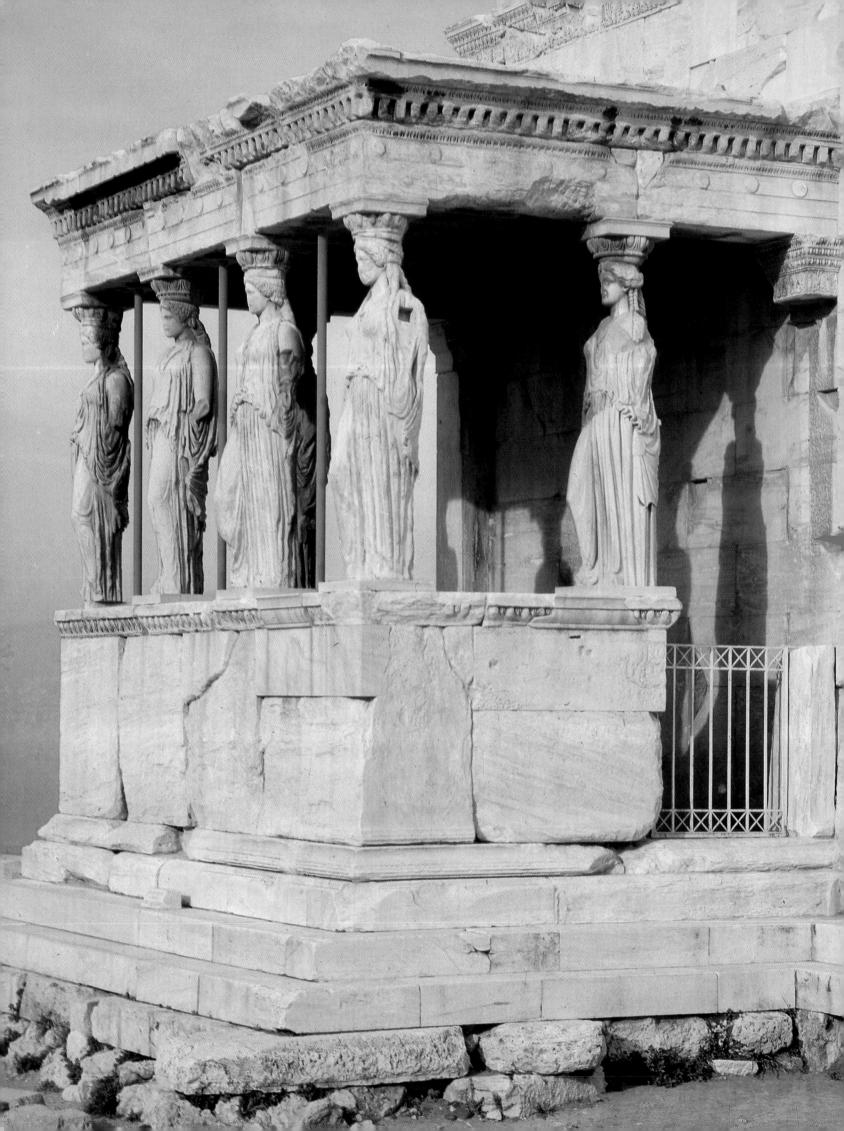

TABLE OF CONTENTS

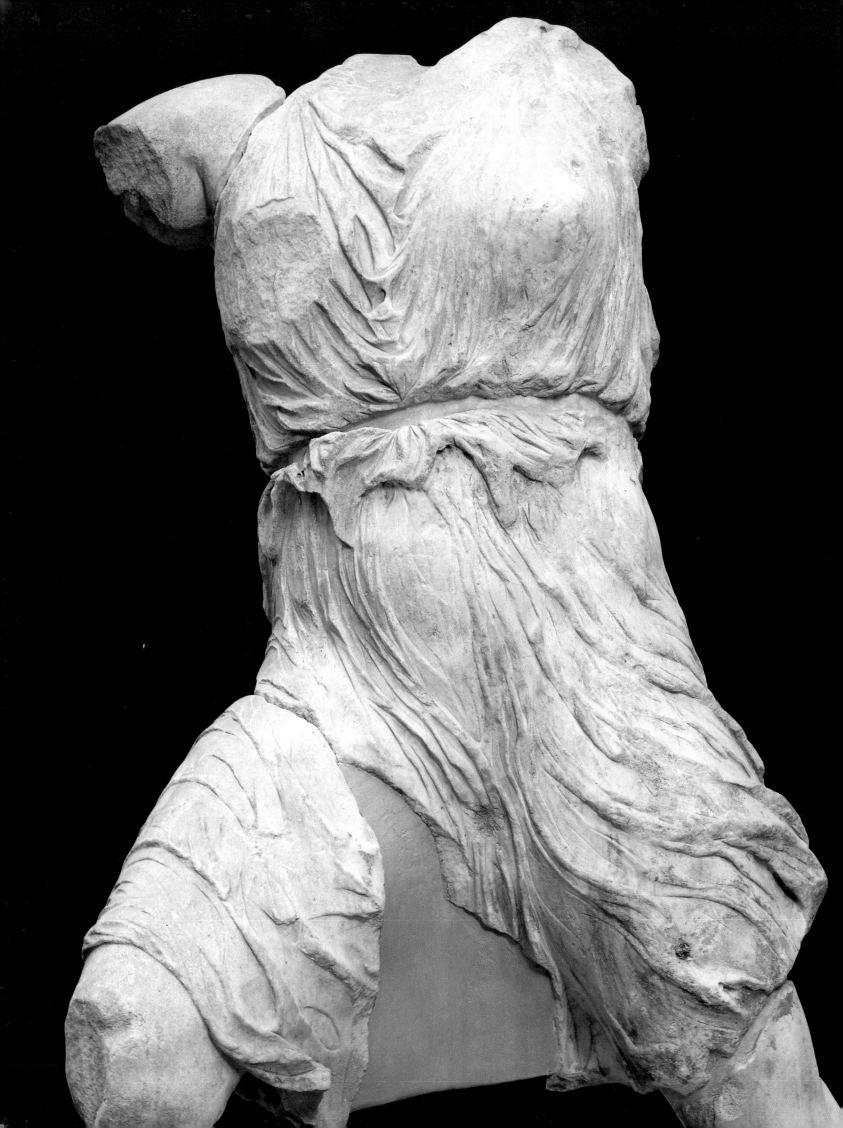

THE PARTHENON FRIEZE

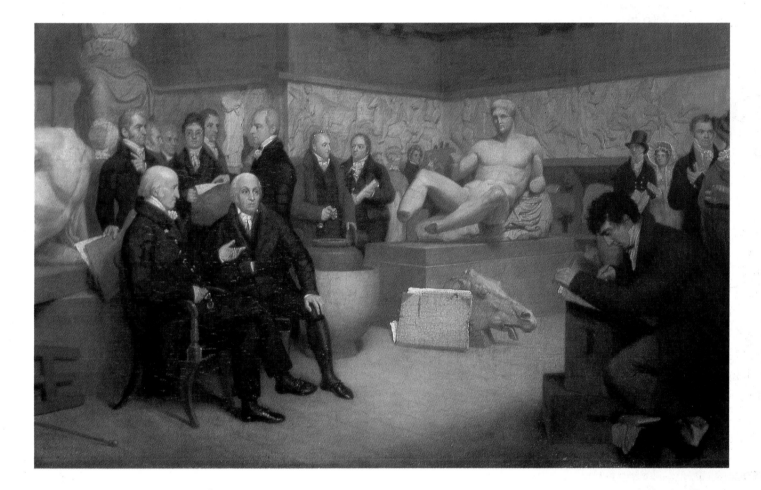

When the marble torsos, busts and horses removed from the Parthenon were first presented to the London public in June 1807, the reaction of the artistic community was immediately enthusiastic. Turner waxed elogious, and John Flaxman, the most famous British sculptor of the day, declared that, next to so much grandeur, the *Belvedere Apollo* was nothing. Still, no one would have imagined the extent to which this event would influence the subsequent history of Western art. Least of all Lord Elgin, His Gracious Majesty's Ambassador to Constantinople, who had undertaken their transfer from Athens, then under Turkish occupation, in the hopes that their presence in England might edify the taste of his compatriots.

Lord Elgin and His Marbles

Oil on canvas (detail), by A. Archer.
British Museum, London.

Opposite

Iris

Pentelic marble, h. 1.25 m. (4 ft.).
Parthenon, West pediment.
Fifth century BC.
British Museum, London.

Belvedere Apollo

Marble, h. 2.24 m. (7 ft.). Roman copy of a Greek original from the fifth century BC.
Pio Clementino Museum, Vatican.

Opposite

Farnese Hercules

Marble, h. 3.13 m. (10 ft.). Roman copy of a Greek original from the fifth century BC.
National Archaeological Museum, Naples.

And so, in a makeshift museum at the corner of Piccadilly and Park Lane, not even properly exhibited, but stacked pell-mell because of lack of space, were such peerless masterpieces as the impressive *Reclining Cephisus*, the busts of *Hermes* and *Iris* from the West pediment; the horse from *Selene's Chariot*, highlight of the East pediment; processions of war chariots, mounted riders, heifers being led to sacrifice, and scores of warriors from the North and South friezes. A crowd of gods, goddesses, animals and human figures before which spectators were unsure as to what to admire most: their intense lifelike quality or the extra-ordinary artistic creation.

And yet their arrival on British soil disturbed the elite of "connoisseurs," who had formed an entirely different idea of Greek art, especially John Payne Knight, the influential spokesman of the learned Dilettanti Society. The impact of his opinion on aesthetic matters was as strong then as John Ruskin's would be subsequently. On the basis of a vague rumour gleaned from some travellers – and before the marbles had even been taken out of their crates – he denounced them as fakes. He stubbornly maintained this opinion until his death, arguing that marble was greatly inferior to the noble medium of bronze for sculpture, and that monumental groups designed to be installed some forty feet off the ground must surely have been executed by mere artisans, not artists.

In those days, the famous *Belvedere Apollo* – although derided by Flaxman – and a half-dozen other statues, such as the *Farnese Hercules* and the *Medici Venus*, all preserved at the Vatican, were considered the greatest masterpieces of all time.

But the statues that Payne and his contemporaries considered quintessentially Greek were in fact Roman copies. Brought to light on an estate belonging to Cardinal Giuliano della Rovere, the future Pope Julian II, the *Apollo* took the name of the place where it was subsequently

displayed: a private garden designed by Bramante at the Belvedere, built on a rise behind the old Vatican palace.

Lord Elgin's marbles, on the other hand, had the virtue of being authentic. Not surprisingly, when the time came to restore them, as had been the practice since the Renaissance, Antonio Canova, the great Italian Neo-classical sculptor and specialist in this field, refused outright. In his eyes it would have been a sacrilege for him or anyone else to "lay a chisel" to sculptures that Socrates and Plato themselves had once contemplated.[1] Restoration was a fairly risky affair, for it involved making large cuts in what remained of the limbs to fit them out with replacements. Canova's refusal was a first, and it is thanks to him that the Parthenon sculptures have come down to us in their "original" state.

These "pieces," finally valued for themselves, completely overturned current perceptions of ancient Greek art, and slowly transformed aesthetic sensibility. This was the birth of modern taste. What for centuries had been seen as mutilated bodies in need of repair began to be perceived as works of art in their own right. It is no coincidence that Auguste Rodin, who came of age just as this change of perception occurred, was the first artist to implement the aesthetic of the fragment.

As for Lord Elgin, he did not reap much reward for his trouble. Byron, brandishing accusations of outright theft and spoliation, lost no time in responding to the infamy in his *Pilgrimage of Childe Harold*, denouncing the "sterile soul and shrivelled heart" of the "modern Pictus" who had contrived the "odious plan of despoiling the sad remains of Athena." Although the Parthenon marbles finally entered the British Museum in 1816 and have since been proclaimed the inalienable property of the British Nation, there was no lack of opposition and heated debate. The English lord who had financed the removal and transfer of the sculptures from Athens to London was eventually reimbursed £35,000 by the Crown, a paltry sum compared to the costs incurred.

It should be said in his defence that the Turkish occupants treated the glorious remains of the Hellenic civilization with total disdain. On the Acropolis, which had been transformed into a citadel, Ottoman troops lived with their families in make-shift huts hastily built among the ruins. The Erechtheum had been pressed into service to house the military commander's harem, while the Propylaea and the

1. William Saint Clair, *Lord Elgin and the marbles*, Oxford University Press 1967.

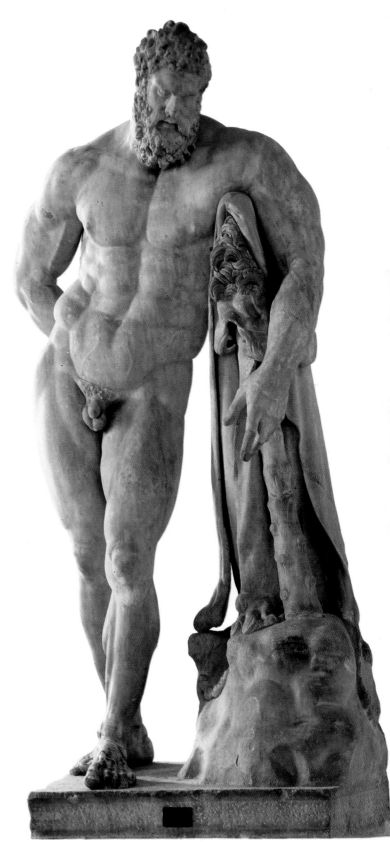

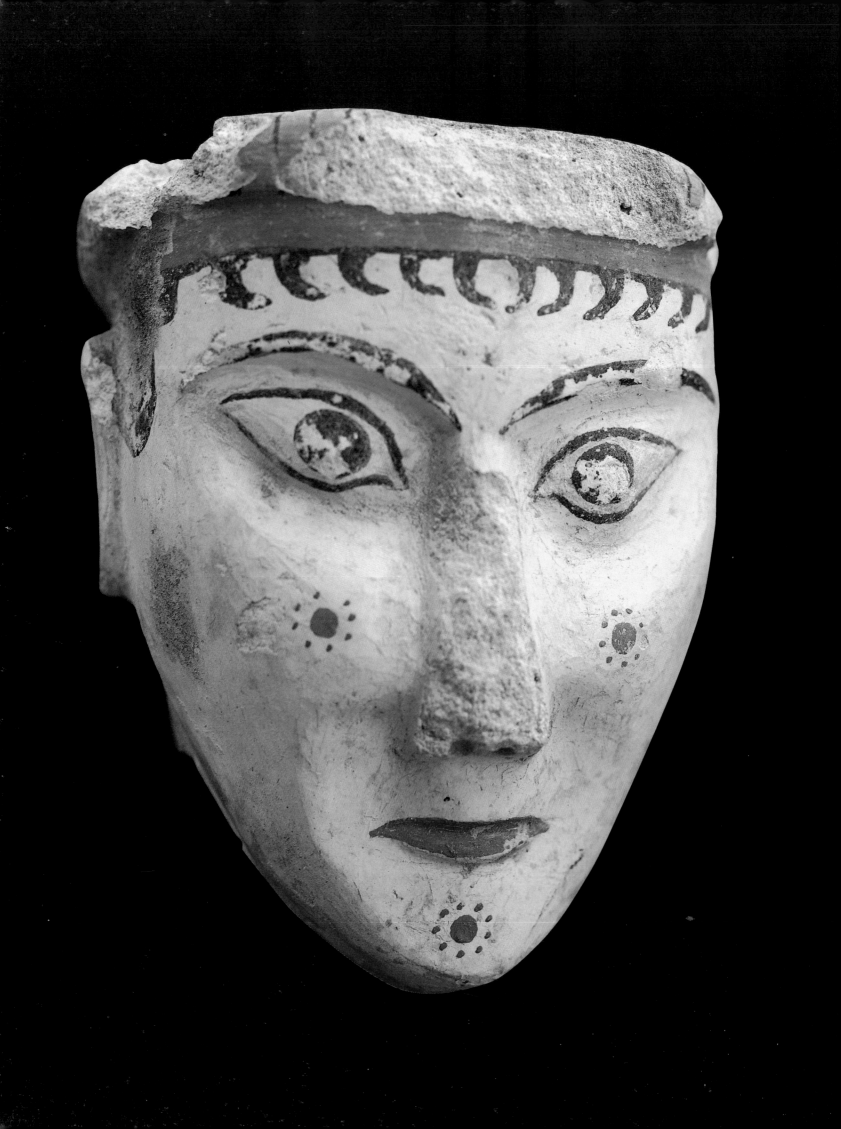

Parthenon, converted into munitions depots, had been damaged by explosions. The fine-quality marble of the sculpture fragments and ruined temples was used in the lime kilns and even as a form of currency: the governor of Athens readily granted removal permits in exchange for chandeliers, spyglasses, clocks, jewelry and other forms of baksheesh. Precious little remained of the grandiose artistic programme inaugurated in the fifth century BC by Pericles, the great Athenian statesman who had wanted to adorn his city with monuments befitting a major capital.

To be sure, Lord Elgin had overstepped his prerogative: a written order from the Grand Vizir authorized him and his collaborators to remove the pieces that were lying on the ground, not to dismantle the ruins still standing – which is precisely what they proceeded to do. An eyewitness reported that, after their passage, all that remained of the cornices of the Parthenon were a few crumbling blocks that looked like scattered stumps. On the other hand, air pollution has been steadily corroding the stone over the years, and so, without Lord Elgin's brazen initiative, there would be little or nothing left today of a decorative cycle that ranks among the most perfect creations of mankind.

More recently, extensive archaeological research and excavations in continental Greece, as well as in the Aegean, Asia Minor, Southern Italy, Sicily and throughout the Hellenic world, have brought to light specimens of Greek art that were totally unknown to Lord Elgin and his contemporaries. Today, we accord as much aesthetic value to Cycladic idols, Mycenaean funerary masks, archaic statues and vases as to works of the Classical period. As for the famous *Laocoön* group, which depicts a father and his two sons being strangled by sea-serpents, and which so moved Michelangelo when it was transferred to the Belvedere gardens in 1506, it has since been identified as a key work of the later Hellenistic period.

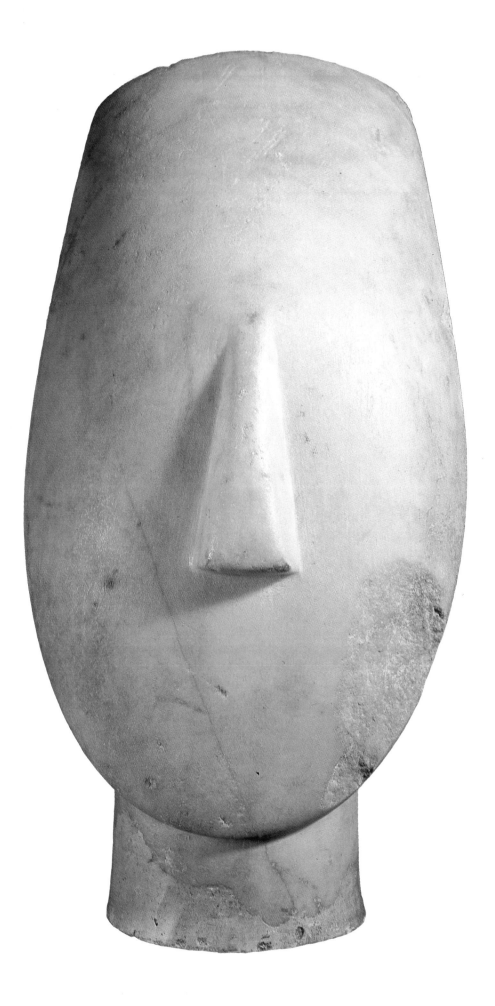

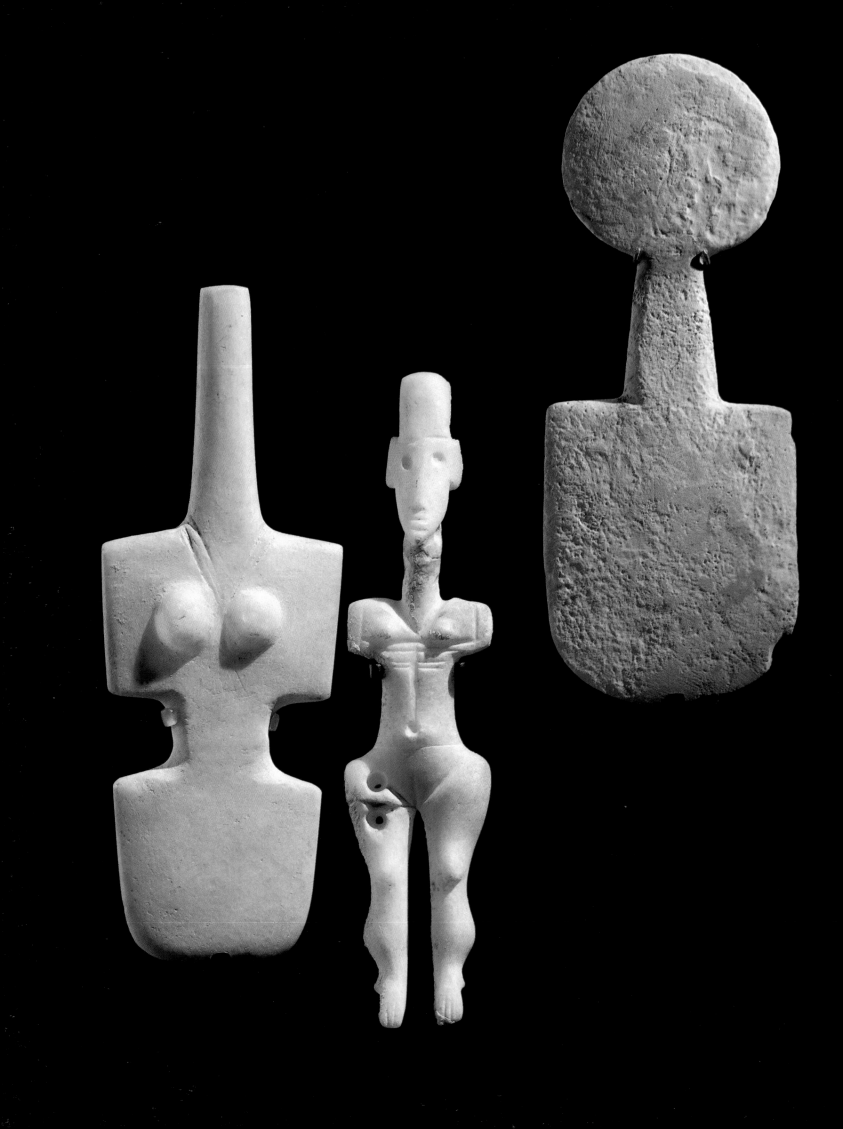

I. THE BIRTH OF GREEK ART

THE ORIGINS OF SCULPTURE IN THE PRE-HELLENIC PERIOD: THE CYCLADIC IDOLS

With André Malraux, who gave it a conspicuous place in his *Musée Imaginaire*[1] forty years ago, Christian Zervos, the founder and director of *Les Cahiers de l'Art*, was among the first to appreciate the ineffable beauty of the art of the Cyclades. Zervos, a Greek himself, was born in 1889 in Argostoli, on the island of Cephalonia. He frequented such significant artistic figures of the 20th century as Picasso, Matisse, Braque and Giacometti, who had given Modern art a new impulse by their use of non-classical art forms, and became attuned to the inherent qualities of Cycladic statuary. Until then, archaeologists had tended to consider these figures as little more than the product of awkward craftsmanship.

Although we now appreciate the primitive power and grace of these highly stylized figures, one wonders what Lord Elgin's contemporaries and the more fervent admirers of the Parthenon sculptures, such as Turner and Flaxman, would have thought of them. They are essentially geometric, composed of isosceles triangles or trapezoids, with cylindrical necks, simplified heads, triangular noses and flat ears. One could say that the Cycladic idols bridge the

1. André Malraux, *The Voices of Silence*, Princeton University Press 1978.

Cycladic Idols

Marble.
IV-III millennium BC.
Barbier-Mueller Museum, Geneva.

Page 18

Double-Flute Player

Parian marble idol, from Keros.
II-I millennium BC.
National Archaeological Museum, Athens.

Page 19

Harp Player

Parian marble idol, from Keros.
II-I millennium BC.
National Archaeological Museum, Athens.

T*he Cycladic idols were intended exclusively for funerary purposes and display no concern for anatomy. The products of an extremely refined sensitivity, they suggest the invisible through deceptively simple means. Christian Zervos remarked that they raised the "difficult problem of representing a figure that incites the beholder to dream."*

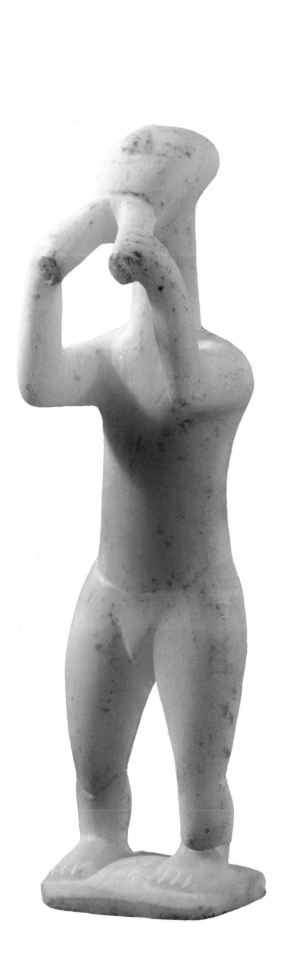

temporal distance between the prehistoric human-headed pillars of the Sahara and the work of such modern sculptors as Moore and Brancusi.

The Cyclades constitute an archipelago of about a dozen main islands of bleached white rock that contrast sharply with the deep blues and purples of the Aegean Sea. The inhabitants of the islands – sailors, fishermen and craftsmen – created their unassuming masterpieces over several millennia, from the beginning of the Late Neolithic to the Early Bronze Age. They claimed to be autochtonous, but many other tribes from the North, South and East had emigrated there and mixed with the local population, gradually forming a new ethnic group.

Their carved and patiently polished marble idols were intended for funerary purposes; the positions of the feet, for example, indicate that they were not meant to stand. They are of average size, the smallest no more than three centimetres long, the larger, such as the idol from Amorgos at the National Archaeological Museum in Athens, a metre and a half long. There must have been even larger figures, judging from the size of certain heads found separated from their bodies, like the beautiful *Marble Head from Paros* in the Louvre. The creation of these idols spans more than a thousand years, starting with those from the Grotta-Pelos (3200-2800 BC) and ending with those of Phylakopi (2300-2100 BC).

What discredited them for a long time in the eyes of most art-lovers was their abstract quality; they made no attempt at any anatomical resemblance. They are the antithesis of the naturalism that would later characterize the work of Phidias and Praxiteles, who both strove to represent perfectly-shaped muscles and lifelike poses.

However, these idols were very carefully constructed. The most typical ones, like those from Keros-Syros, with arms crossed below the breasts, generally observe a set of simple proportions based on precise relationships between the various parts of the body. The length of the idol, whether big or small, is divided into four equal segments: the head and neck, the bust, the abdomen and thighs, and lastly the calves and feet. The widest part – at the shoulders – is equal to one quarter of the length. These were the first stirrings of that specifically Greek urge to elaborate canons, or series of fixed proportions, which reached its highest expression in the Classical age.

Nearly all the idols are female and nude. Among the few male figures that have come down to us are a harpist,

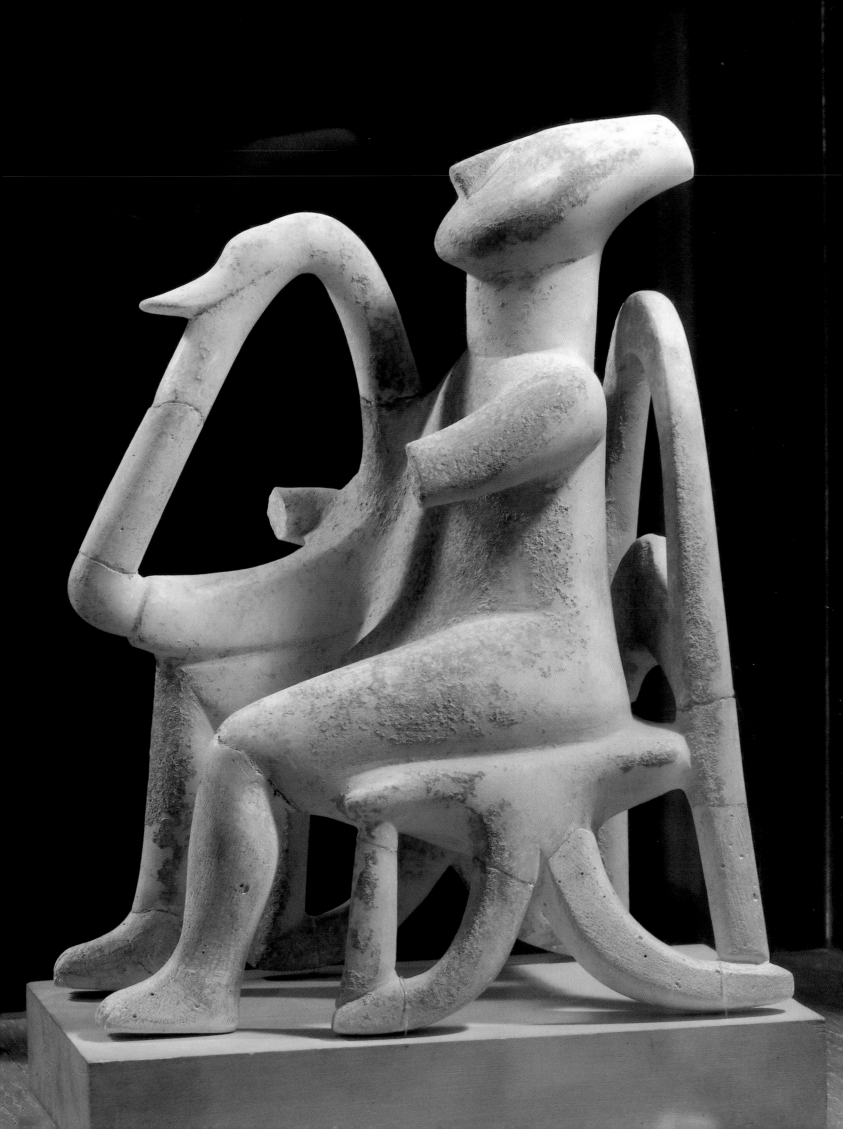

Opposite

Vase

Terracotta, Cycladic art from Naxos.
National Archaeological Museum, Athens.

Neolithic Idol

Terracotta, h. 13.7 cm. (4 ¹/₂ in.),
from Thessaly.
Late IVth millennium BC.
Georges Ortiz Collection.

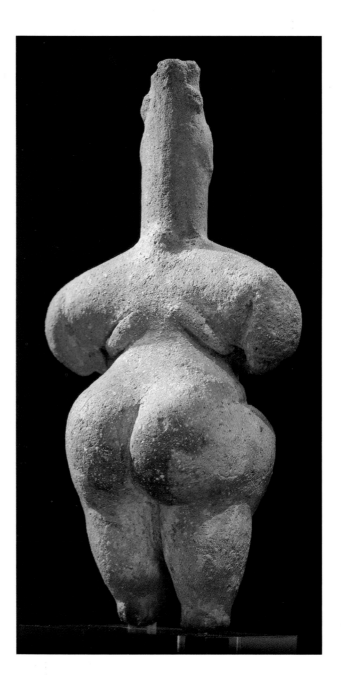

a flute player, a drinker and one presumed to be a warrior. Although the bodies are flattened, their curves and rounded shape are remarkably suggestive of volume. Anatomical details, however, have been reduced to such minimal indications as incisions for the hands and feet, a few lines or dots for the pubic triangle, and diminutive cones for the breasts. Nevertheless, these figures are wonderfully evocative of life, and the gently-shaped female forms have been fashioned with evident delight by the Cycladic craftsmen. The male figures, with their unmodulated limbs, represent an extreme of formal simplification and austerity.

As Zervos pointed out[2], these idols were originally polychrome; traces of pigment may sometimes still be seen on the eyes, cheeks or neck. The colours were applied with a brush directly on the smooth surface of the marble and were probably removed by simple rubbing. Large nuggets of pigment – mostly red and blue – have been found in some tombs; they were used to decorate the faces of the deceased and their accompanying idols. The colours red and blue were believed to have magic powers: they protected the dead against evil spirits during their subterranean journey.

The Cycladic tombs generally consisted of dry-stone walls covered with a large slab for greater stability. Various types of ground-plan were used: rectangular, circular and irregular. They were sometimes on several levels. They were fairly small because the dead were laid to rest on their sides, in the foetal position, a symbolic attitude that returned the body to Mother Earth and prepared it for a new birth. The East-West axis of the tomb, following the sun's daily path, further ensured that it was in harmony with cosmic processes.

One major question yet to be answered is to what symbolic tradition did the Cycladic idols belong? The cult of the Great Mother seems to have been preponderant among the Aegean populations, as it was among many other primitive cultures. Incarnating the power of reproduction, she presided over all creative forces and was the source of all abundance; it was she who dispensed wealth and guaranteed peace. And it was also she who inspired passion in men, cured animals of sterility, protected crops, intervened to heal the lame and sick, promoted health and longevity, and watched over human communities. The

2. Christian Zervos, *L'Art des Cyclades*, Paris, 1957, pp. 43-45.

20

prehistoric image of the Great Mother is to be seen in certain idols with marked female sexual characteristics. Unfortunately, however, archaeological excavations to date have not yielded much information about the religious practices of the primitive inhabitants of the Cycladic archipelago.

For us, these marble idols are like visual poems orienting and inspiring our imagination beyond ordinary reality. Zervos underscored their spiritual intensity, and aptly spoke of "sculpted litotes" expressing the serenity of these ancient peoples in the face of death. According to him, they raised "the difficult problem of representing a figure that incites the beholder to dream." The statuary of the Cyclades suggests the ineffable through apparently very simple means, evidence of a highly refined aesthetic sensibility.

The proliferation of these idols and their stylistic similarities and differences indicate that there must have been several different centres of production on the archipelago. But the experts have reached no agreement on either the origins or the evolution of these figurines. Zervos believed that they evolved from distant Palaeolithic prototypes and belonged to a vast area from the southwest coast of Anatolia eastward to Sardinia. Other experts, such as the archaeologist Henri van Effenterre, maintain that they developed locally and spontaneously, and that they disappeared completely and no less suddenly some time after 2000 BC.[3] What they do agree on is that other Cycladic art forms, particularly ceramics, had a wide-ranging distribution and influence.

The earliest examples of Cycladic pottery, which date from the Early Bronze Age (2700-2000 BC) before the influence of Cretan ceramics became manifest, display a remarkable stylistic unity generally characterized by great simplicity. The craftsmen worked without the benefit of the potter's wheel, which came much later, but must have used some rudimentary form of it, for the volumes of most of the pieces are too regular to have been shaped without a device of this kind. The standard material was the local, impure clay. Among the first pieces of Cycladic pottery were large pot-bellied jugs without handles (they were fitted with loops for hanging) and *pyx*, cylindrical or spherical boxes with lids.

The jugs were decorated with an assortment of ornamental designs: lines, chevrons, hatched zigzags,

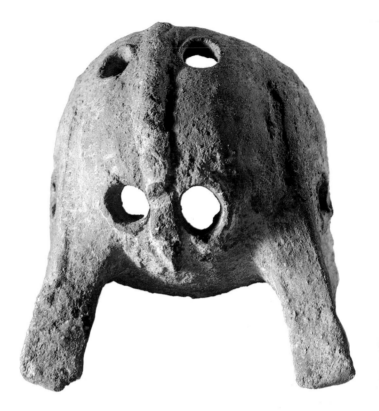

3. Henri van Effenterre, *Les Egéens*, Paris 1986.

Page 22, left

Idol

Marble, Cycladic art from Syros.
National Archaeological Museum, Athens.

Page 22, right

Idol with Crossed Arms

Marble, h. 35 cm. (13 in.). Spedos type, close to works attributed to the Goulandris Master.
Around 2800-2300 BC.
1990 Biennale des Antiquaires, Paris

Page 23, left

Female Idol

Marble, h. 46 cm. (18 in.),
from Chalandriani, island of Syros.
IInd millennium BC.
National Archaeological Museum, Athens.

Page 23, right

Female Idol

Marble, h. 149 cm. (5 ft.),
from Amorgos.
Around 2000 BC.
National Archaeological Museum, Athens.

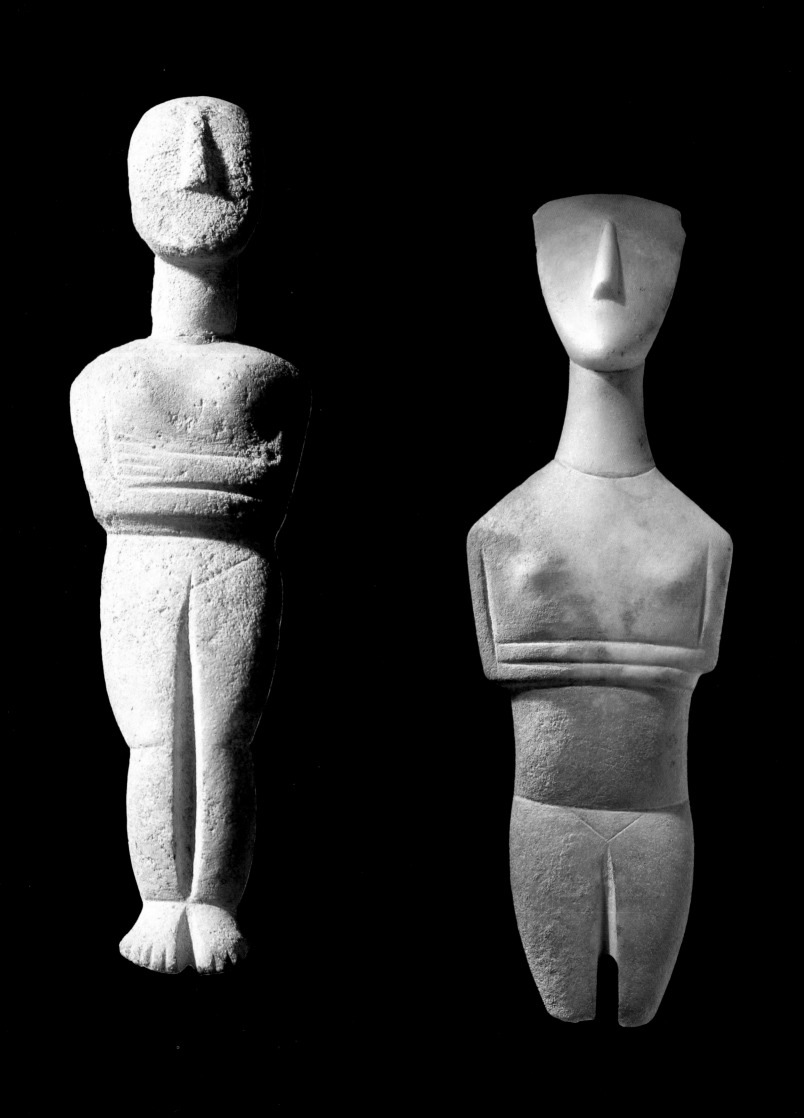

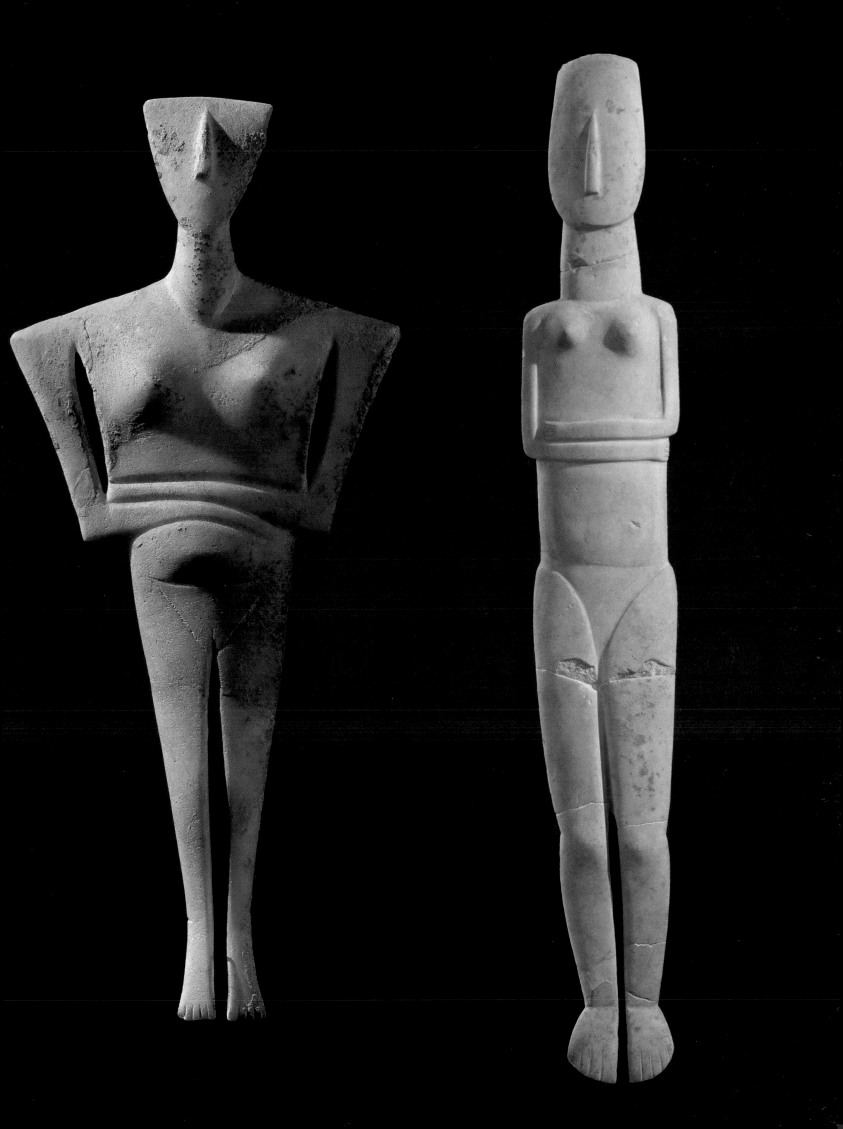

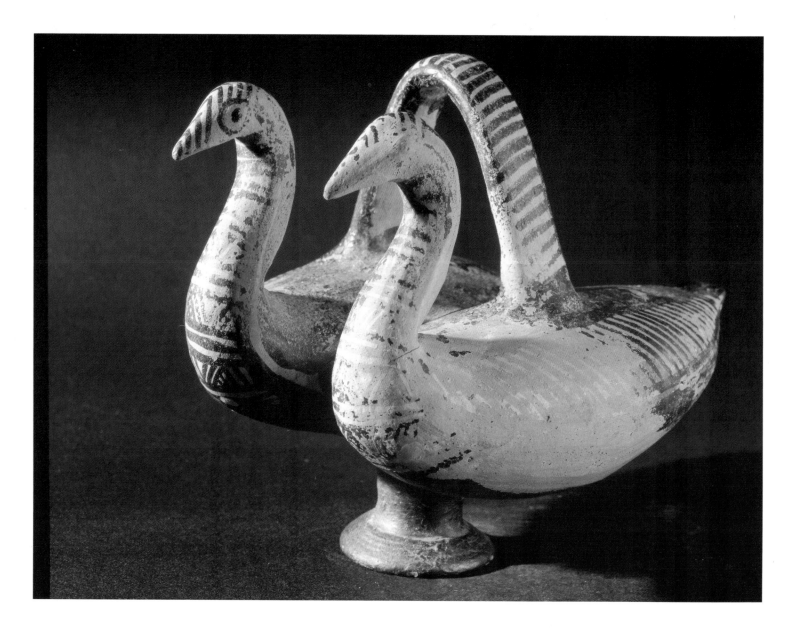

Vase with Two Ducks

Grey clay, dark-brown paint,
h. 16 cm. (6 in.), from the tomb of Seraya,
island of Cos, Greece.
IIIrd millennium BC.
Cos Museum.

Opposite

Pitcher with Upturned Spout

h. 26 cm. (10 in.), diam. 14 cm. (5 $^1/_2$ in.),
from the Cyclades.
Around 1700 BC.
Louvre Museum, Paris.

circles, spirals and scattered dots, all of which were incised in the moist clay. Later, they were decorated with light-coloured motifs against a dark ground, or vice versa. The shape of some of these pots is reminiscent of a human or animal form. The zoomorphic references are obvious: the pot-bellied jug with a straight (sometimes tilted) neck, long spout and large handle looks like a graceful sea-bird, while the oval-shaped *askos* has been dubbed the "duck vase" because of its resemblance to this familiar water fowl.

THE FIRST CITIES: CRETAN PAINTING

The inhabitants of the Cyclades during the Early Bronze Age lived in one-storey houses with, more often

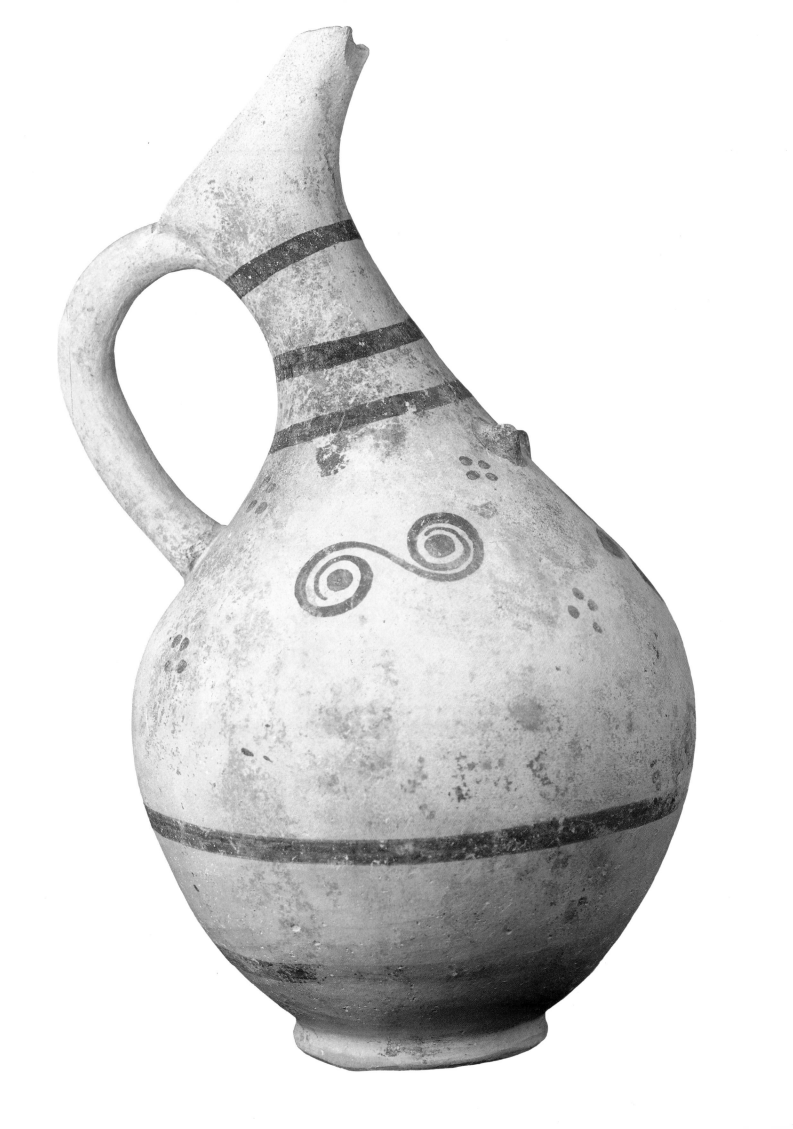

Vase with Octopus Motif

1900-1700 BC.
Archaeological Museum, Herakleion,
Crete.

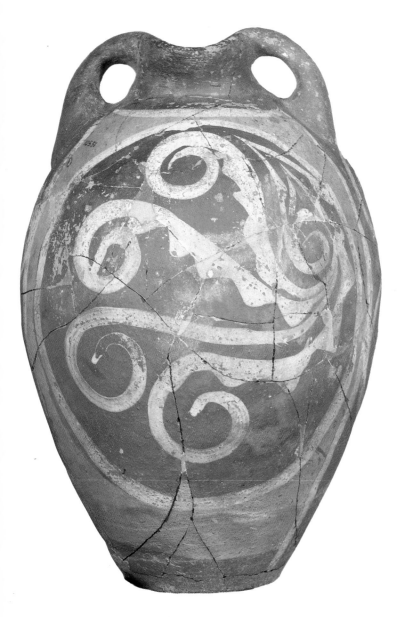

than not, a rectangular ground-plan and thick walls made of stone or carved blocks held together by a clay-based mortar. They consisted of two or three rooms leading into one another and usually had terraced roofs. In order to consolidate the structure, large, unstripped olive branches were sometimes embedded in the masonry. The floors were either beaten earth or paved with pebbles. Some houses were reminiscent of the round Neolithic straw huts that were once common throughout the Mediterranean region. At first, the dwellings stood singly; later, they were grouped into small settlements, and these were eventually surrounded by massive walls with watchtowers to protect them from attack and looting. But there were not yet cities and their architecture was not urban in the strict sense of the word.

A town or city is more than a group of dwellings. It implies social organization in which space is structured on the basis of considerations extending beyond the needs of everyday life. Space in a city is distributed around various centres, which may or may not be built: squares, market-places, esplanades, religious buildings, palaces, and the public buildings necessary for the proper functioning of collective life. It must be large enough to accommodate the various types of activity, from commerce and crafts to public administration. None of these conditions was fulfilled in the first Cycladic settlements – which were more often than not built on top of extinct volcanoes – but they did obtain in Crete at the beginning of the second millennium BC.

True cities appeared in Crete – which Homer called "the island of ninety cities" – because mineral and agricultural riches combined with the civilizing influence of Egypt and Mesopotamia led to development and prosperity. One of these cities, Malia, was built on a plateau about twelve metres high and was divided into several districts along the coast. It was known especially for the excellence of its goldsmiths, whose expert workmanship can be admired in the superb *Pendant with Bees* found in the royal tombs at Chrysolakko. Knossos, the capital of the mythical King Minos, was built in a hilly area and had terraced gardens. Phaïstos, which overlooked the fertile plain of the Messara, had streets with steps built into the hillside, as did Pseira, Arkalochori, Zakros and many others.

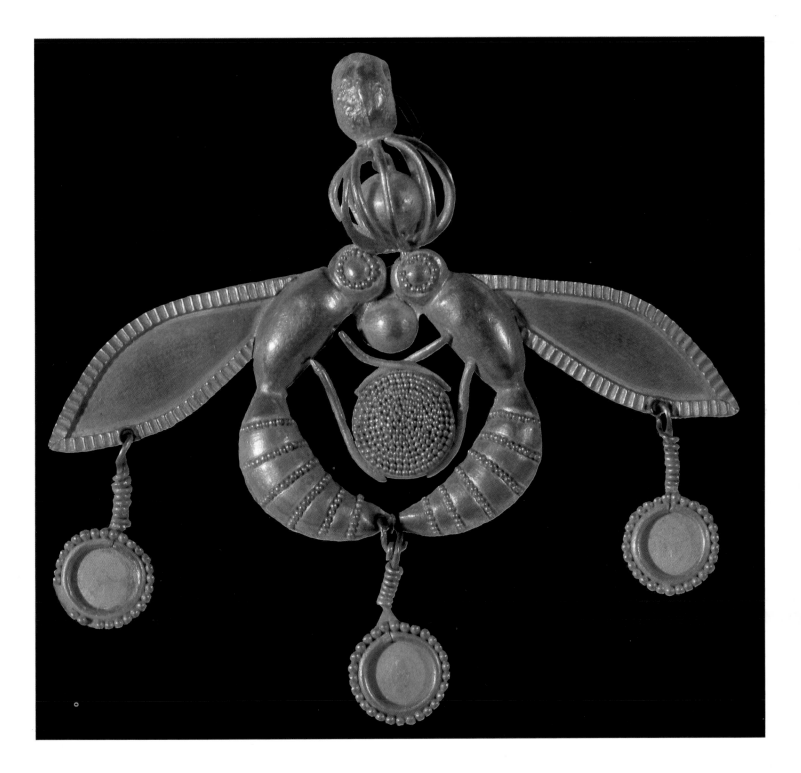

But cities of this importance – Knossos and its port, Herakleion, had a hundred thousand inhabitants – would not have developed without the grandiose architectural complexes which the British archaeologist Sir Arthur Evans called "palaces" when he first discovered their existence between 1900 and 1905.

Pendant with Bees

Gold, from the royal necropolis at Malia.
1700-1600 BC.
Archaeological Museum, Herakleion, Crete.

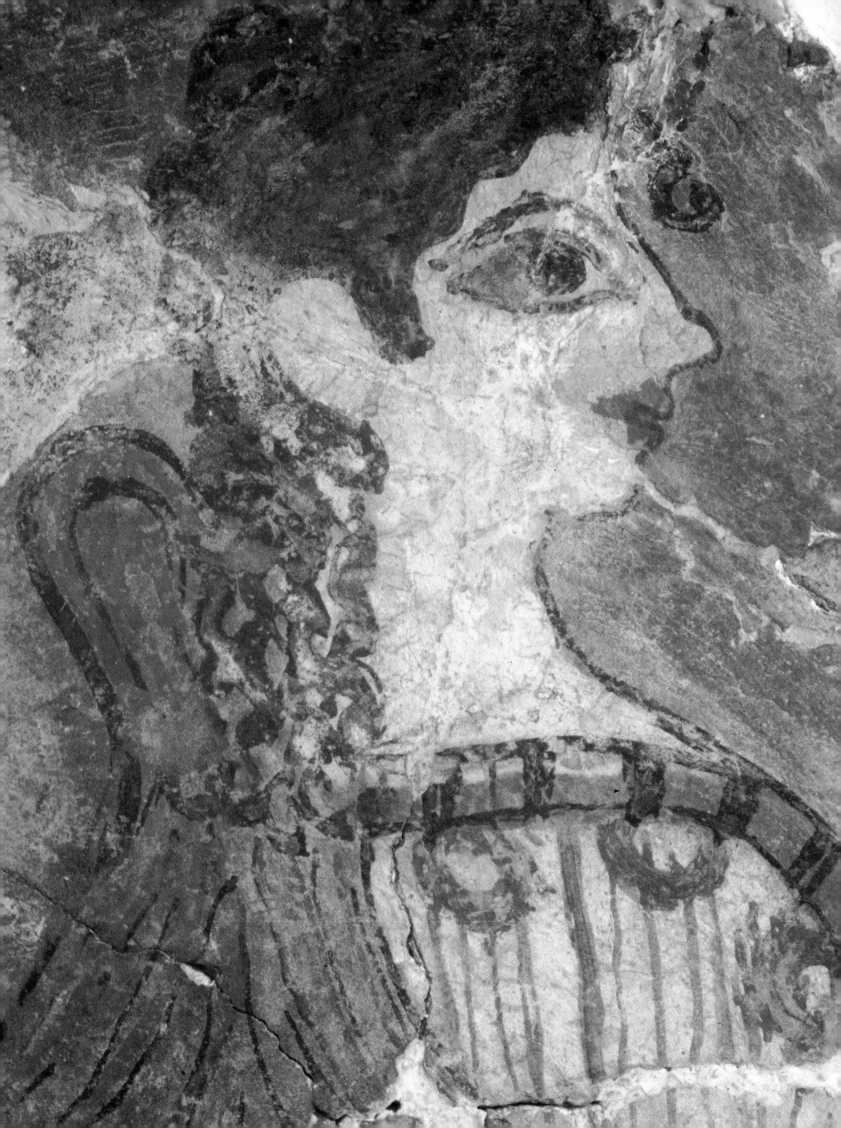

These palaces marked the beginning of monumental art in Crete. Like the palace at Malia, the first of its kind, they formed a massive complex consisting of a central courtyard leading to a throne and reception room, royal apartments, vestibules, workshops and storerooms for oil and wheat. The first palaces in Crete were probably inspired by Asian and Egyptian models and represent the classical age of Cretan architecture. Little is known about them because they were destroyed around 1700 BC, probably by an earthquake, and replaced by others built on top of the ruins. The most impressive construction of this second palace civilization was the palace at Knossos, which covered five acres and had one thousand three hundred rooms, a labyrinthine complex from which, according to legend, only the love and cunning of Ariadne helped Theseus escape. Most archaeologists agree with Sir Arthur Evans that this was the dwelling-place of a priest-king who ruled over a powerful social and economic organization.

While this neo-palatial architecture was among the most brilliant achievements of its kind, the wealth of its interior decoration was even more remarkable. The frescoes at Knossos, both large and small, present a world full of enchantment and fantasy: a bird singing among blossoming bushes, lilies and sweet peas, a blue monkey against a strident red landscape with coloured rocks and umbellated flowers, and even a wide-eyed beauty, nicknamed "La Parisienne" by the archaeologists who discovered her, because of her resemblance to a turn-of-the-century belle. The exuberance of Cretan frescoes is matched only by their elegance. There are many noteworthy scenes of bullfights: an adolescent executing a dangerous jump over the back of a bull; a young man hurtling towards a young woman waiting with outstretched arms, while another youth, demonstrating his skill, seizes the bull by the horns.

A more solemn tone prevails in the works dealing with religious matters, such as the processional frescoes in the great hallway once used by the tributaries of the priest-king in the palace at Knossos. Also preserved are a *rhyton*-bearer with arched torso, bowed by the weight of his load, and above all the paintings decorating the *Sarcophagus of Haghia Triada* that reveal to us the world of the funerary sacrifice. These frescoes depict the various phases of the invocation of Death, the cortege of offering-bearers and musicians, and the arrival of the goddesses in chariots drawn by horses or griffons.

Opposite

Female Portrait, "La Parisienne"

Fresco. Around 1600 BC.
Archaeological Museum, Herakleion, Crete.

Young Woman

Fresco from Thera.
Around 1500 BC.
National Archaeological Museum, Athens.

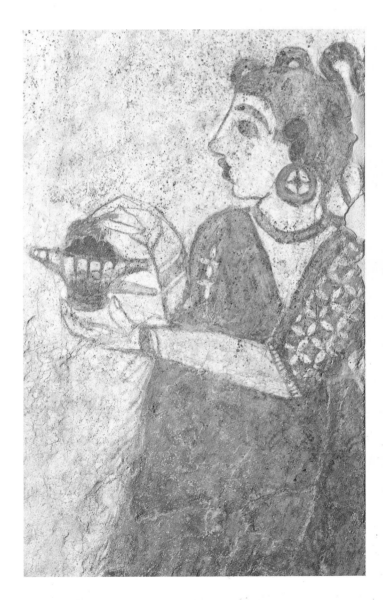

29

In Cretan painting, figures were handled in the same way as in Egyptian painting; the eye was shown frontally in a profile view of the face, torsoes and hips are also frontal, but the limbs are in profile. They appear to be co-extensive with the wall as there is no perspective. Unlike Egyptian painting, which represented pharaohs and high dignitaries on a larger scale than ordinary mortals, the figures in Cretan painting were depicted on the same scale regardless of social rank.

Sarcophagus of Haghia Triada

Painted with scenes of funerary rites. Painted terracotta. Length of sarcophagus 1.375 m. (4 $^1/_2$ ft.). Fifteenth century BC. Archaeological Museum, Herakleion, Crete.

Opposite

Detail. Procession of women.

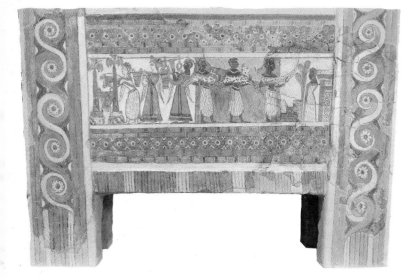

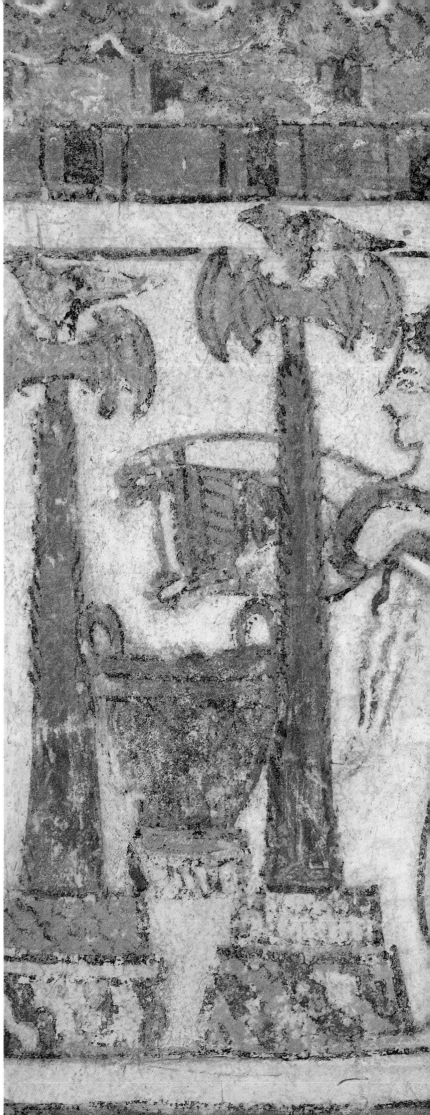

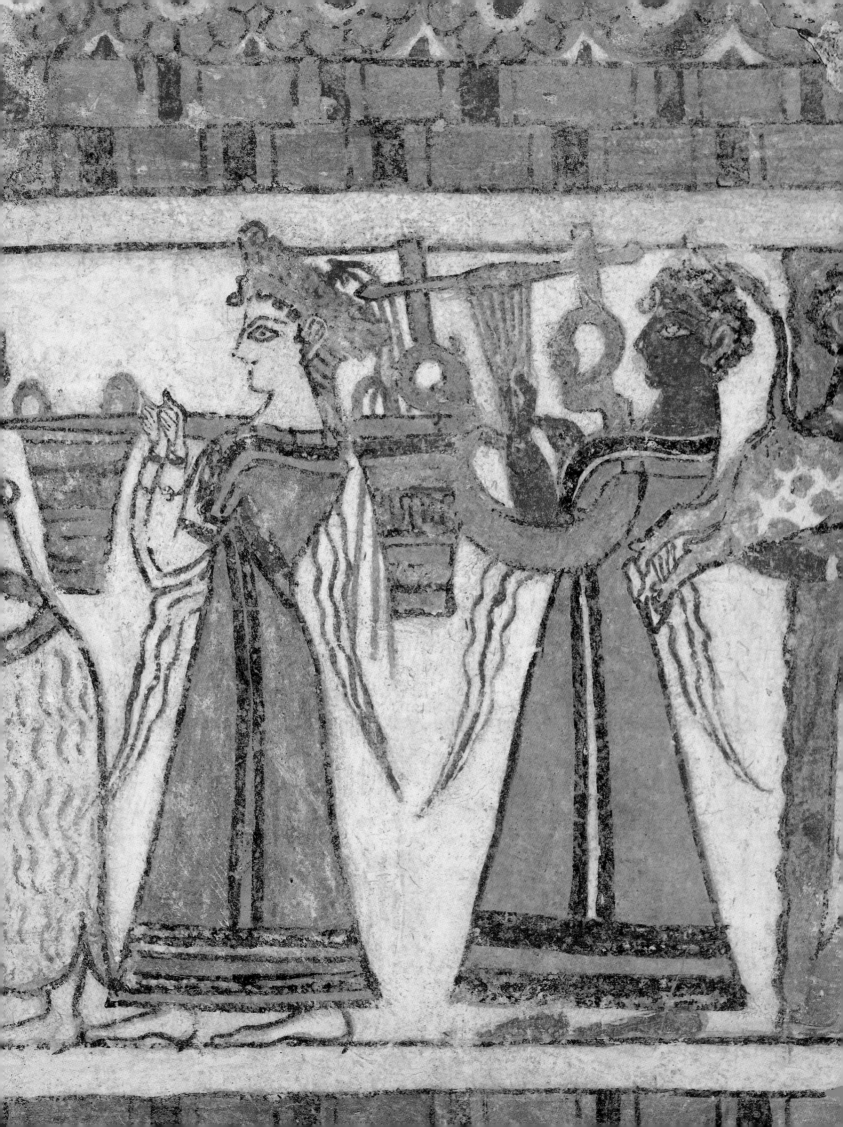

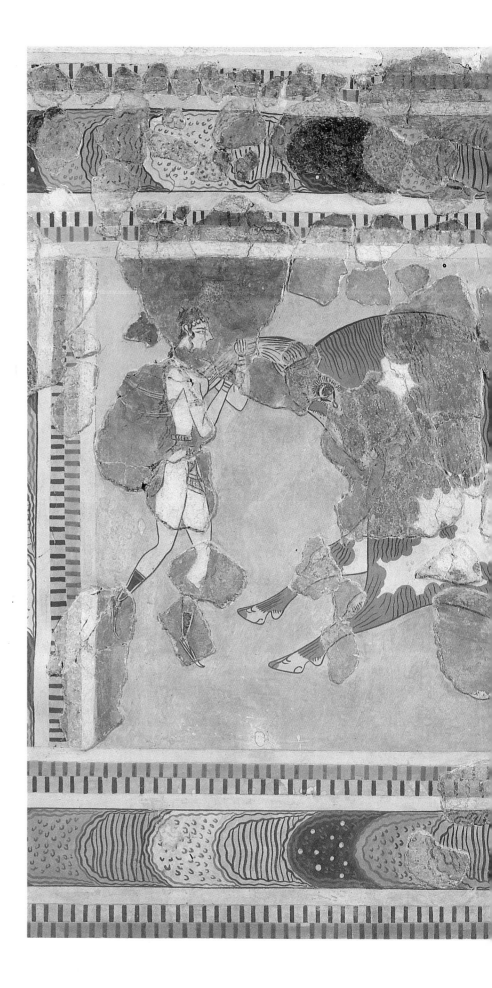

Scene with Bull and Acrobats

Fresco, from Knossos.
1700-1400 BC.
Archaeological Museum, Herakleion, Crete.

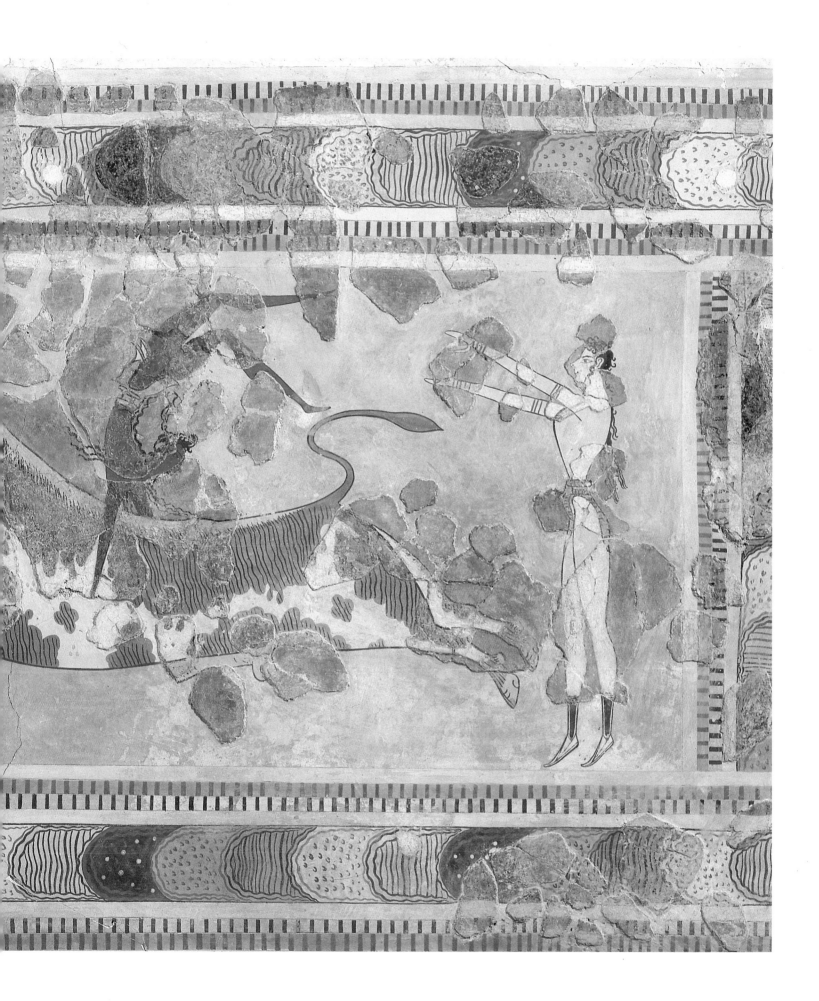

Goddess with Snakes

Glazed ceramic, h. 52.5 cm. (21 in.).
1700-1400 BC.
Archaeological Museum, Herakleion, Crete.

Opposite

Three-String Lyre Player

Clay, h. 7.5 cm. (3 in.), from Arkades.
Archaeological Museum, Herakleion, Crete.

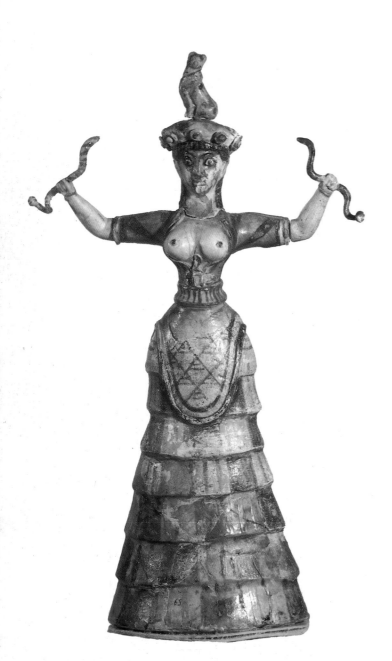

Human figures in Cretan painting are treated in the same way as those in Egyptian painting; the eye is shown frontally in a face drawn in profile, the shoulders, torso and hips are frontal, and the limbs in profile. No attempt was made at perspective; the figures are co-extensive with the plane of the wall. They differ from Egyptian figures in that they are all represented at the same scale, regardless of their actual function or rank; in Egyptian painting, the pharaoh seems a giant in comparison to his high officials, who in turn dwarf the figures of the common people. If Egyptian art is hieratic and suffused with anxiety about the Afterlife, the art of Crete reveals a playful, peaceful and beauty-loving civilization. The quest for eternity seems to have been resolved in a clear assertion of *joie de vivre*.

Cretan painting presents the archetypal image of a Golden Age and universal brotherhood. This is most evident in the frescoes from the Minoan period recently unearthed at Thera, on the island of Santorini. Around 1400 BC, this island was rocked by a cataclysm even more devastating than the one that later buried Pompeii and Herculaneum under the ashes of Vesuvius.

The impression of physical well-being is highlighted by female figurines like the bare-breasted *Goddess with Snakes* which Sir Arthur Evans had the good fortune to discover in the ruins of the palace of Knossos. If there were any large sculptures in Crete, they were most likely made of wood, a perishable material. The figurines that have come down to us are not as well crafted, however, as the pottery, goldwork and carved gems in which the Cretan craftsmen excelled.

The craftsmen specializing in gem-carving created an imaginary world full of fantastic creatures, plants and monsters. Carved on the tiny surfaces of seals or mounted stones – probably with the help of rock crystal "magnifying glasses" – these gems were to protect the Minoans from the evil eye. The gem carvings are wrongly judged to be a "minor" art form, for in many cases they display an amazing spontaneity and freshness, depicting such delightful scenes as a puffin swimming amidst seaweed, or an ibex on a high rock taunting a barking dog.

Religion in ancient Crete was polytheistic. The gods and goddesses tended to be anthropomorphic, but hybrid beings, such as a man with a goat's head or a woman with a bird's head, were not uncommon. As far as we can tell, the Cretans had a rather optimistic vision of life after death,

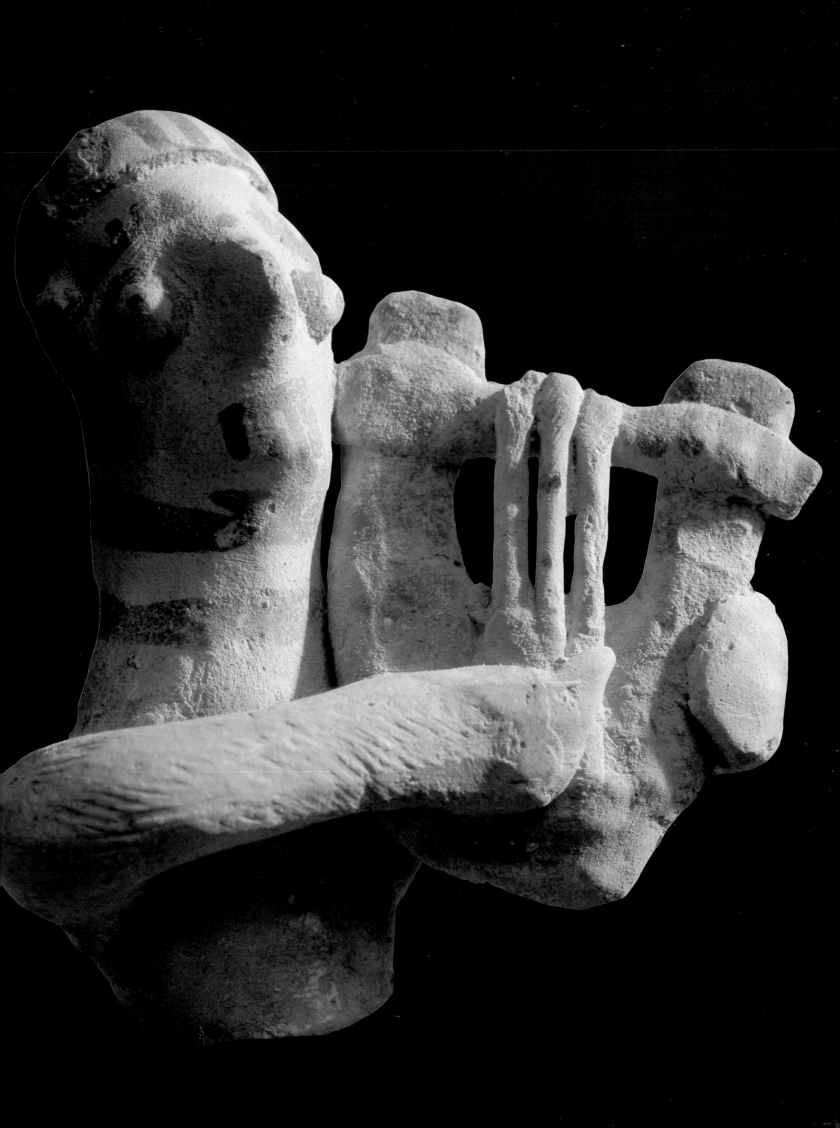

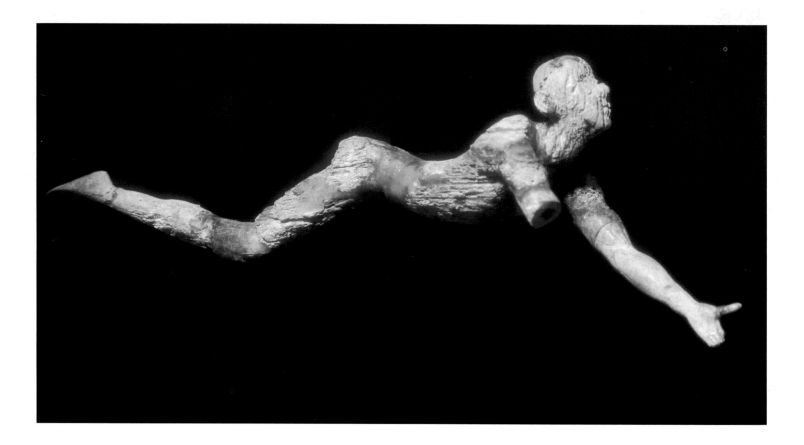

and the promotion to hero status, which ensured eternal happiness to the doers of great deeds, seems to have originated in Crete. Later, during the Hellenic period, access to the Elysian Fields, the otherworldly realm of the blessed – presided over by Persephone, a Cretan goddess – was subject to the judgement of the Cretan divinities Minos and Rhadamanthys, who sat on either side of Aeacus.

The Cretan civilization seems to have been a peaceful and harmonious one, with a passion for life and beauty, and a serene metaphysical and religious outlook – all in all, a far cry from Egyptian and Oriental civilizations, which seem often to have had an inhuman side.

THE BIRTH OF MONUMENTALITY: MYCENAEAN ART

The Palace of Knossos was destroyed around 1400 BC. Like other Cretan palaces it was unfortified. But after Cretan palaces came Greek fortresses. The colossal, nine hundred-metre-long wall that protected the acropolis of Mycenae was composed of stone blocks so huge that even the Ancients believed that only creatures of super-human power, such as the Cyclops, could have built it. Less

massive protective walls could be seen elsewhere, at Tiryns, for example, where they were reinforced with casemates. Their chief function was, of course, to protect the Mycenaean princes, who, with the help of a military commander, ruled over an aristocracy of wealthy land-owners.

The Mycenaean culture was a prosperous one, with horses, advanced agriculture and technology – producing textiles, metalwork, ceramics, gold- and silverwork – and a thriving commerce. Peasants and artisans belonged to a free class called *demos*. The palaces were renowned for their feasts and intense religious life, but such refinements did not completely redeem the brutal military ethic that prevailed. The eminent Hellenic scholar André Bonnard even went so far as to write: "The Achaeans, left untamed by their contact with the Aegean populations, were no better than common looters. Their tombs and palaces overflowed with pilfered gold."[4] No wonder that, of all the cursed families of Greek mythology, the Atridae, sadly notorious for their crimes of incest, adultery and murder, were considered to have been the bloodiest.

The *Lion Gate* at the entrance to the acropolis of Mycenae, is a perfect expression of this will to domination. Situated in a recess between two bastions and flanked by four colossal monoliths, it is decorated by a high-relief sculpture that fills the relieving arch above the lintel and shows two lionesses one on each side of a central pillar. This sculpture had the dual function of supporting the weight of the stone blocks above the lintel and of guarding the citadel. The heads of the lionesses, carved in another, less resistant type of stone (probably steatite) were originally attached with metal crampons, but have been lost, as has a decorative element that once crowned the whole. Yet even in their present state, the noble and powerful simplicity of these two lionesses creates a fitting impression of grandeur. Like a prelude to the colossal *Lions of Delos*, they constitute the first monumental sculpture in Greece.

There has, of course, been much speculation as to their origin and significance. They are probably a larger version of a Minoan motif that the Cretans produced only in miniature. The motif of facing lionesses, symbols of power and sovereignty, is also found in Mesopotamia and the Near East, from where it spread throughout the Ancient

Acrobat

Ivory.
1700-1400 BC.
Archaeological Museum, Herakleion, Crete.

4. André Bonnard, *Civilisation grecque*, (new edition) Brussels 1991, vol. I, p. 19.

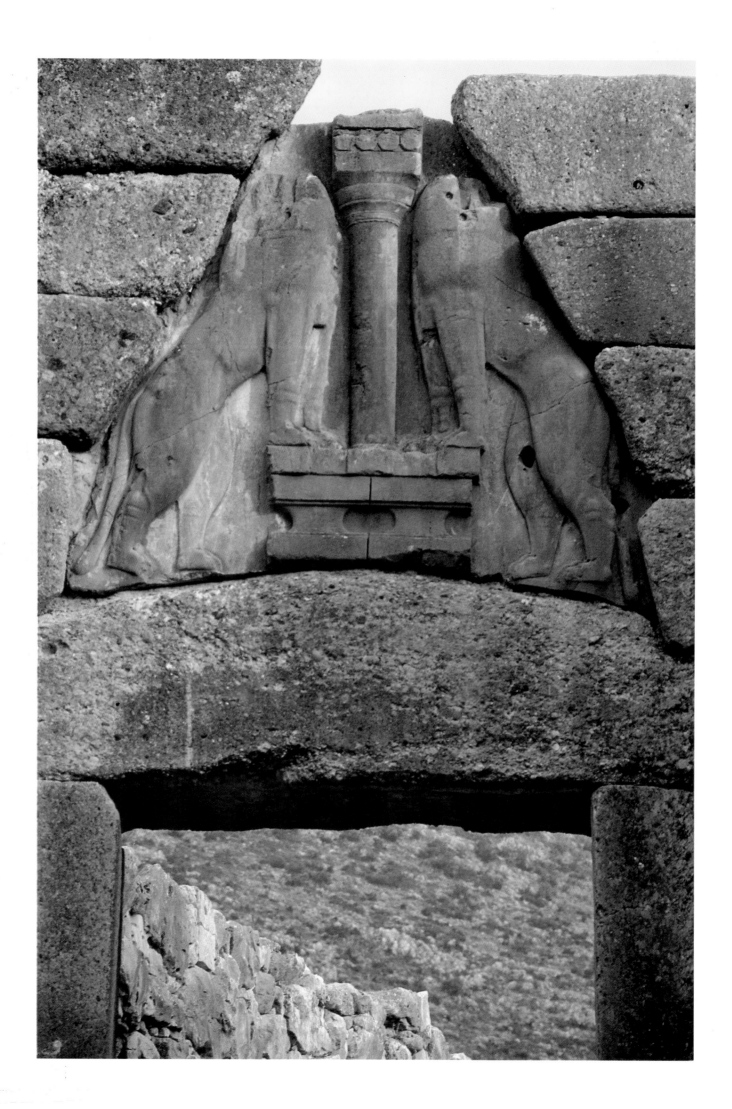

World. The pillar depicted in the centre of the relief is not just part of a building; it is the emblem of a stabilizing god (or goddess), master (or mistress) of the animals, and by extension of the fertile earth, in accordance with the Mycenaean belief in a Mother-Goddess who ruled the Universe.

The two lionesses of Mycenae are of magical inspiration; there is something brutal, even implacable, about them. The word *civilisation* is derived from a Greek word meaning *tamed, cultivated, grafted*. The Greek sculptors of the Classical era saw in the representation of the physically-trained human body the highest form of beauty, akin to that of the gods. But those times were still far off, and André

Opposite

Lion Gate

From the citadel at Mycenae.
1350-1330 BC.
Archaeological site of Mycenae.

Lions of Delos

Marble from Naxos.
Seventh century BC.
Island of Delos.

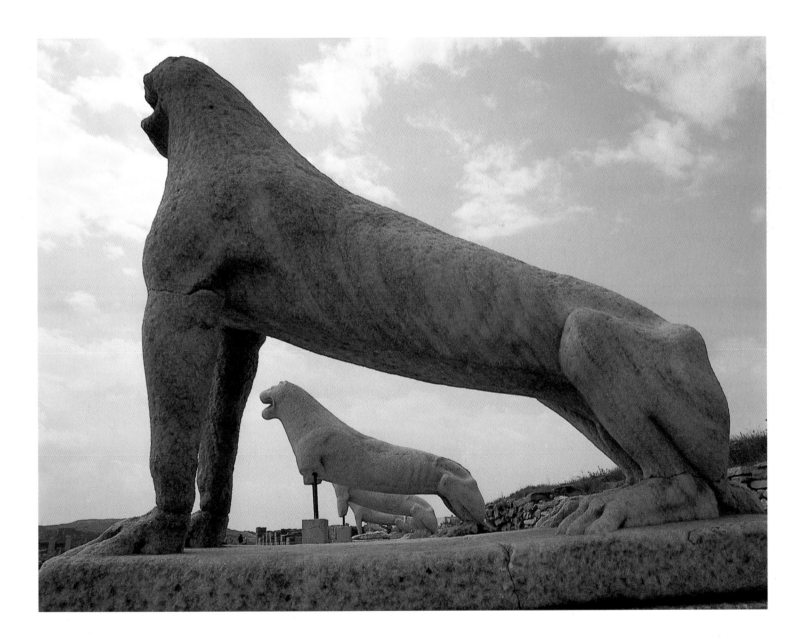

39

Capture of a Bull

Gold cup from Vaphio.
Sixteenth century BC.
National Archaeological Museum, Athens.

Opposite

Taming of a Bull

Gold cup from Vaphio.
Sixteenth century BC.
National Archaeological Museum, Athens.

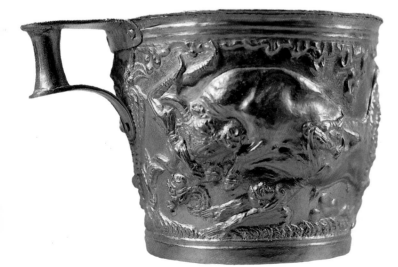

Bonnard could rightly exclaim: "O Greece of the Arts and of Reason, Greece in blue and in pink, sweet Greece, how soiled you are, how fouled with sweat and splattered with blood... You were a green apple that took a long time to become golden. The sun does not shine every day for the human race."[5]

The funerary and military architecture of the Mycenaeans, no less than their sculpture, revealed a marked predilection for the monumental. Burying the dead in foetal position inside rudimentary tombs, as in the Cycladic tradition, was now deemed insufficient. The tombs of rulers were housed in *tholoi*, round edifices covered by a large mound of earth entered through a *dromos*, or long hallway built above or dug out of the earth, and they contained such a wealth of belongings that they were called "treasures." The most famous *tholos* is known as the *Treasure of Atreus*, and was found buried in a hillside a few hundred metres from the *Lion Gate* .

From the gold looted by the warlords and their soldiers, Mycenaean goldsmiths created a masterpiece: a series of eight funerary masks that shine eerily like so many petrified suns. Five of them were discovered in 1876 by Schliemann in the grave circle on the acropolis of Mycenae.

Henry Schliemann, born in 1822 in the town of Neu-Buckow, in Mecklenburg-Schwerin, was an extraordinary figure. He began life as a grocery assistant, eventually amassed a sizeable fortune in international commerce, learned fifteen languages, and left his business at the age of fifty to realize a childhood dream: to search for the ruins of ancient Troy. Steeped in Homer's epics, he thought he had stumbled upon the death masks of Agamemnon and his companions. The straight nose, regular features, pointed beard, everything, down to the yellow sheen of the precious metal, evoked the heroes of *The Iliad* and *The Odyssey*.

It was soon realized, however, that the periods did not correspond, for the tombs discovered by Schliemann dated from 1600 to 1500 BC, some three hundred years before the Trojan War. Of course, this does not take away from the artistic and human value of the masks, which seem to have been fashioned directly on the faces of the dead. One shows a young oval-shaped face with a high forehead, a long, straight nose, and a small mouth framed by a beard and moustache; another has full cheeks, a low forehead, broad

5. André Bonnard, *op. cit.*, vol. I, p. 10.

nose and thick lips; a third, with prominent forehead and wrinkle-lined mouth, presents the features of an elderly man. "O Greece, fouled with sweat and splattered with blood!" There is no stylization, no idealization here, merely the likenesses of three human beings once thrust into the mortal world.

This perhaps explains Charles Maurras's entirely different image of Greece, one in which ugliness and vulgarity prevail.[6] He had only disdain for the barbaric terracotta figurines of the divinities worshipped by the Mycenaeans; with their "Picassian" deformities, they were the antithesis of Classical taste.

The circle of tombs excavated by Schliemann also yielded a fabulous collection of precious objects: bronze and gold plates, cups decorated with fluting or foliage in relief, gold- and silver-encrusted swords, *rhytons* in the shape of bulls' heads, as well as diadems, bracelets, rings and gilded silver sceptres. A spectacular find equalled only by the discovery of Tutankhamen's tomb in this century. Two further masterpieces, gold drinking cups of Cretan inspiration, were brought to light in a *tholos* at Vaphio, in Laconia. On one we see wild bulls being captured in nets, while on the other they are grazing; violence on the one hand and peaceful submission on the other. An apparent rustic idyll that resonates with no less power than the two lionesses of Mycenae. "Tainted" may well be the best term to qualify the beginnings of Greek history, for they were surely neither blue, nor pink, much less sweet.

TOWARDS LATE ARCHAISM: CONTINUITY OR NEW BEGINNING?

After a short existence, the Mycenean palaces suffered the same fate as those of Crete; they were destroyed around 1200 BC, possibly by the Dorians who came from the valley of the Danube, crossed Thessaly, and spread into the Peloponnese. They may also have fallen prey to a surprise attack by the enigmatic "sea people" who left no discernible archaeological traces. Or did a popular uprising put an end to the domination of the hapless Achaean monarchs? Whatever happened, the following half-millennium leading to the Late Archaic Age was marked by a distinct

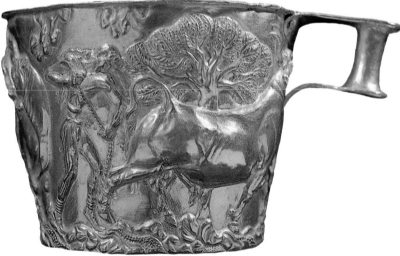

6. Charles Maurras, *Le voyage d'Athènes*, Paris 1939; cited in Effenterre, *op. cit.*, p. 158.

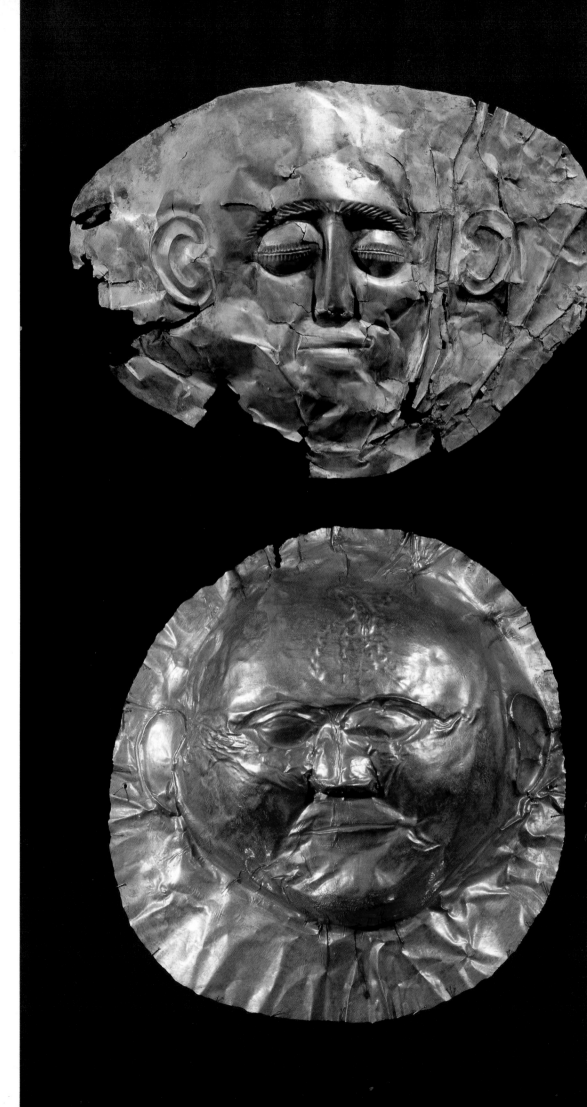

*T*hese funerary masks, found in graves in the grave circle at Mycenae, are made of beaten gold leaf, possibly fashioned directly on the faces of the deceased. The features are stylized, with the eyes closed, and often a beard framing the chin. They exemplify the Greek's enduring fondness for plasticity from the earliest times.

Above

Mortuary Mask

Gold, from Tomb IV
at Mycenae.
Sixteenth century BC.
National Archaeological
Museum, Athens.

Below

Mortuary Mask

Gold, from a tomb at Mycenae.
Sixteenth century BC.
National Archaeological
Museum, Athens.

Opposite

The "Agamemnon" Mask

Gold, from Tomb V
at Mycenae.
Sixteenth century BC.
National Archaeological
Museum, Athens.

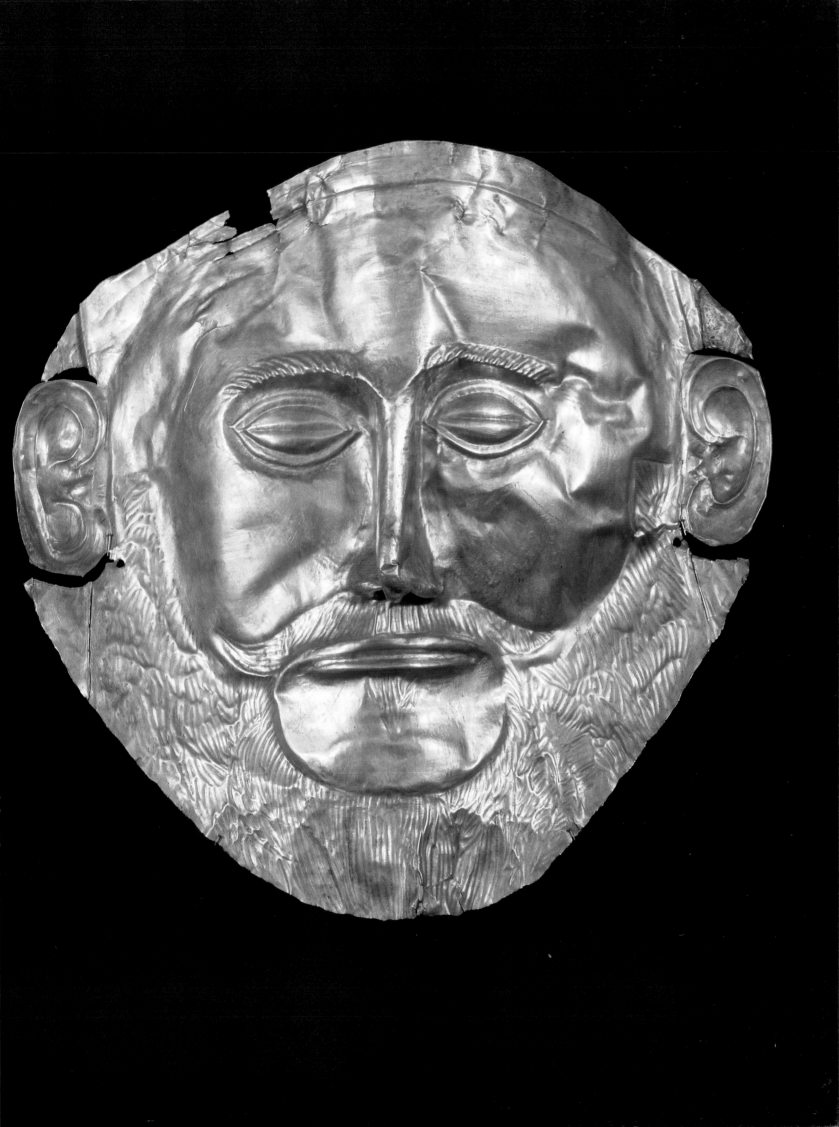

Oenochoe with Geometric Designs

h. 24 cm. (9 in.).
Around 800 BC.
Louvre Museum, Paris.

Opposite

Crater with Geometric Designs

h. 27 cm. (10 1/2 in.), diam. 25.8 cm. (10 in.),
from the necropolis in Athens.
10th-6th century BC.
Louvre Museum, Paris.

change in the realm of monumental architecture, while the folk arts remained relatively stable, especially ceramics, with even more geometric vases.

Although we have not said much about ceramics, an art form that combines fire and earth, it was one in which Greek craftsmen excelled. At the beginning, the objects were modelled by hand from a lump of clay, then with the primitive wheel of the Cyclades. Only centuries later was the process perfected by the invention of the potter's wheel, still used by potters today, permitting the creation of perfectly round pieces. Around 1000 BC, the decoration of the vases consisted mainly of geometric patterns – parallel lines, undulating stripes, concentric circles, etc.; there were no motifs taken from the plant or animal worlds. What may appear to be aesthetic sterility seemed like a very normal development to a specialist like Christian Zervos[7], who has explained that once the craftsmen had exhausted the stock of forms inspired by nature, they had to turn to abstraction, as a necessary return to their source, just as Malevich and Mondrian did later in reaction to the extreme naturalism of the nineteenth century. This was accompanied by a change of taste linked to the rising importance of Athens, which had been spared by the Doric invaders. The tombs of Attica are the source of most of our knowledge of geometric pottery.

But pure abstraction reigned for only a very short period. By the middle of the 7th century BC, funerary vases were displaying human figures, discreetly at first, then increasingly, until the geometric patterns had been reduced to the role of framing devices. Still, these were not so much figures as signs: a ball for the head, two triangles for the body, four segments for the arms and legs. Summary though they may be, on some of the best pieces these "signs" convey a remarkable sense of movement.

The huge *Geometric Crater* (1.23 m. high, with a diameter of 0.78 m.) at the Archaeological Museum in Athens illustrated here is a superb example. It has two registers of decoration showing a procession of relatives and mourners accompanying the body of the deceased to its burial place, complete with mortuary sheet and bed, and a procession of chariots drawn by two horses. On another

7. Christian Zervos, *La civilisation hellénique*, vol. I, Paris 1969, pp. 81-95.

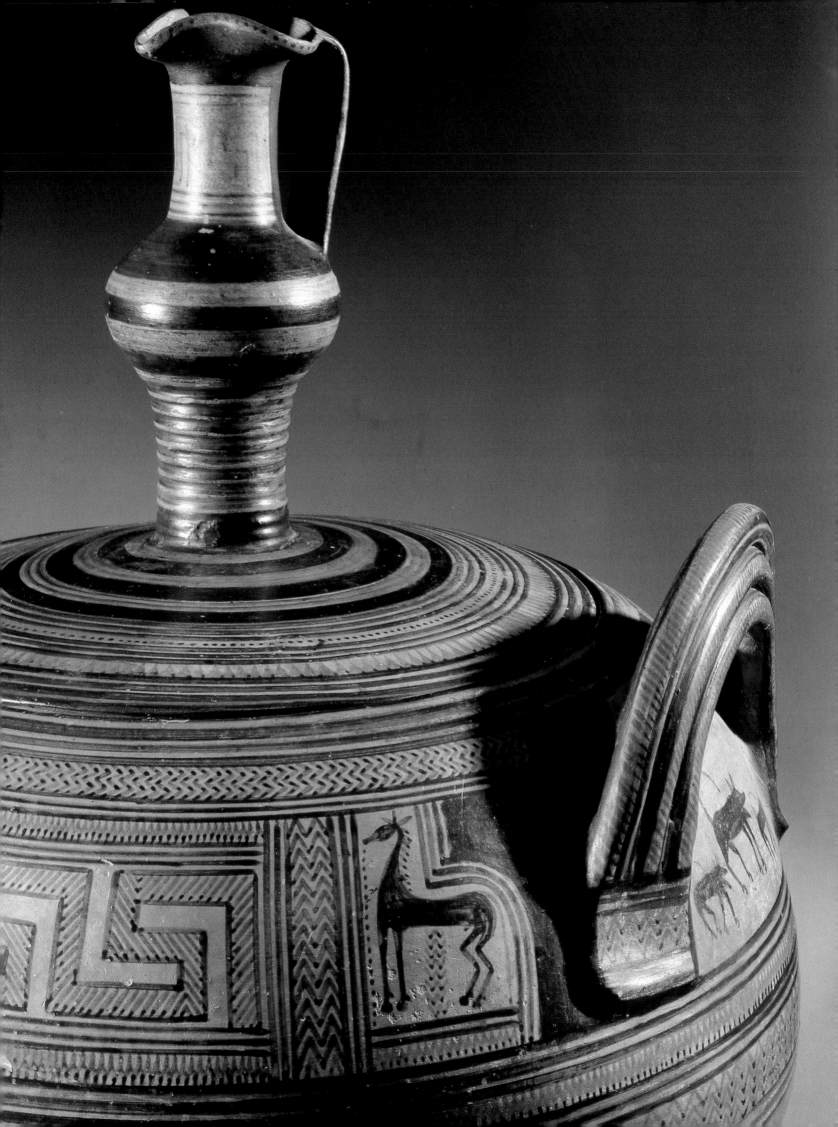

The "Levy Oenochoe" with Trefoil Spout

h. 39.5 cm. (15 ¹/₂ in), diam. 30 cm. (12 in.).
Detail of the top: plant motifs with geese,
griffons, goats and sphinx.
640-620 BC.
Louvre Museum, Paris.

crater found at Thebes, the figures, traditionally represented in profile as in Egyptian or Cretan painting, are depicted in three-quarter view and even almost frontally. On yet another, we see the wild silhouette of the Nemean lion standing on its hind legs and being attacked by a sword- and javelin-wielding Heracles. Note the extreme simplicity and concision of form. During this same period, Homer was characterizing his heroes with a single gesture or utterance. Without resorting to description, he created the most fabulous gallery of living actors of all time.

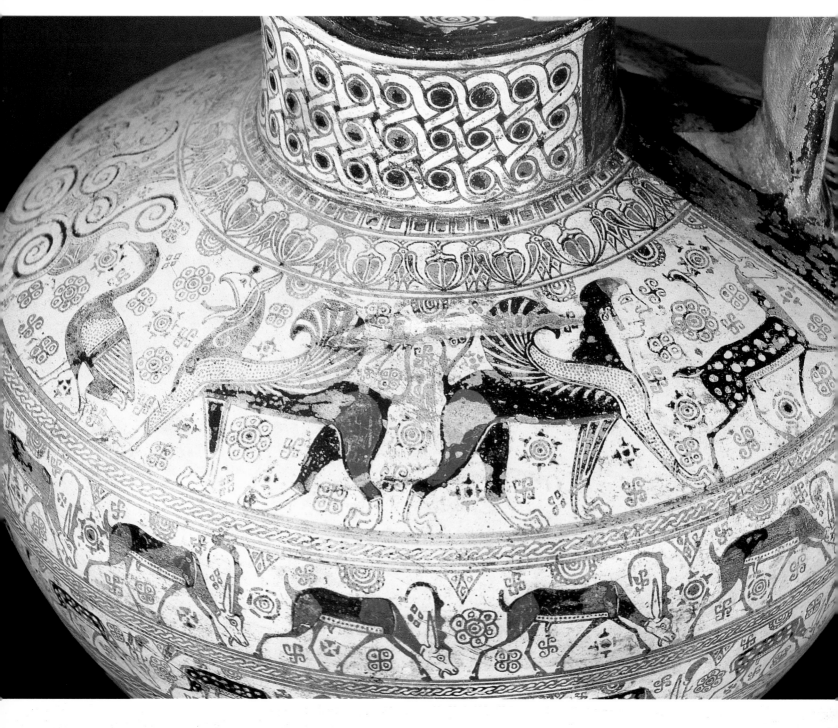

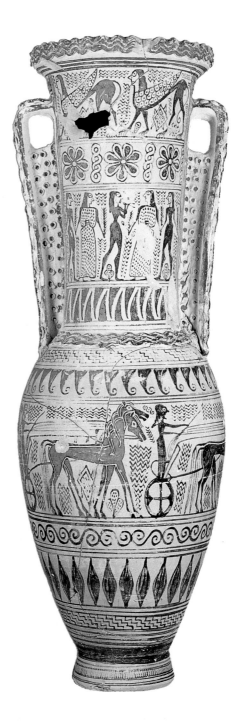

Loutrophorus

h. 81 cm. (32 in.).
Attributed to the Analatos Painter.
Around 700-680 BC.
Louvre Museum, Paris.

Above

Detail of the neck with sphinxes.

The geometric style in pottery was not unrelated to the epic. As the Athenian craftsmen perfected their modelling and firing techniques, the size of the vases increased, leaving ample room for decorations of all kinds: processions of wild, man-eating beasts, warriors in furious hand-to-hand combat, ships sinking in fateful naval battles. Some of the amphorae placed on tombs in lieu of steles were of human height. In Greece, pottery was the monumental art of the Late Archaic Age.

The sculpture of this geometric period is very little known, for the major works were made of wood, a material that easily decays. Only small works made of bronze (statuettes) or hand-modelled terracotta (heads) have come down to us, and it is impossible to determine if they were copies of larger statuary or independent creations.

These diminutive terracotta heads – the remains of originally entire figurines – have a variety of faces, both youthful and old, expressing anxiety, astonishment or impassivity. They were, of course, depictions of gods, not humans. The bust of a beardless musician playing on a three-stringed lyre found at Arcades is probably a figure of Apollo, the titular god of this instrument. The figurines were placed in the tomb of the deceased along with an idol representing the Mother-Goddess, who protected the dead. These idols were often bell-shaped, with a very long neck, small head with a low brow, multi-stringed necklaces and a large pendant on the chest. They also had bell-shaped dresses and

47

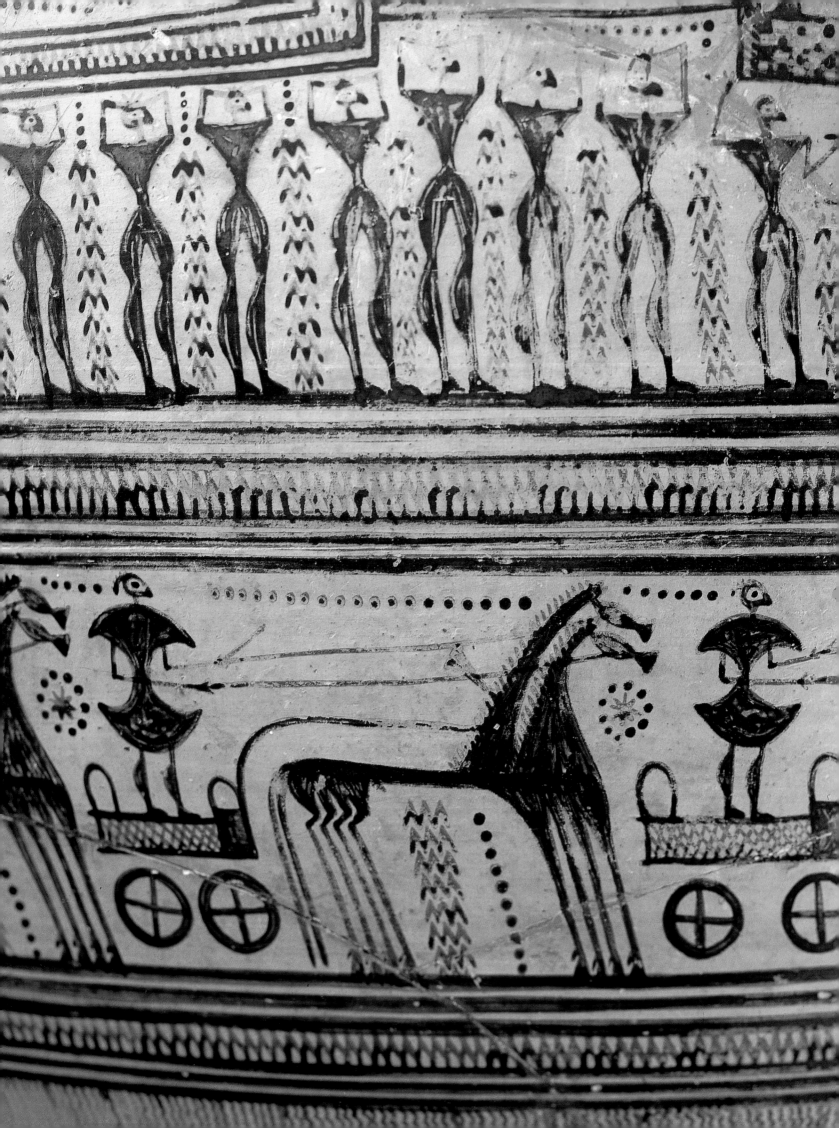

painted shoes. The general impression is one of a summarily executed doll.

The small bronze sculptures, which include male, female and animal figurines, display quite different formal characteristics. One of the frequent types is a charioteer with reins in both hands, wearing, curiously, a broad-brimmed hat turned-up at the front, a pointed bonnet or a helmet. Another frequent type is the warrior wearing only a broad belt and displaying an erect phallus. The female statuettes may be clothed or nude, cylindrical and rigid in shape, or with undulating forms, in the case of dancers. Although human in appearance, these figures all belonged to the realm of the sacred: this is not a warrior, but Zeus brandishing his lightning bolt; not just any young woman stretching her bow, but Artemis, the divine huntress in search of game. Likewise, the female rider mounted side-saddle found at Olympia is a divine horse tamer, while the earliest representations of an anthropocephalic horse – the ancestor of the centaur – go back to the 10th century BC.

Although these human figures are in fact gods and goddesses, their novelty lies in the fact that they have a human shape. The scholars of ancient Greek history all agree that, around the end of the 8th century BC, a religious revolution of considerable scope occurred. It found its first timid aesthetic expression in the small statuary of the Late Archaic, and determined the future development of Greek art.

The figure of the Great Mother was definitively replaced by a powerful male god who, what is more, was in the habit of mating with ordinary mortal females. The result was a pantheon of humanized gods and goddesses, representing a higher stage of human development. As Jean Charbonneaux put it: "Hellenic humanism annihilated the mysteries of the world by giving to all questions put to the Unknown an answer in a human voice."[8] One era was coming to a close, another dawning. The door to Phidias and the Parthenon was open.

In two centuries of tremendous creative activity, Greek artists acquired an incomparable mastery in the representation of life in all its forms. During the 7th century BC contacts with the Orient were strengthened. Greek and Phoenician ships in

8. Jean Charbonneaux, *La sculpture grecque archaïque*, Lausanne 1942, p. 5.

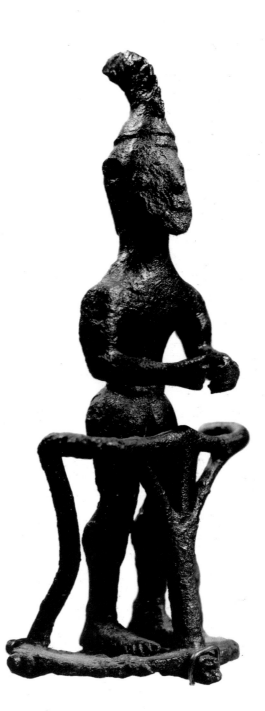

Geometric Crater from the Dipylon

Detail showing a procession of chariots and mourners.
Second half of the eighth century BC.
National Archaeological Museum, Athens.

Warrior on a chariot

Bronze statuette, h. 13.6 cm. (5 1/2 in.).
Around 750 BC.
Olympia Museum.

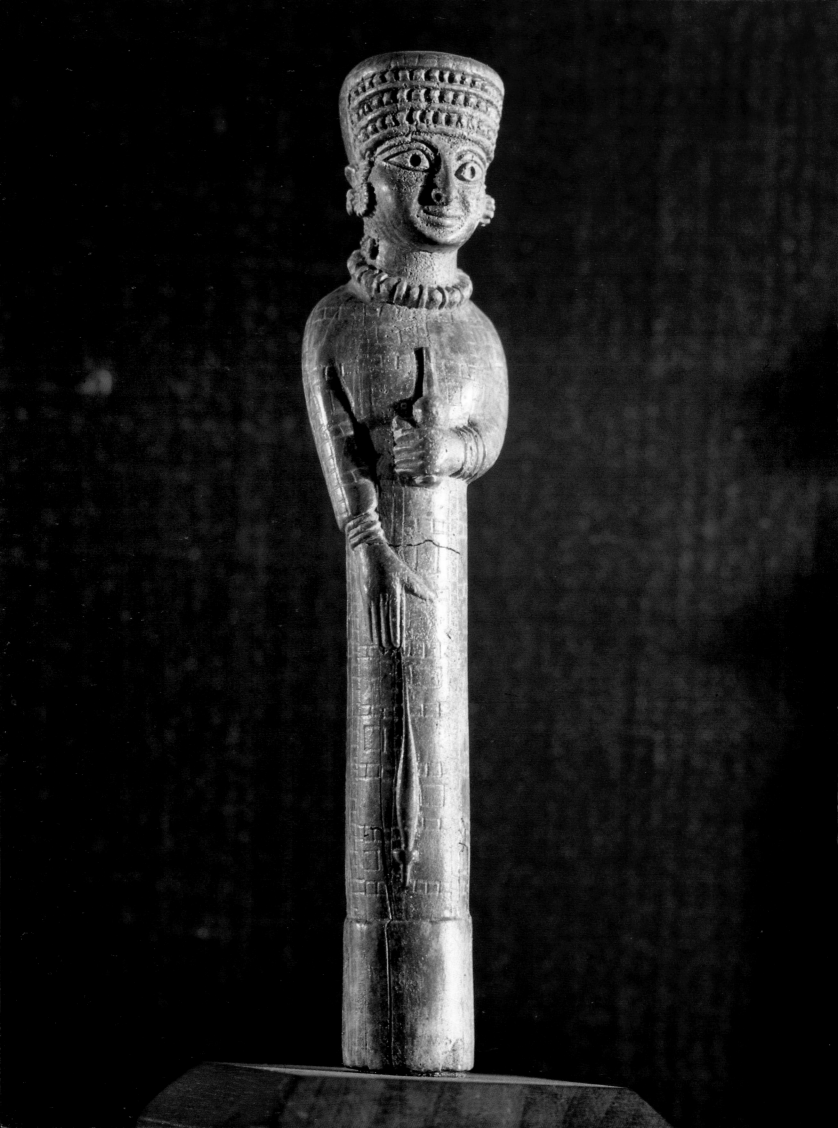

search of new lands and markets cruised the Mediterranean in great numbers, disseminating their designs and techniques.

Syro-Phoenician ivories, Ur bronzes, Neo-Hittite figurines were circulated and traded, along with the textiles that played an important role as vehicles for imagery, although only the versions transposed into less perishable materials have survived. Located at the crossroads of the Greek and Oriental streams of influence, the metalworkers of Cyprus and Crete devoted their incomparable technical mastery to the creation of original forms.

Importation? Imitation? Influence? The exchange of goods and techniques was so brisk, with artisans constantly on the move, that it is sometimes difficult to know what was what.

Ceramics all over the Aegean world, whether Corinthian or Cycladic, displayed rich decorative fauna, part real, part imaginary: lions fighting with bulls, panthers facing each other, rows of grazing stags, or composite creatures like sphinxes, griffons, gorgons and chimeras. A new vocabulary of ornamental motifs, much of it of Oriental origin – palmettes, lotuses, swastikas – filled all the available pictorial space, attesting to a veritable "horror vacui."

Throughout the Mediterranean world, from East to West, from Asia Minor to Etruria and the Iberian coast, the arts were experiencing an Orientalist phase. But only the Greeks succeeded in integrating these influences, infusing them with their own native genius, and achieving a new originality. The amazing and somewhat anarchic vitality of the 7th century BC was to be followed by several decades in which Greece demonstrated its remarkable capacity for assimilation and re-creation.

Opposite

Woman Spinning Wool

Ivory, h. 10.5 cm. (4 in.).
Found in the foundations of the Temple of Artemis at Ephesus.
Late seventh century BC.
Archaeological Museum of Istanbul.

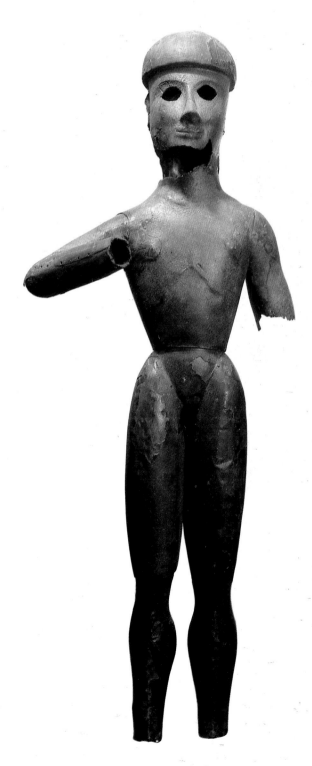

Page 51

Apollo

Cult statue of bronze-plated wood, found at Dreros.
h. 80 cm. (32 in.).
Sixth century BC.
Archaeological Museum, Herakleion, Crete.

This page, left

Female Idol

Terracotta, from Piskokephalo.
2000 BC.
Archaeological Museum, Herakleion, Crete.

This page, right

Female Idol

Terracotta, from Petsofa.
Around 2000 BC.
Archaeological Museum, Herakleion, Crete.

Opposite

Two Female Idols

Left, 14th-13th century BC.
h. 11.4 cm. (4 $^1/_2$ in.).
Right, early 6th century BC.
h. 20 cm. (8 in.).
Kunsthistorisches Museum, Antikensammlung, Vienna.

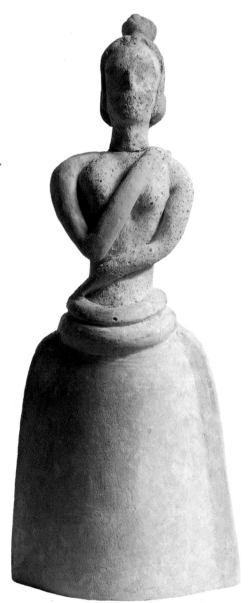
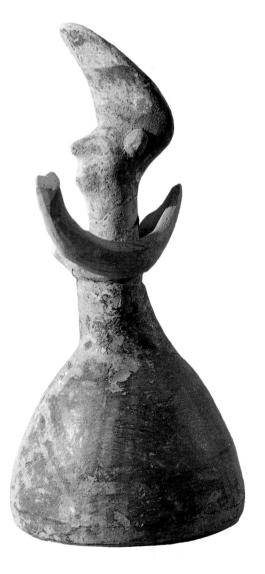

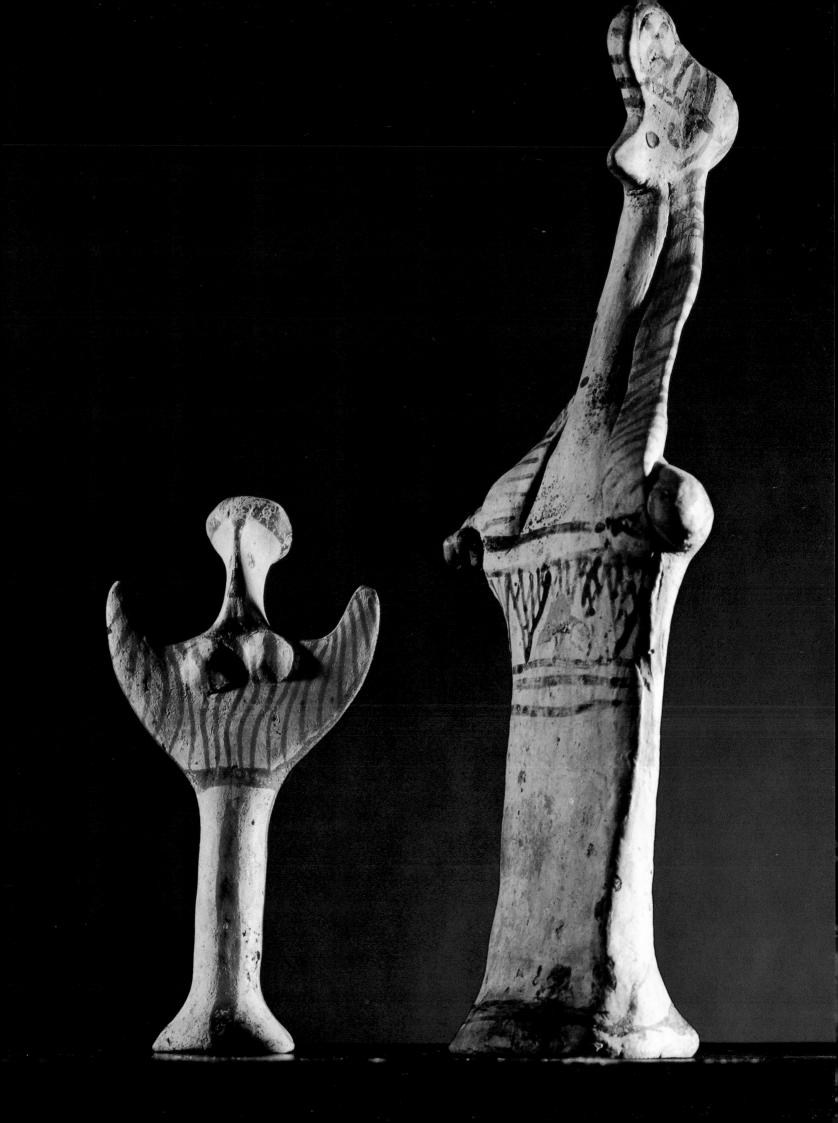

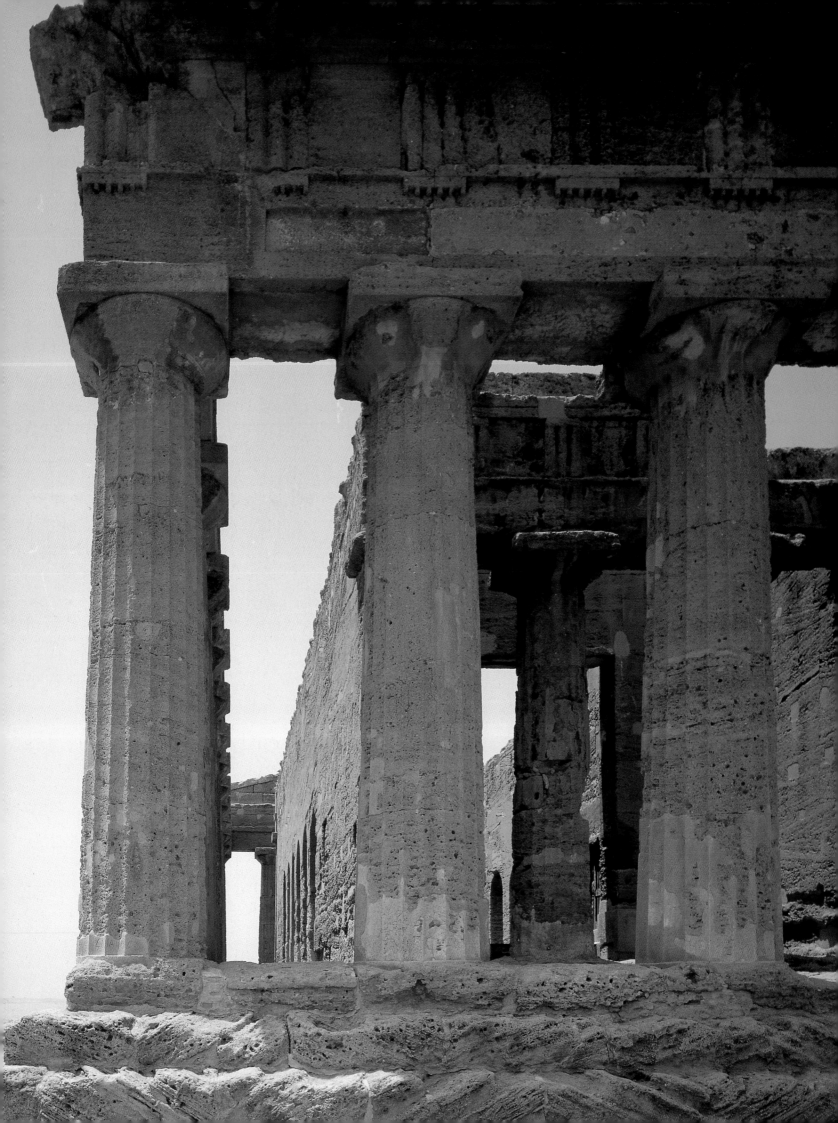

2. ARCHAIC ART

MATERIALS AND FORMS:
FROM WOODEN TO STONE TEMPLES

The first sanctuaries built to worship the new human-ized divinities were of simple design and modest dimensions, the humble forerunners of the most perfect religious edifices ever raised.

We have an idea of these beginnings thanks to the terracotta votive house models found at Argos and Perachora. These were essentially like small chapels and vestiges of them have been found at sacred sites throughout continental Greece. They consisted of a rectangular or domed room, a façade with a small porch supported by columns, and a ridge roof. Built in regions that were slowly recovering from recent conflicts, these dwelling-places of the gods were little different from those of their worshippers, and the sculpted figures inside were still rudimentary. Such temples were probably unknown to the populations of the Aegean, who generally celebrated their cults in caves or high places. They were long thought to be the successors of the beam-and-plank dwellings of former times, but this supposition has now been proved incorrect.

Since the days of Schliemann, we have learned that the origins of the Greek temple – in particular of the Doric style – are to be found in the *megara* of the Mycenaean palaces. The

Votive House

Drawing of a terracotta model found in the sanctuary of Hera at Perachora.
h. 20.8 cm. (8 in.).
Around 800-750 BC.
National Archaeological Museum, Athens.

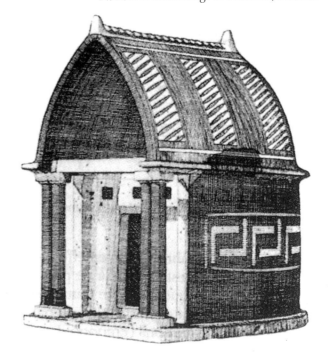

55

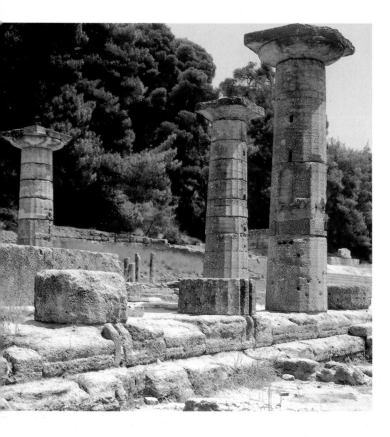

Temple of Hera

Around 600 BC.
Olympia.

Page 54

Temple of Concord

112 x 19.70 m. (336 x 60 ft.).
Fifth century BC.
Archaeological site of Agrigentum, Sicily.

Opposite, above

Temple of Apollo

Around 540 BC.
Archaeological site of Corinth.

Opposite, below

Temple at Segesta

61 x 26 m. (200 x 85 ft.).
Fifth century BC.
Archaeological site of Segesta, Sicily.

latter were composed of unconnected rooms or series of rooms. These rooms, often quite small, were used to store provisions or as living quarters for family members or servants, and were situated away from public view. The *megaron*, on the other hand, was a space that represented the owner's wealth and power. The word *megaron*, used by Homer, means "great hall," and, as its name implies, it was larger in size and served as an official reception hall and the focus of social life in the palace. It opened onto a spacious courtyard situated in front of the palace. The one excavated at Tiryns by Schliemann had the rectangular ground-plan of the *cella*, or *naos*, of the first temples. The two projecting side walls enclosed a double vestibule preceded by a pair of columns at the entrance. The main material used was wood, which played an important part not only in the reinforcement of the walls, but also in the entablature and ceiling, which was covered by a flat or a ridge roof. Stone and unfired bricks were occasionally used. The brick walls rested on a low stone foundation, and the columns on a block set on the ground to prevent rotting.

The archaeologist Henri Lechat described the *megaron* in these terms: "Take two of the type found at Tiryns, eliminate the rear walls and place them back to back, then surround the whole with a colonnade and the result will be more or less the Heraion."[1]

The Heraion, or Temple of Hera, built in Olympia around 600 BC, had an oblong ground-plan and a *cella* divided into a succession of spaces that subsequently became the established pattern: a *pronaos*, or vestibule, followed by a *naos*, or main hall, subdivided into three naves by two rows of columns. The Heraion at Olympia is noteworthy because of its columns; the first ones were made of oak, but these were gradually replaced by stone columns without any regard for symmetry or stylistic uniformity. Some were still standing in the second century AD when Pausanias visited the sanctuary to study it for his *Geography of Greece*. Its strange architecture was devoid of sculpted pediments or metopes, and its humble materials were dissimulated by a bright colour-scheme of yellow, white and black.

Meanwhile, in many areas around the Aegean Sea, efforts were being made to create new buildings; in Asia Minor, for example, the first large-scale temple dedicated

1. Henri Lechat, *Le temple grec*, Paris 1902, p. 21.

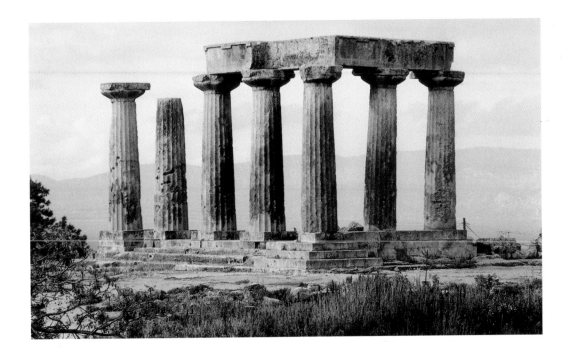

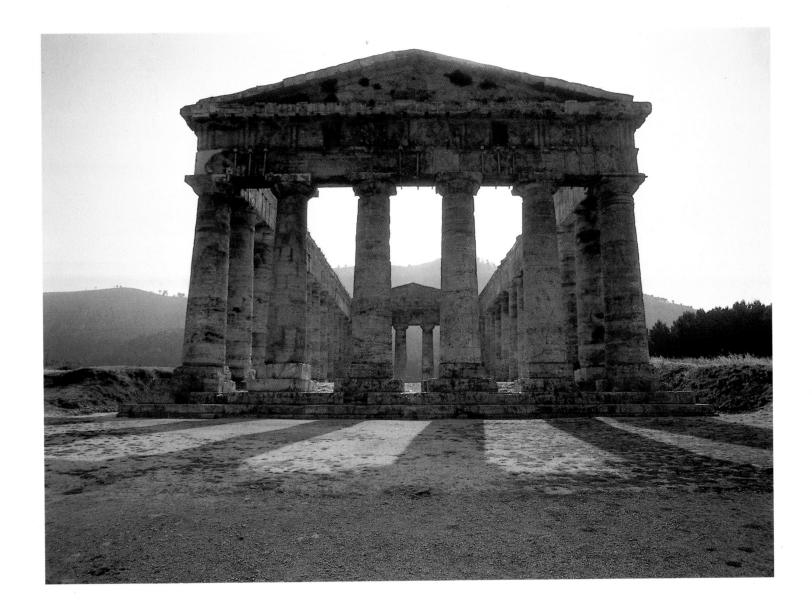

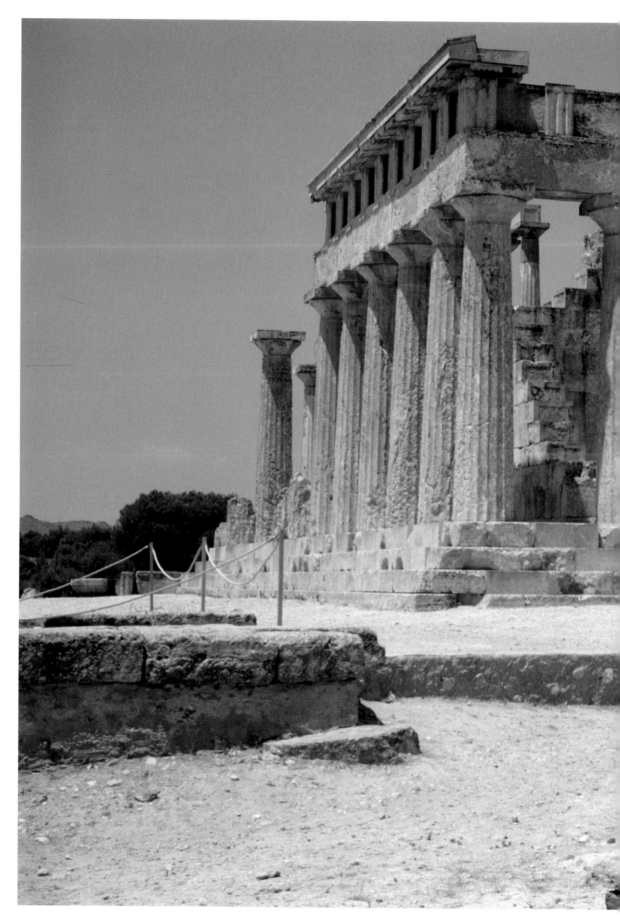

Temple of Aphaia

13.77 x 28.31 m. (45 x 93 ft.).
500-490 BC.
Archaeological site of Aphaia
at Aegina.

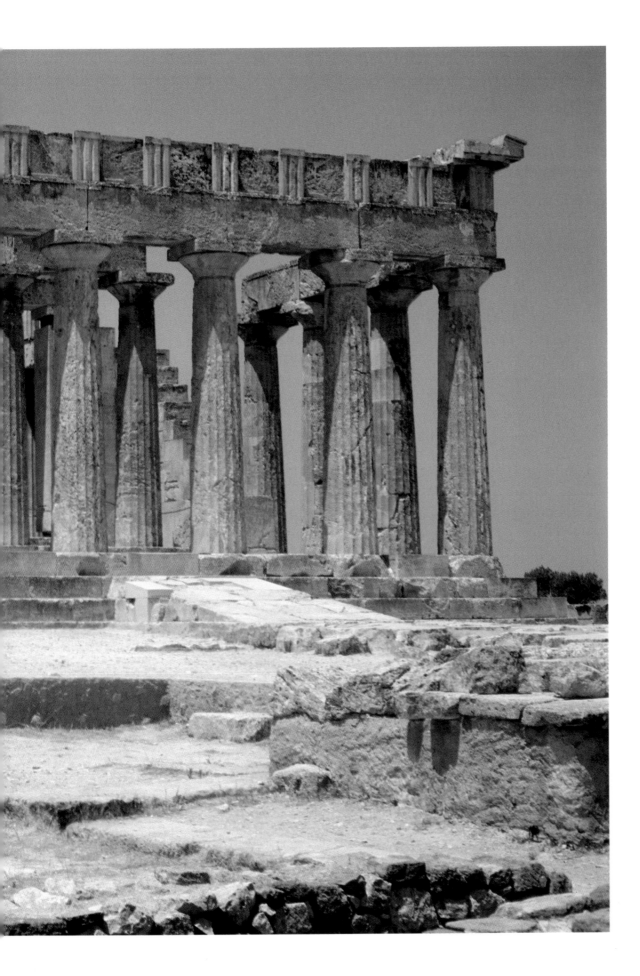

to Hera was erected at Samos. The miraculous cult-statue of the goddess, which legend says was brought there by the Argonauts, was at first worshipped under a canopied structure near the sacred reeds on the marshy banks of the Imbrasos, next to free-standing altars. Then, around 800 BC, the idol was housed in a new shrine that was probably the first *hecatompedon* in Greek architecture.

So-called because it measured one hundred Samian feet in length (32.86 m.) – and 6.50 metres in width – it consisted originally of a simple *cella* covered by a roof borne on several rows of pillars. Already at the turn of the ninth century, it was surrounded by a peristyle consisting, respectively, of seven and seventeen columns which formed an attractive and inviting ambulatory. Around 606 BC, it was replaced by a new temple, a crowning achievement in the architects' efforts to create vast interior spaces and impressive exterior proportions. The centrally-placed pillars that had divided the original *cella* longitudinally in two were moved to the side, towards the side walls, in order to create a suitable space for the idol placed at the far end of the temple. The former brick walls were then entirely replaced by stone blocks carved in irregular shapes.

It was during this period that two of the three major Greek architectural orders were defined: the Doric, which prevailed in the Peloponnese, continental Greece and Sicily, and the Ionic, which spread mainly to Asia Minor and the Aegean islands.

According to Vitruvius, the Doric order came from Argos and aimed to give an impression of strength and simplicity. The squat columns rested directly on the stepped-pedestal that formed the base of the temple, the last step of which was called the *stylobate*. These columns were made of stacked-up tambours which the Greeks called "vertebrae" because they compared columns to bodies with strong backbones. They were decorated with a pattern of sixteen, eighteen or twenty flutes which had the optical effect of emphasizing the vertical axis and drawing attention away from the horizontal joins that divided the column into segments. The diameter of the column diminished irregularly from the base upwards. Doric columns were topped by a simple capital composed of an *echinus* – probably derived from the thick, rounded Mycenaean capitals – and a square *abacus* which held the *entablature*: The latter consisted of an *architrave*, frieze and cornice, itself decorated by an alternating series of *triglyphs*

Temple of Poseidon

60 x 19.55 m. (196 x 64 ft.).
Consisting of thirty-nine columns
and a *cella* with three naves.
Around 450 BC.
Archaeological site of Paestum.

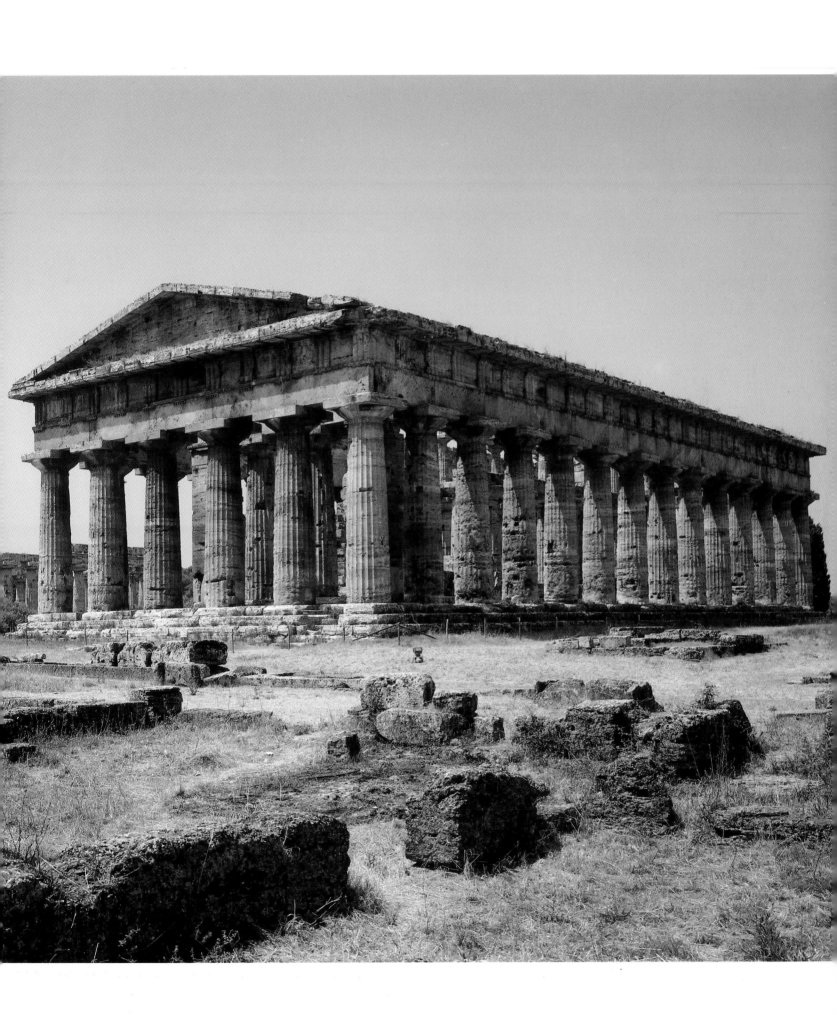

DORIC CAPITAL

*From the sixth century BC the Doric order prospered
in the Peloponnese, the Greek mainland and Sicily.
The Doric column, whose shaft was carved with from sixteen
or eighteen to twenty sharp-edged flutes, was topped by a very
plain capital. The fluting stops at the circular moulding,
or "neck," which forms a transition between the shaft
and the top of the capital, called the echinus. The latter had
a more or less flat, cushion-like shape depending on the period,
and supported the abacus, a square block that connected
the capital to the entablature.*

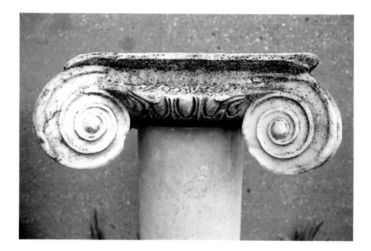

IONIC CAPITAL

*The Ionic order, influenced by contacts with the Near East,
was developed at the same time as the Doric but presented
more decorative effects. The Ionic capital borrowed ornamental
elements from furniture, metalwork and ceramics.
Typical motifs were palmettes, volutes, lotus flowers,
and ovolos. Ornamentation had come into its own.
The Ionic column was more slender, had more and deeper flutes
than the Doric column, and was topped by a capital with large,
projecting volutes. The space between them was usually filled
with broad palmettes.*

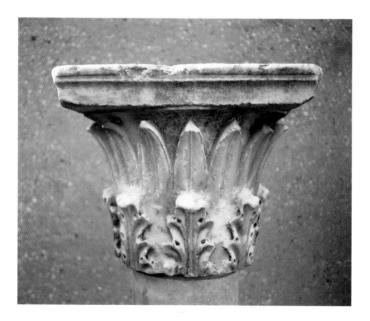

CORINTHIAN CAPITAL

*The Corinthian order appeared at the end of the fifth century BC,
and partially replaced the Ionic order in popularity.
It was created by the sculptor and goldsmith Callimachus,
who designed a capital ringed with acanthus leaves.
Legend has it that Callimachus had a sudden inspiration
in the cemetery of Corinth on seeing a basket of acanthus leaves
left as an offering on a grave. The Corinthian order was long
considered a secondary order and used only for minor
monuments. It came into its own at the end of the Hellenistic
period in major architectural projects.*

and *metopes*. The façade was surmounted by a low-pitched triangular *pediment*.

Also during the sixth century BC, and even more in the course of the fifth century, architects turned their attention to the problem of optical correction or refinement. In order to avoid the illusion that the horizontal lines of the monument bent downwards in the middle when seen from a distance, the *stylobate* was slightly arched. And to make the columns appear parallel, their axes were made to converge at an ideal point in the sky, and they were curved to avoid the impression of being concave.

Sicily, with monuments ranging from the colossal Temple of Apollo at Syracuse to the slender edifices that crowned the acropolis of Selinus, manifested a predilection for the Doric order as early as the sixth century BC. Proud of having solved their architectural problems, the builders of the Temple of Apollo left their signatures on the huge block from which the steps were carved. The Temple of Concord at Agrigentum, of later construction, is of such pure inspiration that it blends perfectly with the harsh surrounding landscape. However, it was at the Temple of Artemis in Corfu that the characteristic features of Doric architecture were established. The Temple of Aphaia at Aegina, with its masterful interplay of line, surface and volume, although built at the dawn of the fifth century BC was a direct prefiguration of Classicism.

The Ionic order, which prevailed in the eastern parts of the Greek world, enriched the architectural vocabulary with such motifs as palmettes, ovolos and lotus flowers found on a variety of utilitarian objects: pottery, furniture, funerary steles, etc. The Ionic column was slender, with abundant, deeply-cut fluting (sometimes separated by plane sections called fillets), stood on a base and was topped by a sculpted capital. Derived from elements (palm-tree trunks and clusters of reeds) used in the older constructions, the capital was formed by two ornamented lateral scrolls that extended beyond the *echinus*, or were raised and joined, as in the Aeolic capitals.

Ionic temples were often gigantic. At Ephesus, around 570-560 BC, the architects Chersiphron and his son Metagenes from Knossos constructed a temple to Artemis that still ranks as one of the most majestic of all Greek monuments. It was a marble edifice of 220 cubits long and 105 cubits wide (115.4 x 55.1 m.), comprising twenty-two columns along the sides and three rows of eight columns

each on the façade. The columns of the peristyle were nineteen metres high. The first Temple of Apollo at Didyma, near Miletus, built by the same architects, was on a smaller scale, but so richly ornamented that even the lower tambours of the front columns were carved with figures of young maidens in high relief.

In the course of time, this ornamental proliferation led to the development of the Corinthian order to the detriment of the Ionic order. Legend has it that the first Corinthian capital was the invention of Phidias's archrival, the sculptor and goldsmith Callimachus who was strolling through a Corinthian cemetery one day, when the sight of a basket filled with acanthus leaves sparked a sudden inspiration. It is also reported that this same Callimachus, who designed the famous hanging lamp in the Erechtheum, decorated the first Ionic capitals with leaves made of metal.

In any event, the slender Corinthian order, more decorative and less severe than its Ionic forerunner, corresponded perfectly to the desire of Greek architects to decorate interiors. It was long treated as a secondary order and initially used only for small monuments, but during the Hellenistic period it was chosen for major architectural projects.

We have already come a long way from the *megaron*, yet many of its original features survived in the marble Greek temple: the stone entablature preserved the memory of its former wooden construction; the six drops lined up in a row under each triglyph reproduced the pegs that attached the roof joists to the architrave, which was itself formed by a beam; originally, the *metope* was probably a wooden or terracotta plaque intended to cover the spaces left between the beams. It was out of such plain and functional forms that the Greek genius created a new, glorious architecture.

THE SMILE OF THE GODS: KORAI AND KOUROI

The gods, although now created in man's image, were represented larger than life. According to André Bonnard, Greek sculptors of the primitive age began carving out the human form from straight tree trunks that were somewhat taller than the average man. Out of the round trunk they would carve two long arms held against the sides, legs with feet planted squarely on the ground, then indicate the main

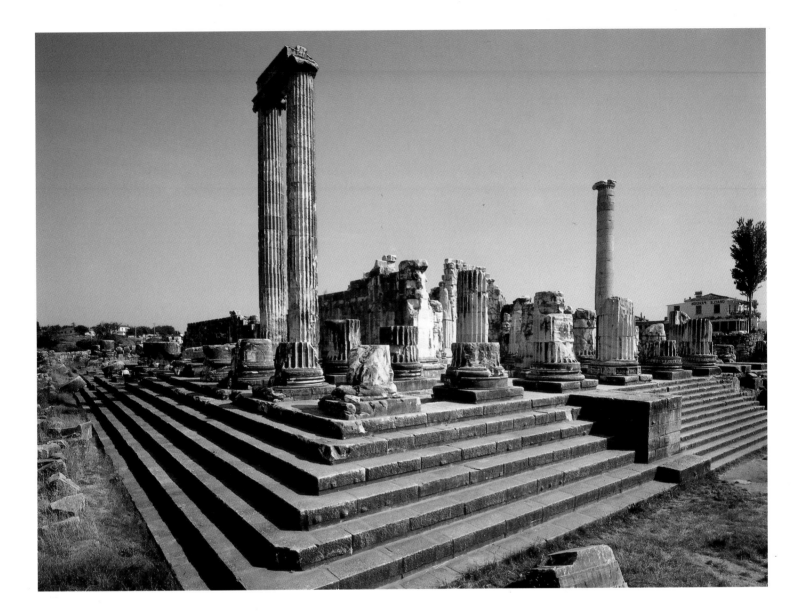

articulations of the human body in perfect symmetry. The phallus of the male gods was clearly represented and the breasts of the goddesses outlined by their drapery. All the sanctuaries of the ninth and eighth centuries BC must have had wooden statues of this kind, but time has destroyed them all and none has come down to us.

It was probably from such antecedents that one of the first major statues in stone, the Louvre's *Hera of Samos*, was derived. It dates from around 560 BC and stands on a round, column-like base. The stiff drapery enveloping her body scarcely hints at her female identity; neither waist nor hips have been indicated, and her legs are completely covered by her costume. Only at the bottom is the long, columnar tunic lifted to reveal the feet. She was a purely Ionian creation, and the gentle roundness of the forms of

Temple of Apollo

Fourth century BC.
Archaeological site of Didyma.

Opposite

The "Auxerre Kore"

Limestone, h. 75 cm. (29 $^1/_2$ in.).
650-600 BC.
Louvre Museum, Paris.

Kore dedicated to Hera

Sculpted by Cheramydes
of Samos.
Marble, h. 195 cm. (6 $^1/_2$ ft.).
Around 570-560 BC.
Louvre Museum, Paris.

Opposite

Kore 674

Marble, h. 92 cm. (36 in.).
Around 500 BC.
Acropolis Museum, Athens.

Page 68, left

Kore 675

Marble, h. 55.5 cm. (22 in.).
Around 510 BC.
Acropolis Museum, Athens.

Page 68, right

Kore 670

Marble, h. 115 cm. (45 in.).
Around 510 BC.
Acropolis Museum, Athens.

Page 69, left

Kore 674

Back view.
Marble, h. 92 cm. (36 in.).
Around 500 BC.
Acropolis Museum, Athens.

Page 69, right

Kore 681,
the "Antenor Kore"

Marble, h. with plinth 255 cm.
(8 $^1/_2$ ft.).
Around 510 BC.
Acropolis Museum, Athens.

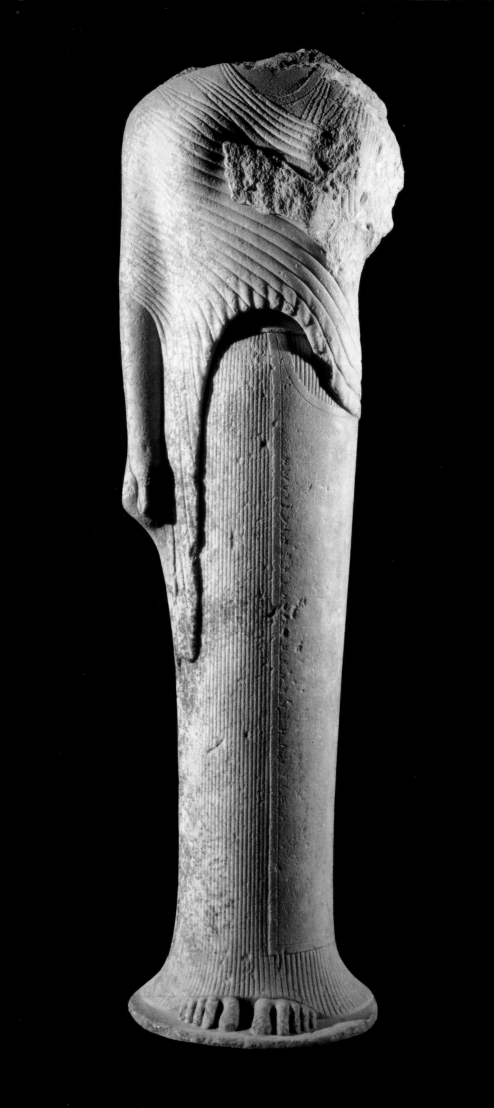

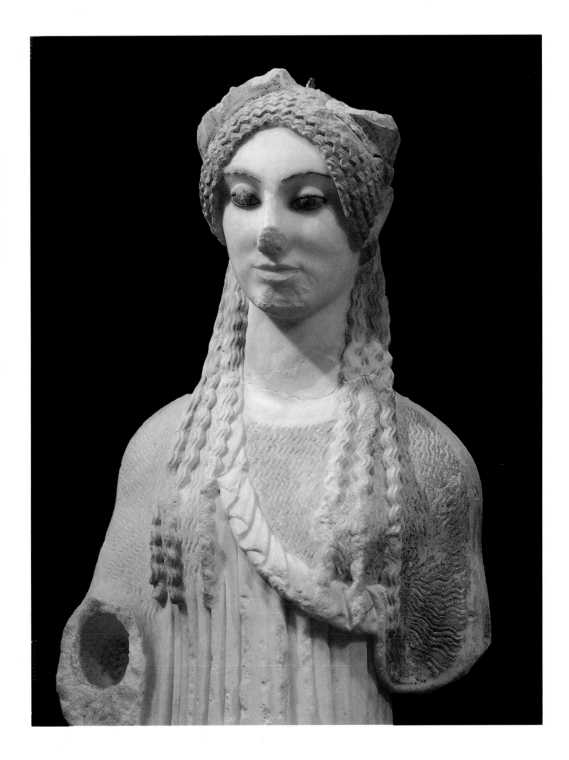

Fourteen korai, figures of young women or goddesses with an Oriental charm, were unearthed a century ago
on the Acropolis of Athens, where they had been piously buried after being damaged by the Persians in 480 BC.
As André Bonnard noted, the discovery of these "pert young women gave the lie to the academic theory thatthe Greeks never had
the bad taste to paint their statues; it was believed that only the whiteness of the marble could express the serenity of an art
that was in fact not as serene as had been thought, but full of life;....
Seeing them assembled today in the Acropolis museum, they look like a group of models ready for a fashion show,
but who have been left to choose their dresses somewhat at random."

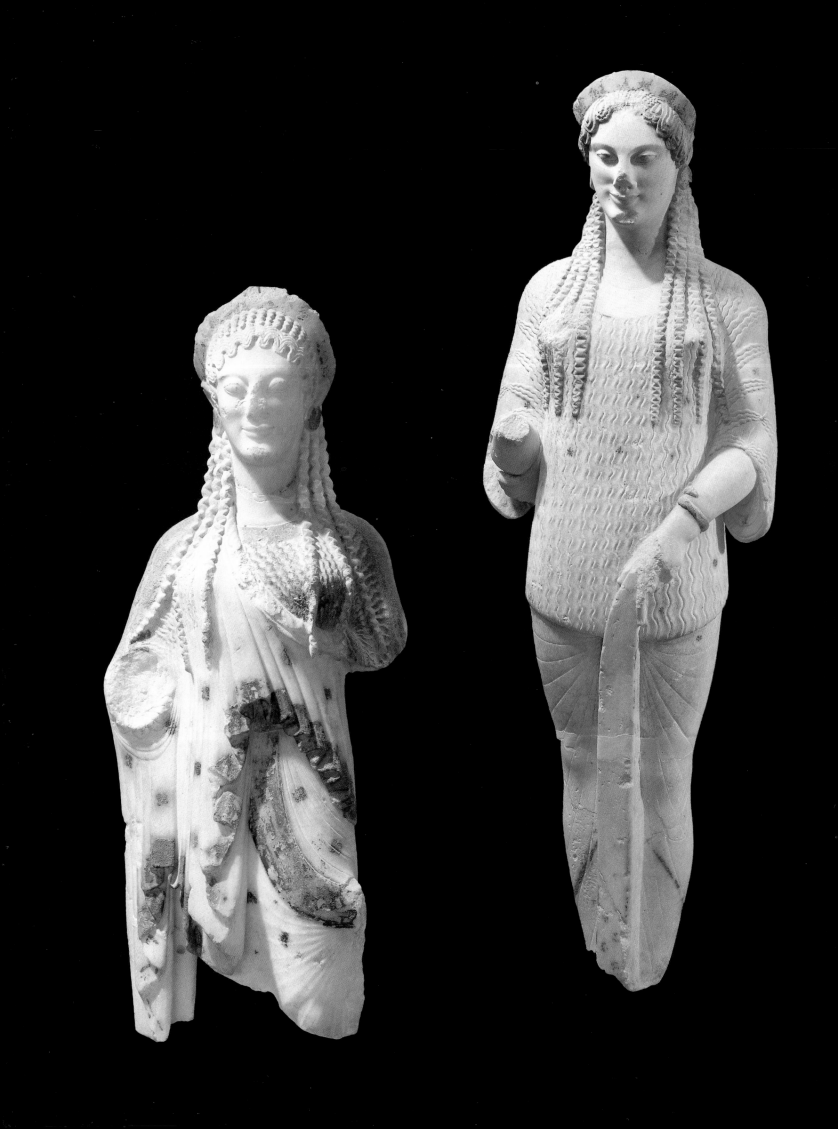

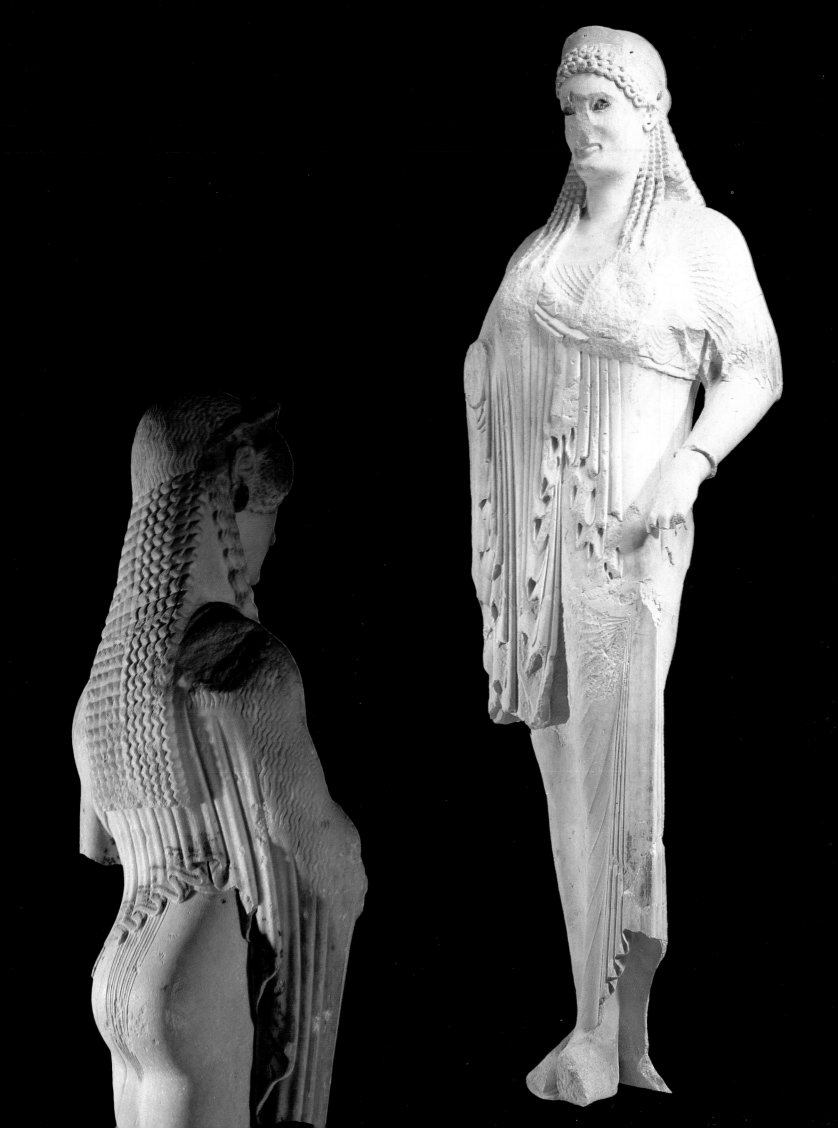

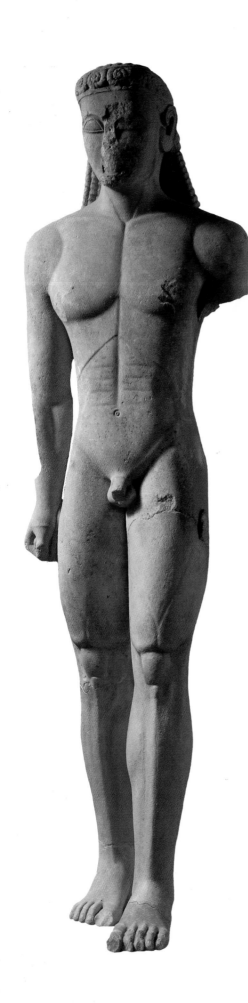

her breasts, back and abdomen are not devoid of sensuality. In this respect she was quite different from such Dorian counterparts as the *Kore with a Peplos*.

Also of Ionian origin are the fourteen *korai* – maidens more than goddesses this time – that were unearthed in near-perfect condition on the Acropolis in Athens, where they had been used as backfill. They had been vandalised during the Persian sack of Athens in 480 BC and later piously buried all together, as if in a common grave.

They introduced their oriental charms to stern Attica, their ochre and violet hair, their colourful jewellery, and their tunics hanging in irregular folds down to their ankles. Indeed, the sculptor seems more interested in the complex patterns of drapery than anatomical form. The costume was usually neither sewn nor fitted; two pins and a strip of cloth around the waist sufficed to transform a rectangle of cloth into a stunning cascade of folds. Unlike the stiff Dorian *peplos*, the Ionian draperies seem to be in perpetual motion. Body and clothing were in perfect harmony, the drapery suggesting the body's curves, while artfully concealing them. There is something pert about these lively *korai*, of whom André Bonnard wrote: "All together at the Acropolis museum, they look like a group of fashion models ready for a show, but whose dresses have been chosen at random."[2]

The art of drapery is a specifically Greek development; Egyptian statues had rigid skirts and loincloths, the Mesopotamian civilizations made only timid inroads into this field and limited themselves to conventional fold patterns, while the Assyrians burdened their figures with heavily-embroidered robes. Wool drapery differed from linen, and the presence or absence of a belt gave infinite variety. Although adjusted in different ways, it always gives the impression of an essentially aesthetic freedom, a quality still to be seen today in the art of some Asian and African populations. It was referred to as "the mirror of the body," and based on women's fashions of the Archaic period, but it was also an art form that combined a sense of geometry and decoration.

The male counterpart of the sweet-faced and elegantly draped *kore* was the virile *kouros* (pl. *kouroi*). It was always represented nude and was the personification of virility, a formidable god in the guise of an athletic youth seemingly

2. André Bonnard, *op. cit.*, vol. II p. 274.

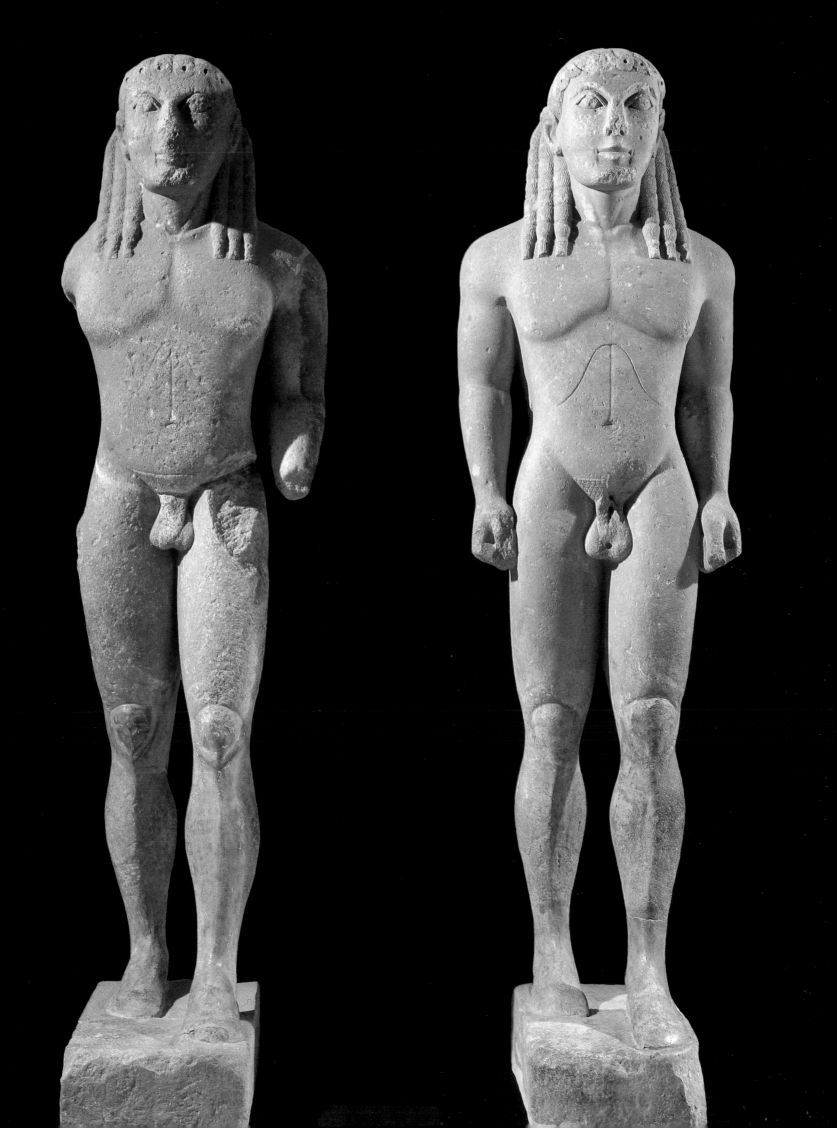

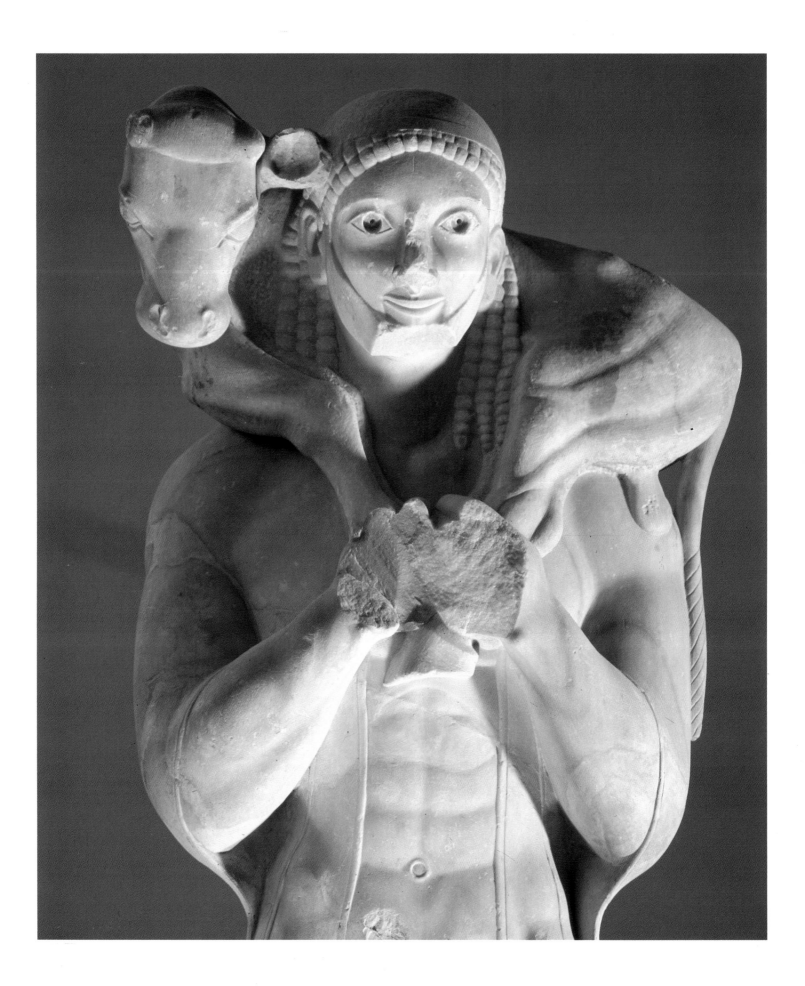

unaware of his own beauty. Archaeologists once regularly referred to these figures as "Apollo," but more often than not they depicted mere mortals. In any case, there was not a great difference between the physical beauty of the youths trained in the palaestras and that of the denizens of Mount Olympus.

The shoulders of the *kouroi* are as wide as their waist is slender, the hips are narrow, the stomach flat, and the arms held close to the body with the hands clenched. The chest muscles are summarized in the prominent pectorals, while in most cases the rib-cage is indicated by a simple curve. Yet the *kouroi* are neither rigid nor static. The elegant contours, shapely modelling, and full torso the *Sounion Kouros* suggest the natural inflow and outflow of breath, and create an impression of contained strength. The figures of Cleobis and Biton, known as the *Twins of Argos*, were represented in movement, with their arms bent at the elbows; in Greek mythology, the divinely-favoured twins died of exhaustion after drawing Hera's sacred chariot from Argos to her sanctuary.

Except for the consistent feature of the advancing left leg, the *kouroi* were usually represented frontally, with both body halves in perfect symmetry. There is every reason to suppose that they developed from Egyptian models, which were always frontal and were shown with the left leg forward for symbolic reasons. The major difference between an Archaic Greek statue and an Egyptian one is that – with the exception of a brief period under Amenophis IV, during the New Empire – the latter remained confined within the limits of the basalt block from which it was carved, while the former, although retaining the material qualities of the stone, was liberated from it.

This liberation took place very gradually, over the centuries, and Egyptian features persist in the *kouroi*: the foot placed flat on the ground with parallel toes, or the summary modelling of the median part of the rib-cage as a straight line ending at the navel. The Greek sculptors of the Archaic period, however, strove to perfect this human type. Without changing the general disposition, little by little, almost imperceptibly, they began introducing signs of life into the hieratic forms inherited from their counterparts in the Nile Valley. The Greek genius for clarity and logic led from an art of stereotypes to a statuary of flesh and blood before progressing to the virtuoso accomplishments of the Classical and Hellenistic periods.

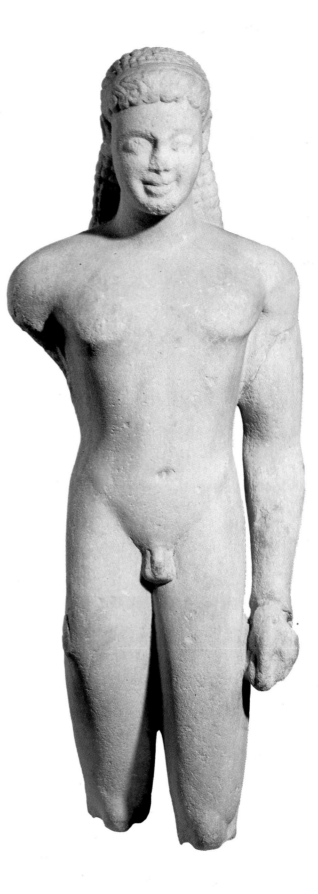

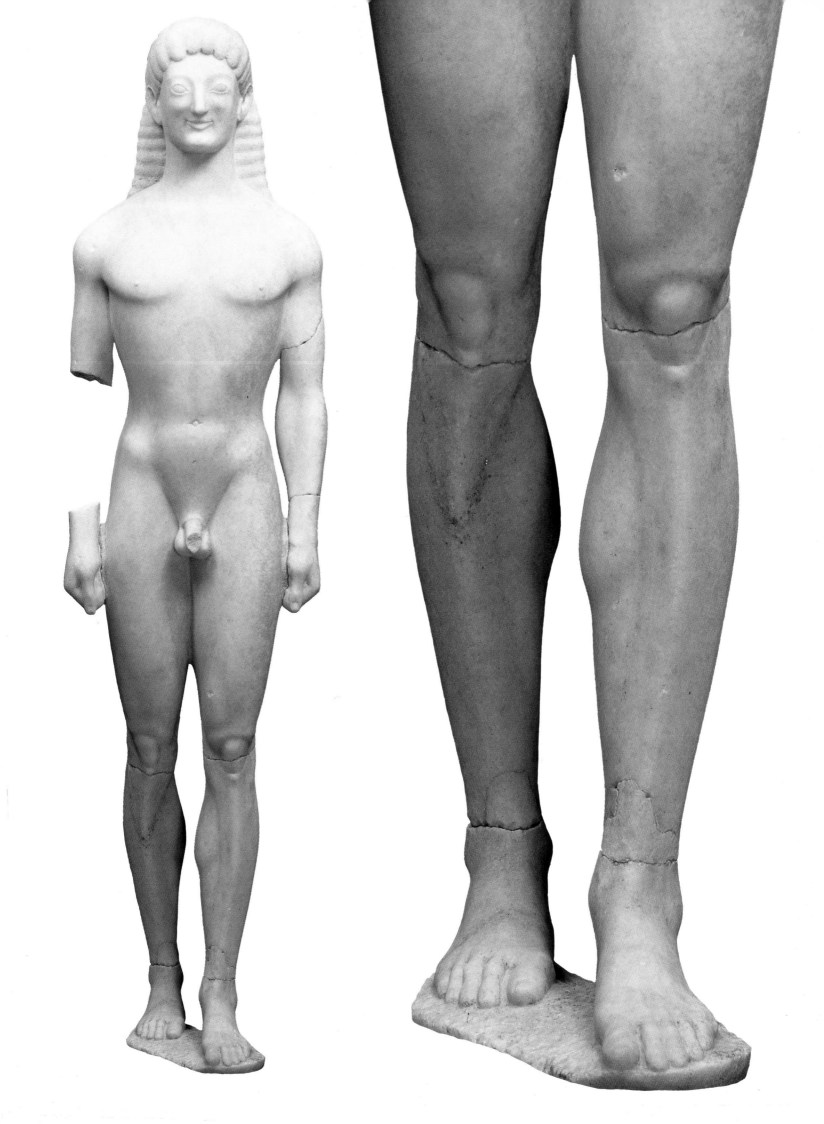

They were no strangers to the science of anatomy. At an early stage they began to concern themselves with rendering the musculature of the abdomen and studied the difference between the internal and external profiles of the legs. In this respect, the *Kouros of Tenea*, with its legs displaying a broadening of the shins known as the "Assyrian style," full buttocks and bulging pectorals, already stands at some remove from the hieratism of Egypt. Yet in the frontal statuary, the torso continued to be shaped symmetrically. Thus although the famous *Moschophorus*, or "Calf-Bearer," is innovative and has his arms raised above his head to carry the calf on his shoulders, his torso is the same as if his arms were hanging by his sides.

Jean Charbonneaux, an eminent specialist in Greek sculpture, demonstrated that the development of the *kouroi* involved a convergence of two main tendencies: one, analytic in nature, which strove to emphasize significant anatomical details, and another, of a more formal nature, which tended to treat the body as a whole. The first tendency gradually prevailed. While remaining frontal until the end of the sixth century BC, in certain details the *kouroi* nevertheless showed a growing predilection for the asymmetry typical in life. Thus, according to Charbonneaux and Picard, the knee was first represented geometrically stylized in the Egyptian manner, but eventually began to display an uneven distribution of the muscles on either side of the kneecap.[3]

The anonymous sculptors of the Archaic period were different from a Phidias or a Praxiteles but in no way inferior, contrary to the opinions of some authors at the beginning of the century under the influence of naturalism.

The hair of the *kouroi*, unlike that of the *korai*, was for a long time a purely decorative feature. It was depicted with braid patterns, strings of beads, curlicues and spirals, as in the *Sounion Kouros*. The Greeks have always liked their hair curled or waved. In the Archaic statues, the hair conforms to the simplified shape of the skull, forming a sort of cap, or sometimes falling onto the shoulders like a wig. And when there is also a beard, together they make a sort of ornamental frame for the features of the face. The face was represented fairly flat, with high cheekbones, inordinately large eyes, and a square jaw. Nose and forehead are often in the same plane, while the ears are level with the temples and sometimes simply carved in a spiral shape.

3. Jean Charbonneaux, *La sculpture grecque archaïque*, Lausanne 1942, p. 31.

*T*he kouros *remained posed frontally until the end of the sixth century BC. However, the development of certain anatomical details, such as the knee, show an effort at anatomic exactitude. At first given a square or rectangular shape, as in Egypt, its volume was progressively refined until the form, both in frontal and in profile views, came close to nature, as we can clearly see in the* Apollo of Tenea.

Opposite

Apollo of Tenea

Marble, h. 153 cm. (60 in.).
Around 550 BC.
Glypthothek, Munich.

Page 70

Kouros

Marble, h. 165 cm. (65 in.).
From the Temple of Poseidon
at Cape Sounion.
Around 600 BC.
National Archaeological Museum, Athens.

Page 71

The Twins of Argos

Cleobis and Biton.
Marble, h. 2.18 m. (7 ft.).
From the sanctuary of Apollo at Delphi.
590-580 BC.
Museum of Delphi.

Page 72

"Moschophorus," the Calf-Bearer

Attic marble, h. to the knees 96 cm. (38 in.).
From Hymettos.
570-560 BC.
Acropolis Museum, Athens.

Page 73

Kouros from Paros

Marble, h. 153 cm. (60 in.).
Around 530 BC.
Louvre Museum, Paris.

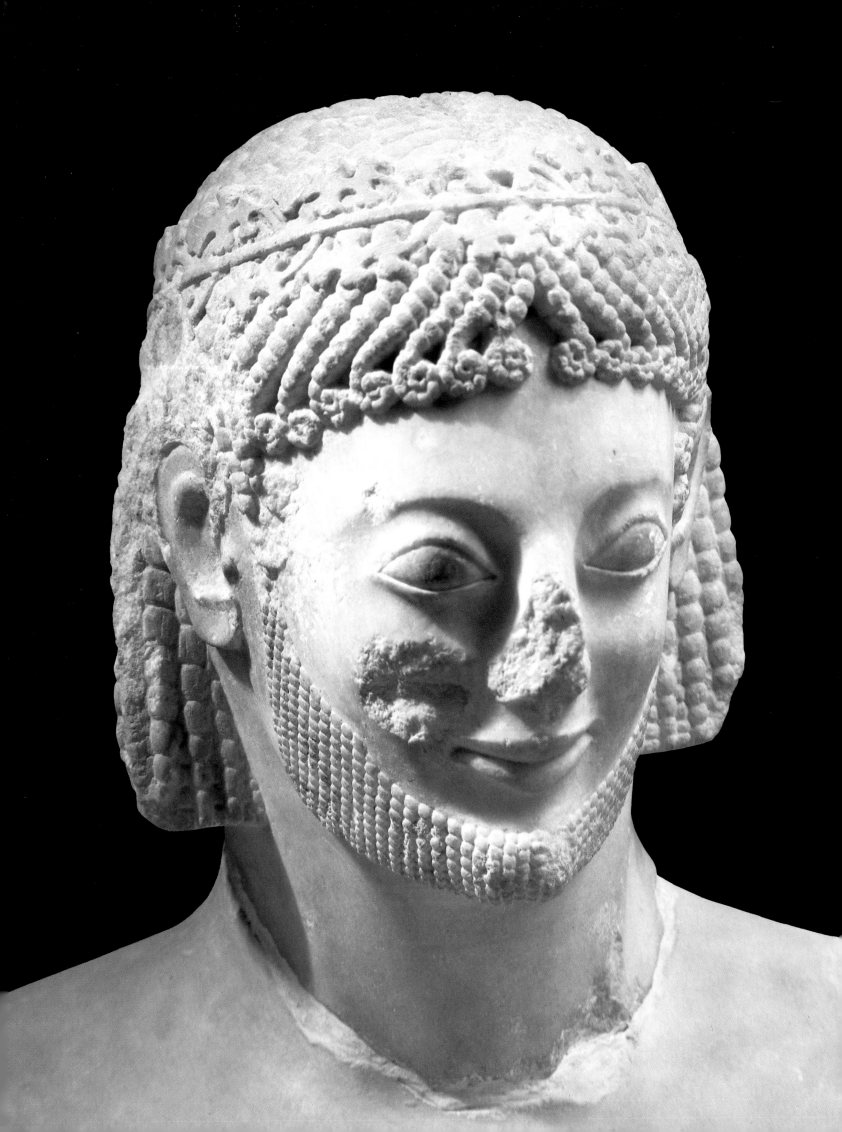

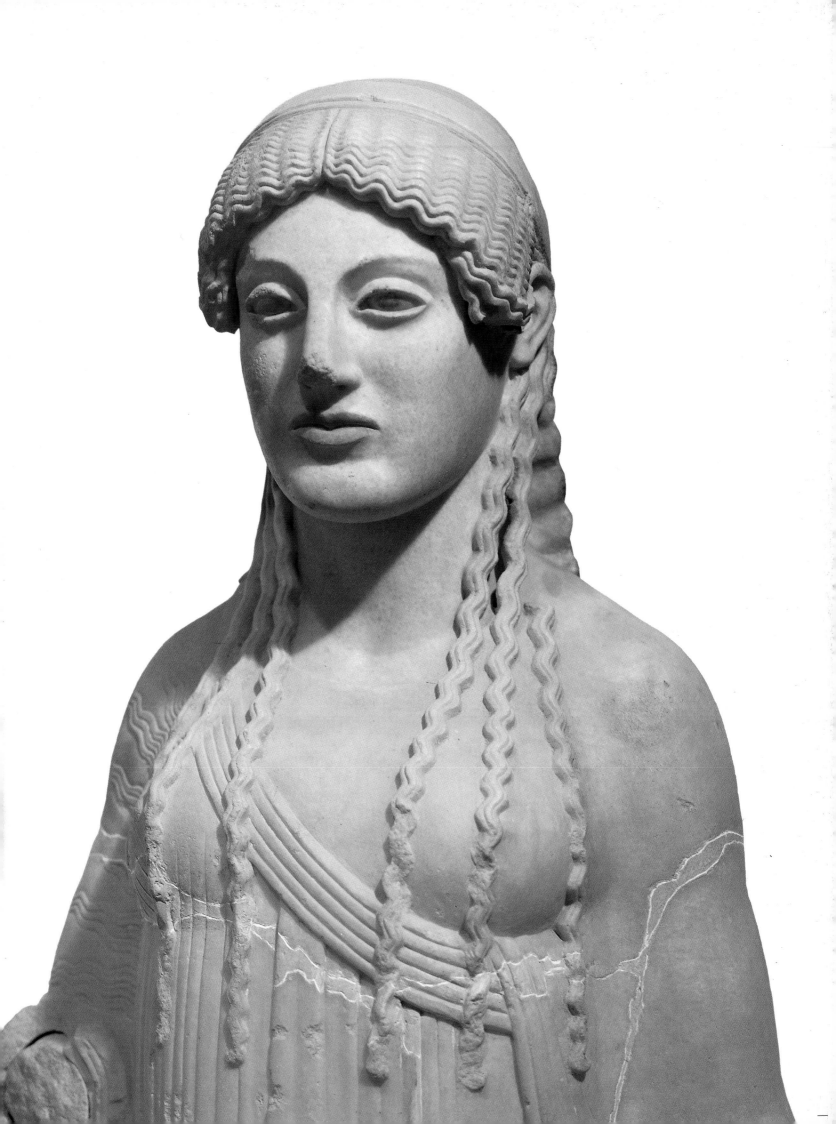

Head from the Dipylon

Back view (opposite page, front).
Marble, h. 44 cm. (17 in.).
Around 600 BC.
National Archaeological Museum, Athens.

Page 76

Head of the "Rampin Rider"

Marble, h. of head 27 cm. (11 in.).
From the Acropolis, Athens.
Sixth century BC.
Louvre Museum, Paris.

Page 77

**Kore,
called "The Sulky One"**

Marble, h. 58 cm. (23 in.).
Around 480 BC.
Acropolis Museum, Athens.

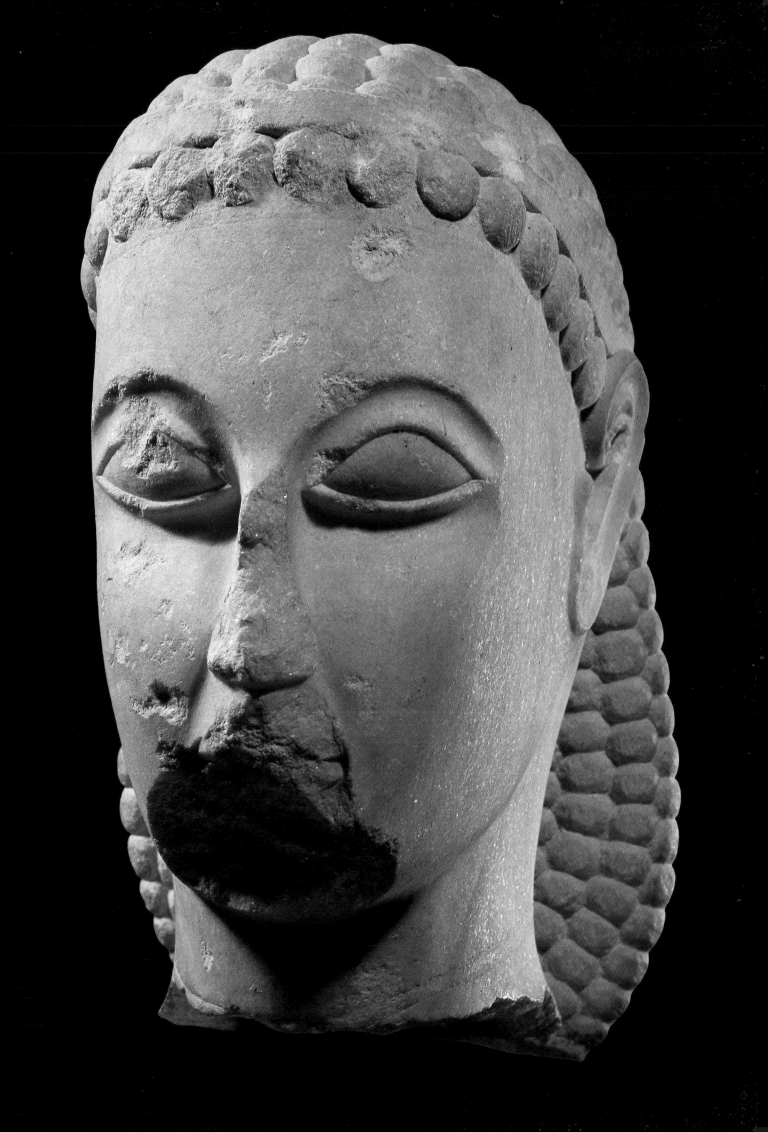

Head of a Blond Youth

Marble.
Around 485 BC.
Acropolis Museum, Athens.

But are these faces actual likenesses? Their original polychromy – lips and hair coated with red pigment, irises purple, and eyebrows and eyelids lined with black – must have differentiated them.

Today no one would attribute the expression that characterizes both *kouros* and *kore* to a lack of technical skill. The slight, somewhat mischievous or subtly humorous smile was an attribute of the gods, and thus of the humans who resembled them: the heroes and mortals whose piety had made them worthy of this resemblance. The so-called Archaic smile was a prerogative of the divinely blessed and expressed the joy of eternal life. Yet in a later work such as the *Kore of Euthydicos*, nicknamed "The Sulky One", with its square jaw and moody expression, the Archaic quality was reduced to a slight trace that was soon to disappear. On the day that Greek sculpture stopped smiling, Classical sculpture was born.

ART AND ARCHITECTURE: MONUMENTAL SCULPTURE

Fascinating though it may be, Archaic sculpture was not limited only to the production of *kouroi* and *korai*. Already in the second quarter of the sixth century BC, the *Payne-Rampin Horseman*, the oldest-known equestrian statue, introduced a new genre: the sculpture group of two or more figures. This type of composition did not lend itself so readily to a frontal treatment. And so with new temples being built in every part of Greece, increasing the demand for friezes, metopes and pediments, a monumental art based on new principles provided the first solutions to the problem of how to express movement.

The pediment, carved out of the temple façade, offered a convenient stage where the deeds of the gods, goddesses and heroes of mythology were depicted for the edification of the faithful. But its triangular form did not lend itself to the representation of groups of figures. Even Phidias was unable to prevent a discrepancy in scale between the figures in the middle and those at the corners of the Parthenon pediments.

Such discrepancies are particularly evident in Corfu, the ancient Kerkyra. A partially reconstituted pediment from the ruins of a temple dedicated to the cult of Artemis found at the site of Paleopolis, near the present-day city, reveals that there was no unity of scale in the scenes represented.

The pediments of Greek temples were like a theatre set – always very colourful – where the mythical gods and heroes enacted episodes of the sacred drama. Their squat, triangular shape, however, was a constant challenge in composing large groups of figures. This is particularly evident at Corfu (the ancient Kerkyra), where the remains of a temple dedicated to Artemis were found: the figures show that there was no unity of scale, their size was dictated by the available space. The corners were later filled with such motifs as serpents or recumbent figures. Even at the Parthenon, a slight discrepancy in scale was not entirely avoided.

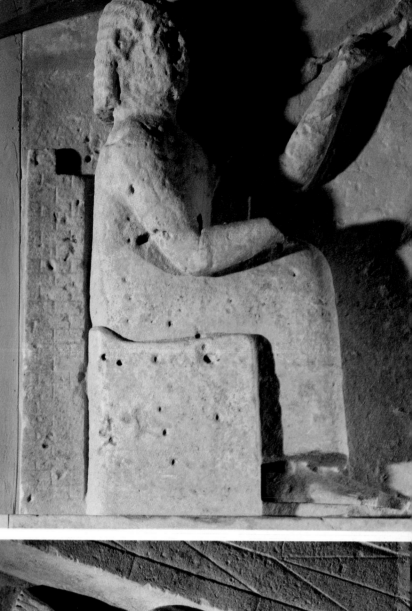

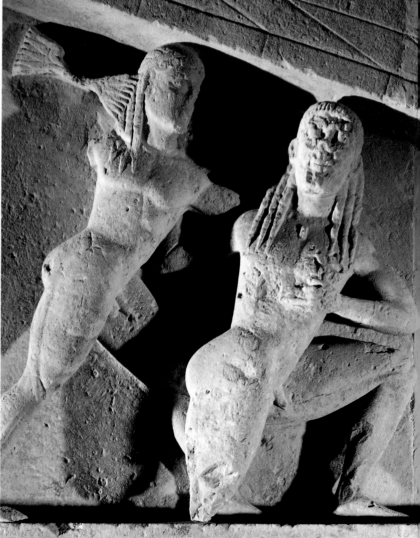

Above

Gaea, the Earth Goddess

Corner of the West pediment
of the Temple of Artemis at Corfu.
600 BC.
Archaeological Museum, Corfu.

Below

Zeus Fighting Cronus

Corner of the West pediment
of the Temple of Artemis at Corfu.
600 BC.
Archaeological Museum, Corfu.

Opposite

Gorgon

Central figure on the West pediment
of the Temple of Artemis at Corfu.
600 BC.
Archaeological Museum, Corfu.

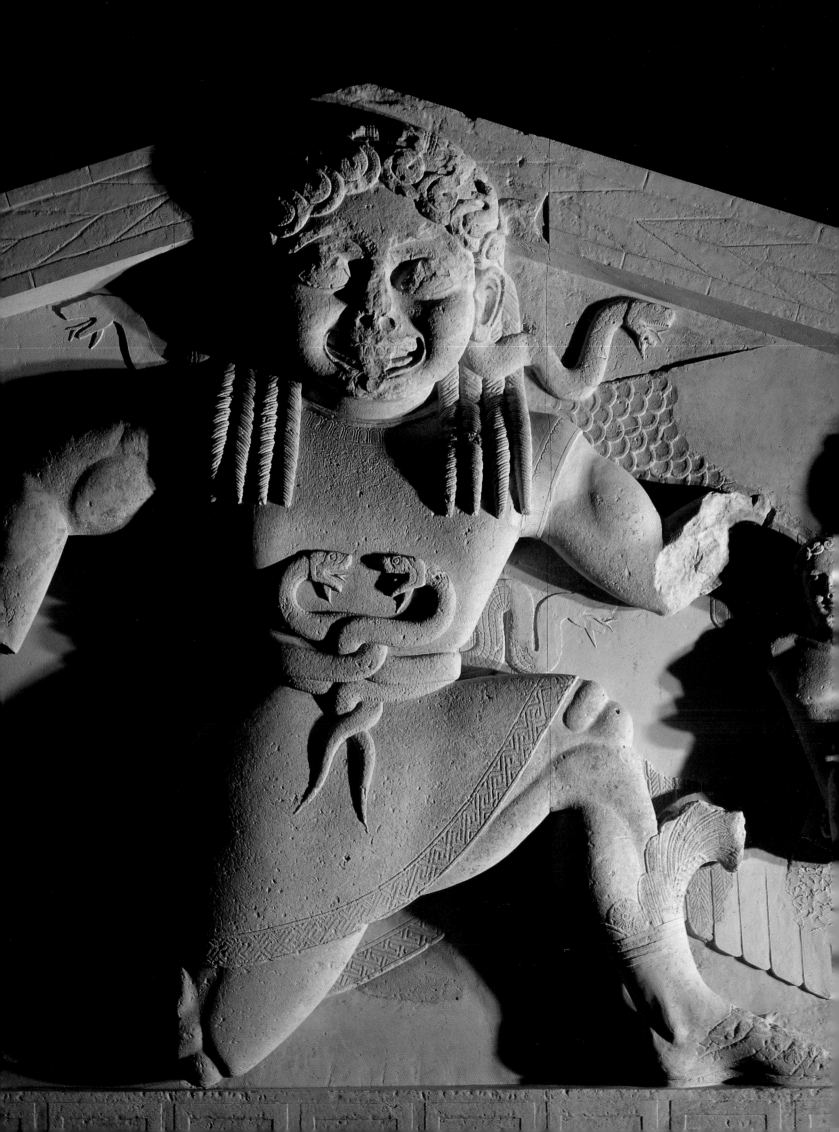

Fountain with Female Bearer

"Olive Tree" pediment.
Around 570 BC.
Acropolis Museum, Athens.

Opposite

Group with the Water God, Nereus

West pediment of the old Temple
of Athena in Athens.
Tuff, l. 440 cm. (14 ft.),
h. approx. 115 cm. (4 ft.).
580-570 BC.
Acropolis Museum, Athens.

In the middle, we see the huge, grimacing figure of Medusa, the Gorgon of "the dreadful fate," still exuding her demoniac power. With her terrifying mask, her girdle and hair of snakes, the wings attached to her shoulders and even to her feet, she is one of the most extravagant figures in Archaic Greek sculpture. Emerging from her sides we see Pegasus and Chrysaor, the half-animal, half-human offspring that came into the world when she was decapitated by Perseus. She is flanked by two recumbent panthers, symbols of her might, depicted on the same scale. However, the scenes shown at either end of the pediment, episodes from the Battle of the Gods and the Giants – on the right, Zeus hurling a lightning bolt at a Giant, and on the left, Gaia, the Earth goddess, raising her left hand in a gesture of supplication to one of her slain sons – are represented on

such a small scale that they appear totally unrelated to the central composition.

Another example is the enigmatic "Olive Tree" pediment excavated on the Acropolis of Athens. Carved out of soft stone, the figures look like marionettes, standing out from a background consisting of a small building in the middle and a wall, above which protrudes the foliage of an olive tree, giving an indication of the scale. But this type of pictorial arrangement with landscape elements, which may be ascribed to Asian influence, was essentially at variance with the Greek taste for purity, and landscape elements were subsequently omitted.

These limitations did not prevent artists from depicting elaborate scenes, as in the pediment of the old Temple of Athena in Athens: on the left is Heracles struggling with

Overleaf

Dying Warrior

Corner figure from the East pediment of the Temple of Aphaia at Aegina.
l. 1.85 m. (6 ft.).
Around 490 BC.
Glyptothek, Munich.

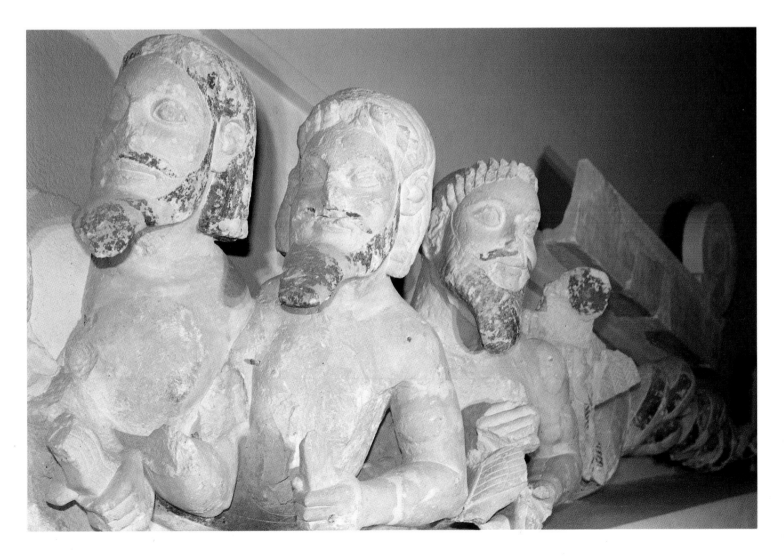

85

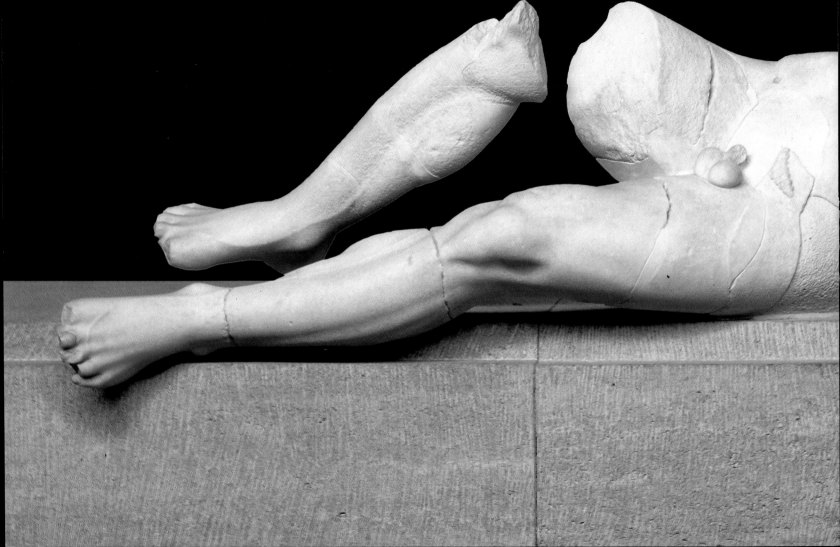

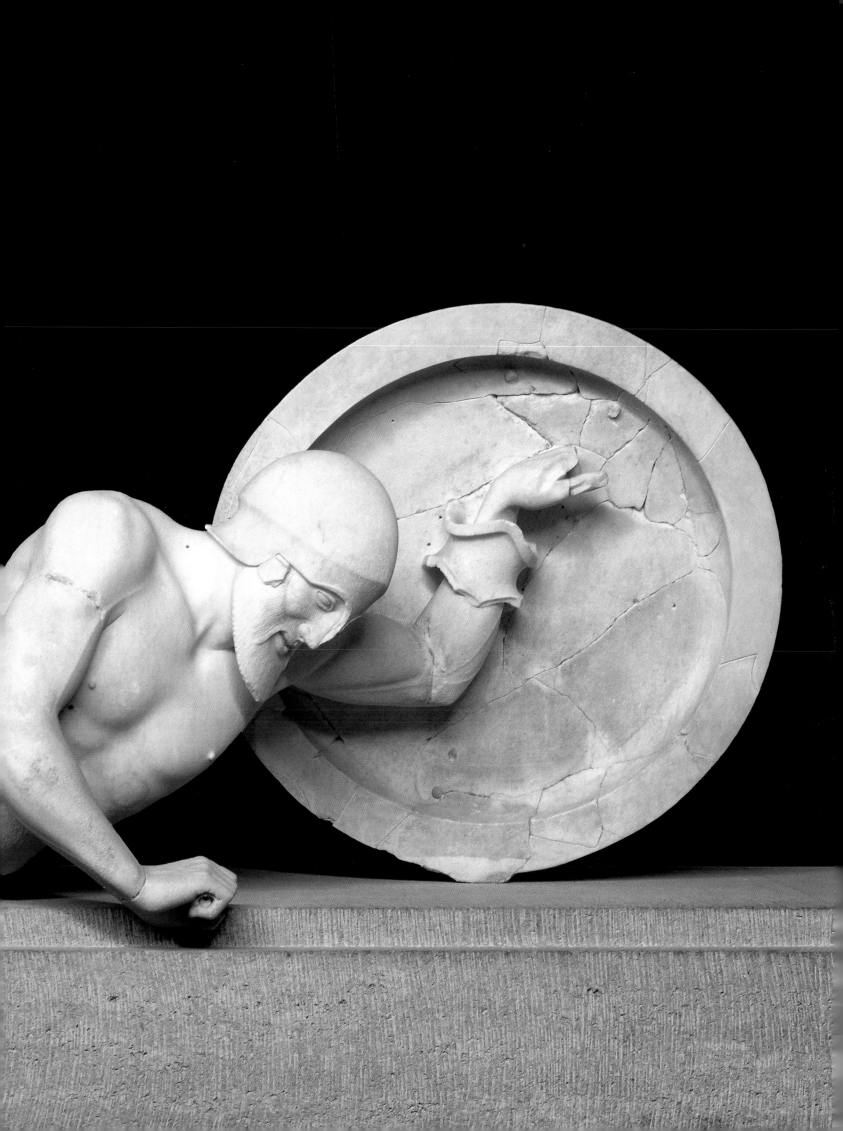

*T*he Cercops, evil and mischievous gnomes, were so
bold as to attack Heracles and try to rob him. The
hero managed to capture them as they fled and tied them
upside down to a staff, as shown in the metope on page 89.
From this vantage point, the gnomes saw that Heracles'
buttocks were black, which caused them to roar with
laughter. Disarmed by their malice, Heracles relented
and set them free. But their manners did not improve
and finally they irritated Zeus so much that he turned
them into monkeys.

Perseus and Medusa

Metope from Temple C at Selinus.
Limestone, h. 147 cm. (5 ft.).
Around 560-550 BC.
Archaeological Museum, Palermo, Sicily.

Opposite

Heracles and the Cercops

Metope from temple C at Selinus.
Limestone, h. 1 47 cm. (5 ft.).
Around 560-550 BC.
Archaeological Museum, Palermo, Sicily.

the sea-monster Triton, while Nereus stands on the right,
watching the fight. Nereus, the father of the Nereids, could
change his shape at will, a characteristic of the pre-
Olympian gods. Thus the sculptor represented him as a
monster with three human busts prolonged to the right by
intertwined snakes. The three bearded faces, deliberately
portrayed with coarse features, are wonderful to behold: the
first two watch the heroic struggle, while the third faces the
spectator. Jean Charbonneaux spoke of the sculptor "staging
and directing" the figures like so many actors, exactly as in
the theatre or cinema.[4] The moment chosen was the climax
of the action, which was further highlighted by the strident
colours. It is a foretaste of the dramatic genius that was to
find its most perfect expression in Greek tragedy.

The West pediment of the later Temple of Aphaia at
Aegina (c. 480 BC) was devoted to the exploits of the
Aeginan heroes Ajax and Teucer before the walls of Troy and
the Greeks and the Trojans killing each other. There is a clear
progression from the centre to the sides, with connecting
action. On the East pediment, we see an archer stretching
his bow and a warrior dying from a direct hit. Coarseness
has been replaced with rigour. The artist achieved unity of
action, while maintaining a high level of emotional tension.

The decoration of the metopes presented less problems
than that of the pediments. There was, of course, an empty
space to be filled with figures, but it was quadrangular in
shape, and so the problem of changing scale at the corners
did not exist. All the artist had to do was connect the
various scenes, either on a same façade or all around the
building. The result was a series of separate pictures – not
unlike a modern-day comic-strip – that were nevertheless
related and told a story with a clear narrative and theme.

Charbonneaux liked to compare metopes to the
stained-glass windows of cathedrals, in the sense that they
"covered the Doric temples with series of mythical scenes
which both paid homage to the titular deities and edified
the faithful."[5]

During the Archaic period such scenes were generally
full of life and action. Although the sculptors respected
stone as a material and carved it to perfection, they did not
shy away from painting it or having it painted: the hair,

4. Jean Charbonneaux, Roland Martin, François Villard, *Grèce archaïque*, Paris
1968, p. 114.
5. Jean Charbonneaux, *op. cit.*, p. 114.

beard, eyes and lips in bright red, the breastplates blue. Only the bare limbs kept the original colour of the marble, which was polished with a coat of melted beeswax. The pediments and metopes called for a new type of sculptural treatment that was specifically Hellenic: the high relief where the figures were carved deeply enough out of the stone to appear free-standing from a distance, without being detached from the supporting base.

The third type of temple decoration was the continuous frieze. Borrowed from oriental art and adapted to Greek architecture, it used the traditional technique of the bas-relief, a sort of "modelled drawing." One of the best-preserved friezes decorates the *Treasury of Siphnos* at Delphi. The Siphnians, then newly enriched by the discovery of

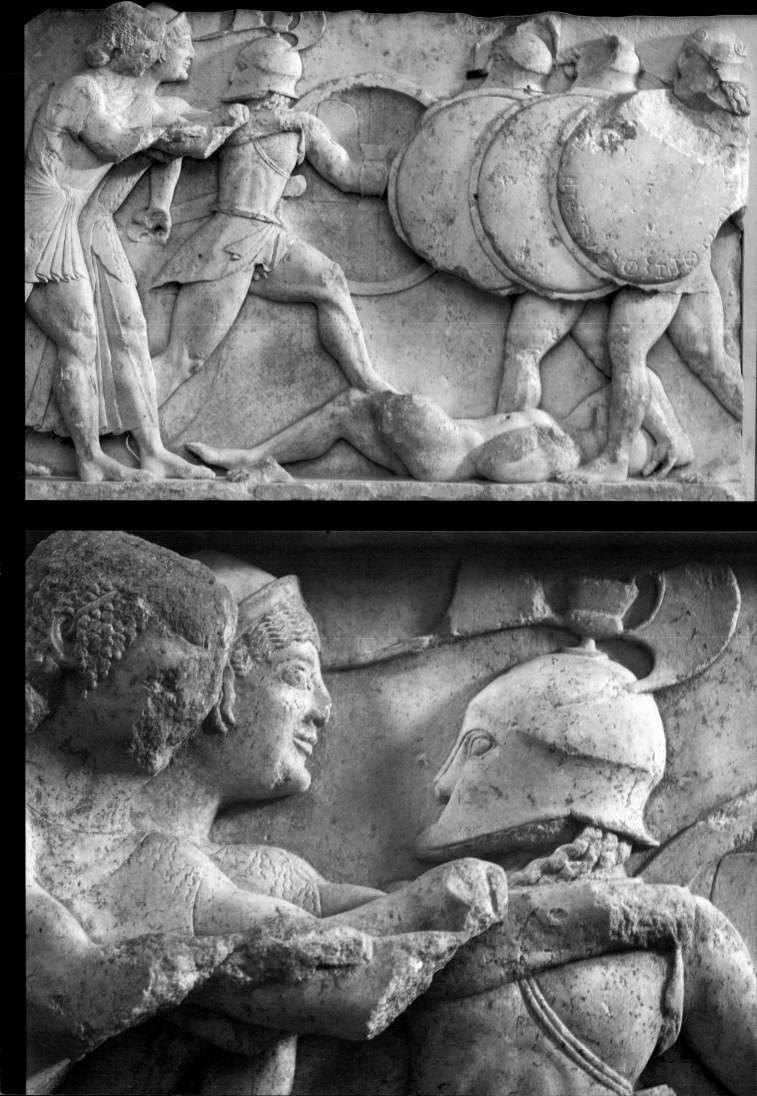

gold on their island, wanted to impress the pilgrims with a dazzling display of architectural ornamentation on their treasury – and they succeeded. Executed by two sculptors, one of whom seems to have been more talented than the other, the frieze runs round the entire entablature and presents a different theme on each of the four sides of the building: an episode from *The Iliad* depicting an assembly of gods and a battle between the Greeks and Trojans, an abduction scene of a kind often occurring in Greek mythology, the Judgement of Paris, and the Battle of the Gods and the Giants. The superimposition and crossing of the different spatial planes and the massiveness of the figures in this last scene give it a rare power.

The figures were still represented in the traditional way, with torso shown in frontal view, and the eye, head and legs in profile. The hair was arranged in decorative patterns and poses were conventional, not unlike those of the Egyptian and Mesopotamian bas-reliefs. And yet this frieze remains quintessentially Greek: it is not a mere succession of scenes, but rather a series of dramatic climaxes, in the sense that the action is always depicted at the moment of crisis.

PAINTING AND PAINTED CERAMICS

During the Archaic period there were some notable painters whose names and life histories have come down to us thanks to the writings of ancient authors. These painters had the same standing as sculptors. Their work was greatly admired, but because it was executed on such fragile supports as canvas, wood and stucco, little remains and we can have no clear idea of it.

According to these accounts, a purely linear style of painting developed in Corinth and Sicyon, in the Peloponnese. It consisted of outlines with few other details and no colour. The Corinthian painter Ecphantos coloured the figures with a pigment made from baked and powdered clay, to which the Athenian Eumares added white for the female figures. As far as we know, the only major painter was Cimon of Cleones, active at the end of the sixth century BC who brought this genre "devoid of skill and taste" out of its infancy and into its prime. According to Pliny, he was the first painter to depict figures in different attitudes and positions – looking backwards, up and down – to show bulging veins and drapery. But not a trace remains of these important discoveries.

Bas-Relief of the North Frieze, Treasury of Siphnos

Page 90, top

Detail. Gigantomachy.
Around 525 BC.
Museum of Delphi.

Page 90, bottom

Detail. Artemis fighting a Giant.

Page 91

Detail. The goddess Hera.

Opposite

Detail of the Battle of the Gods and the Giants.

Other artists are mentioned including Iphion of Corinth, Calliphorus of Samos, and Bularchos of Ephesus. The latter was famous for his depiction of the victory of the Ephesians over the Magnesians, complete with their cavalry and wardogs, a work for which he was paid his weight in gold by King Candaules. Subjects were drawn from history, epic poetry and mythology.

Painting very early on played a part in the partial or total decoration of temple interiors and porticoes, and later decorated private homes. Contrary to some claims that have been made, the Greeks did not paint in oils; they used water-based tempera or encaustic. In addition to murals, there were also portable paintings that were meant to be framed and hung; these were executed on wood or canvas, sometimes on marble and terracotta plaques. But techniques were still fairly rudimentary. A small votive painting found in the Grotto of the Nymphs at Pitsa, near Sicyon, was executed on wood, with a white plaster ground, and showed a sacrificial procession in which the officiants were painted in flat colours, with no gradation of tone, the volumes of the drapery and bodies indicated solely in line.

Because the paintings of the Archaic period have almost all been lost, archaeologists have concentrated on painted ceramics, which have been found in such great quantity that one tends to think of it as the only genre that used painting. All the more so as this was less of a craft then than a true art form, the artists – potters and painters – commonly signing their work.

Even the Corinthian jars and vases of the early sixth century BC, such as the *Eurytios Crater* in the Louvre, which has the names of the figures inscribed above them – as was the practice in murals – were of exceptional beauty with their subtle play of flat colours and line.

The highpoint of Archaic Greek ceramics, however, took place in Attica as early as 580 BC. It was then that the famous "black-figure" style, so-called because the figures were painted black against the plain clay ground, was developed and disseminated. While retaining certain conventions of the past, such as figures in profile with eyes shown frontally, this style of painting introduced major innovations in the structure of the bodies and their movements, generally tending towards more realism.

The unquestionable masterpiece of the black-figure style is the *crater* with volutes commonly known as the *François Vase*, executed by the potter Ergotimos and the

Black-Figure Crater with Colonnettes

Heracles at the home of Eurystheus.
h. of vase 46 cm. (18 in.).
625-620 BC.
Louvre Museum, Paris.

painter Clitias. A whole side of the *crater* is devoted to the story of Achilles and his father Peleus: the Calydonian boar-hunt, in which Peleus played a major part; the wedding of Peleus and Thetis, with a procession that encircles the entire vase; Achilles slaying Troilus; the funeral games in honour of Patroclus, Achilles's friend. On the handles is depicted the death of Achilles, with Ajax carrying the hero's body. The other side of the *crater* presents two of Theseus's legendary exploits: the liberation of the Athenian youths and maidens sacrificed to the Minotaur, joyfully celebrated by Theseus's shipmates; and the battle of the Centaurs and the Lapiths, with whom the Athenian hero fought. There are also two secondary scenes treated in parodic mode: Hephaistos brought back to Olympus by Dionysos, and – on the *crater*'s foot – a sort of burlesque epic with Pygmies fighting cranes.

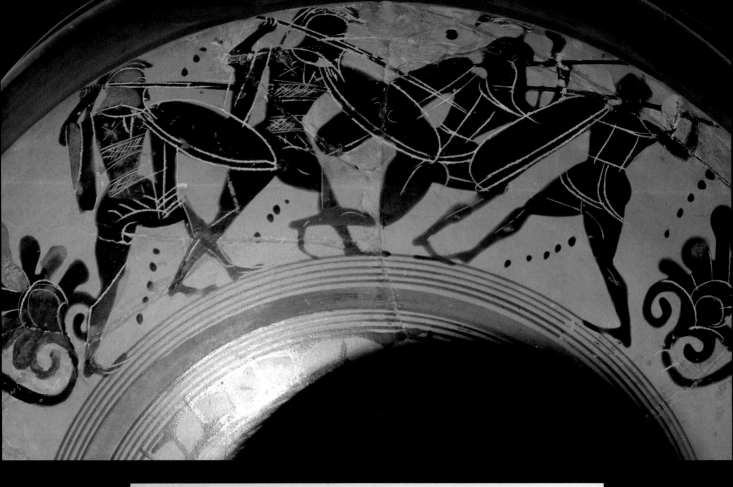

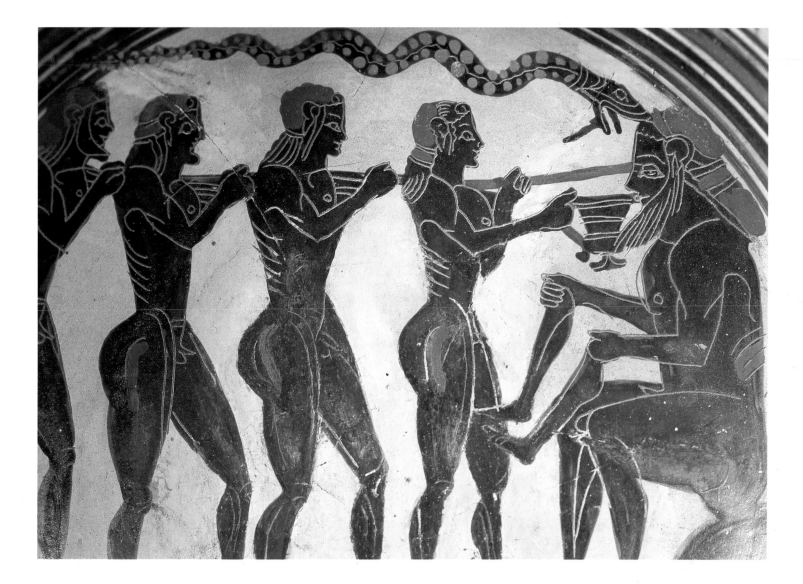

Although fairly small in size – 66 cm. high – this *crater* includes more than two hundred and seventy human and animal figures distributed in five superimposed registers, and one hundred and twenty inscriptions. Some of the scenes are entertaining, like the one with the sailors leaping for joy in Theseus's ship; others, dramatic, such as Priam at one of the gates of Troy, waiting anxiously and in vain for Troilus to return. This work marks the apogee of the narrative style.[6]

The number of potters and painters signing their works in Athens increased; some were so well known that their work was in demand throughout the Mediterranean world. Nearkos, painter and potter, was an acute observer of the animal world. Exekias, who depicted the battle between

6. François Villard, *"Peinture et céramique,"* in *Grèce archaïque,* Paris 1968, pp. 29-106.

Protoattic Amphora

Detail. Odysseus and three companions blinding the Cyclops Polyphemus.
Sixth century BC.
Bibliothèque Nationale,
Cabinet des Médailles, Paris.

Opposite

Black-Figure Cup from Attica

Found at Vix, Champagne, France.
Sixth century BC.
Archaeological Museum,
Châtillon-sur-Seine.

Above

Detail. Warriors in combat.

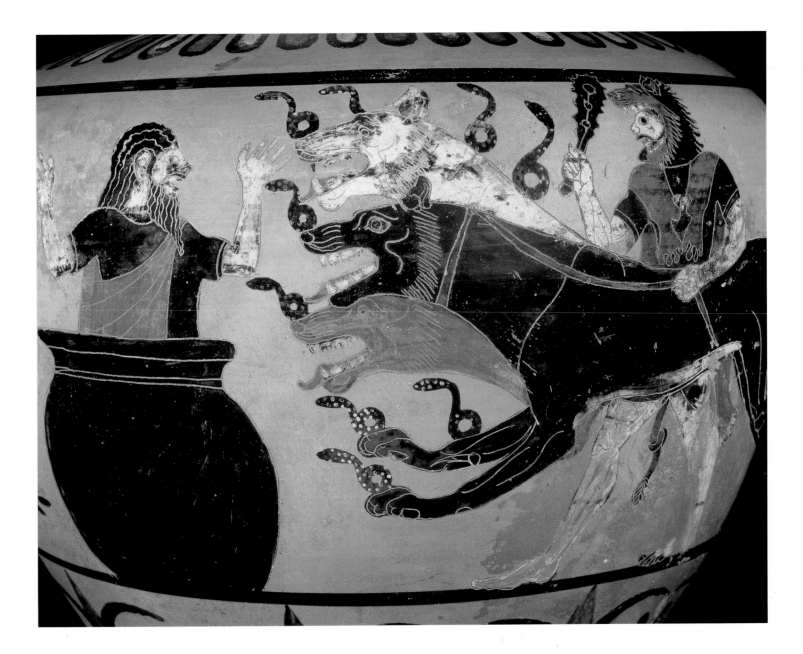

The capture of Cerberus, the monstrous three-headed dog that guarded the entrance to the Underworld,
was the last and most perilous of Heracles' legendary Twelve Labours.
With the help of Apollo and Athena, the hero descended into the Underworld, from which usually no one ever
returned, yet succeeded in capturing the beast and taking him back to Eurystheus in Argolis. The latter, who had
given him these tasks in the hopes of being rid of him, is seen above, so terrified that he is taking refuge in a jar.

Opposite

Black-Figure Hydria from Caera

Detail. Cerberus, watchdog
of the Underworld. h. 63 cm. (25 in.).
530-525 BC.
Louvre Museum, Paris.

Above

Detail. Heracles bringing Cerberus
to King Eurystheus.

**Crater by Clitias and Ergotimos,
known as the "François Vase"**

Around 570 BC.
Archaeological Museum, Florence.

Page 98, top

Detail. Chariot race held to
commemorate the death of Patroclus.

Page 98, bottom

Detail. Peleus's chariot leads the
procession at his wedding with Thetis.

Page 99

Detail. The hunt for the Calydonian boar.

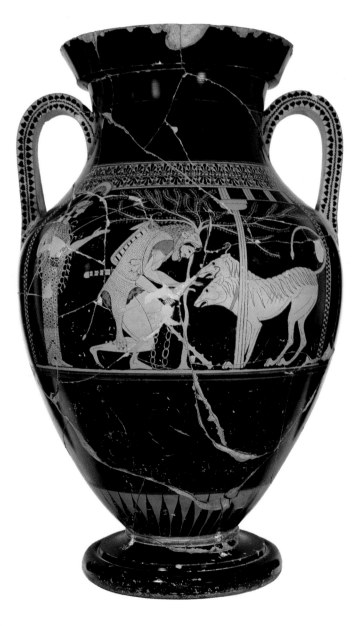

Achilles and Penthesilea and a dice game between Ajax and Achilles, was a master of balanced composition. An anonymous contemporary, who depicted Heracles slaying the malevolent birds of Lake Stymphalos with thrashing wings, gives the lie to the notion that the Greeks were indifferent to the spectacle of nature.

The painters of the Ionian school, who were dispersed in small workshops as far afield as Asia Minor and Etruria, were in no way inferior to their counterparts in Attica. Their outstanding characteristic was humour and verve. Just one example of a masterpiece is a vase showing Eurystheus, king of Tiryns, terrified by Cerberus, the three-headed watchdog of the Underworld, summoning a laughing Heracles to his rescue although he had tried to get rid of him by encouraging him to accomplish the Twelve Labours.

The principal limitation of the black-figure style was that it was essentially an art of the silhouette: the details of the figures painted against the clay ground could be rendered only by scratching them out with a burin; in this respect it was closer to engraving than to painting. Subsequently, around 525 BC, some young Athenian masters in quest of originality introduced an innovation that was destined to become a major success: the technique of red-figure painting. This involved a simple inversion of figure and ground: instead of painting black shapes against the plain clay ground, the vase was entirely coated with black varnish, except for the figures, which retained the reddish colour of the clay. This amounted to replacing the burin with a brush, and so permitted a more nuanced or emphatic rendering of details, more expressive facial features, and a better handling of muscles and drapery. Yet it was a long time before this new technique completely supplanted the black-figure style; there was even a transitional phase in which vases were decorated on one side with black figures and on the other with red figures, either by the same artist or by different hands.

There were a great many masters of the red-figure style. Euphronius, one of the best, could render the male anatomy with almost scientific precision, taking his display of skill so far as to indicate even the usually invisible internal muscles. Another master, Epictetos, was known for his clear and flowing lines. Euthymides and Phintias were two more illustrious names. The red-figure technique led to what has become known as the early classical or "severe" period even though it was not completely devoid of

sensuality. An amphora attributed to the Cleophrades Painter depicts extremely voluptuous figures of Dionysos and the Maenads, the female figures clothed in diaphanous *chitons* that emphasize their curves and tantalizingly reveal their anatomy.

Before concluding this brief survey, we should look again at one of Euphronius's most impressive works, *Heracles and Antaeus*. This vase perfectly demonstrates his obsession with anatomical accuracy, no detail being too slight to be omitted. But there is also something new: while Heracles' hair appears as a flat pattern of stylized curls in the purest Archaic tradition, Antaeus's hair has been rendered by lines beginning at the top of his head and falling on either side of his nape and forehead, like a normal thick head of hair. A new page has been turned, a precursor of Classicism.

Red-Figure Calyx-Crater

Attributed to Euphronius.
Heracles fighting Antaeus.
Around 515 BC.
Louvre Museum, Paris.

Opposite

Red-Figure Amphora

Heracles training Cerberus.
Attributed to the Andocides Painter.
Around 510 BC.
Louvre Museum, Paris.

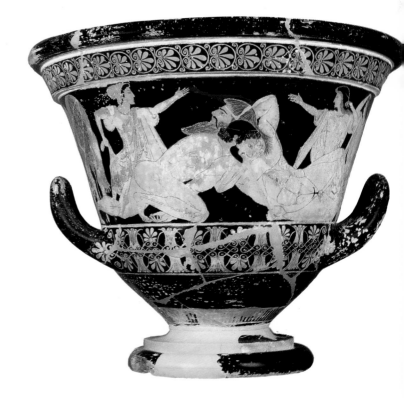

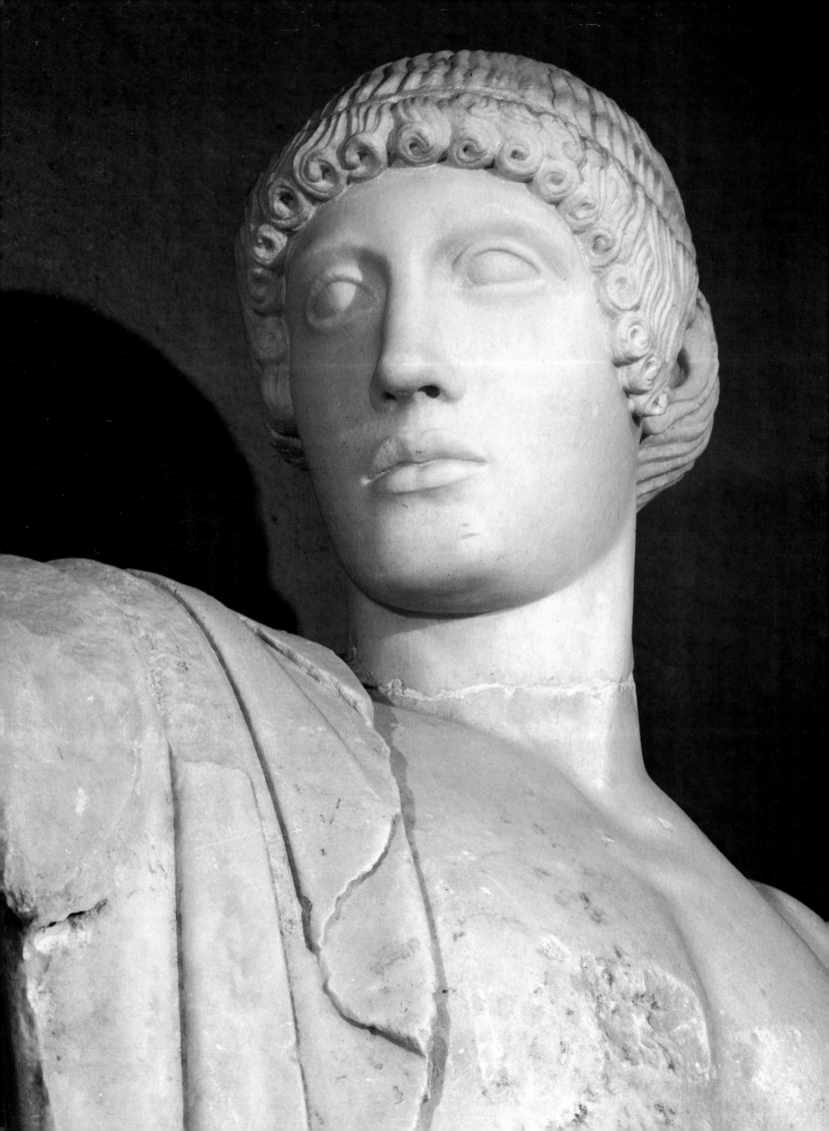

3. CLASSICAL ART

THE MASTER OF OLYMPIA

The Temple of Zeus at Olympia, the largest temple in continental Greece before the construction of the Parthenon, was the first building to break away from the Archaic tradition. Fortunately, the sacred precinct in which it stood was not destroyed in the wars that pitted Athens and its allies against the Persians between 499 and 479 BC. A further stroke of fate contributed to saving some of the finest works of the nascent Classical age: in Late Antiquity, a flood, probably occasioned by an earthquake, covered the site under a deep layer of sand, thus effectively preserving and protecting it from looters for centuries. Excavations undertaken in modern times have brought to light the majority of the sculptures that once decorated the temple, and enough architectural fragments to give an idea of its original appearance.

The Olympic Games, famous throughout the Hellenic world, were held at this sanctuary every four years. The athletic competitions took place within and around the sacred precinct which, apart from the Temple of Zeus and the Heraion – mentioned in the previous chapter – included other buildings, a monumental portico, numerous altars, and statues of gods and goddesses in marble, bronze or gold which, it was said, were purchased with the fines

Apollo

From the West pediment
of the Temple of Zeus at Olympia.
479-460 BC.
Archaeological Museum, Olympia.

The Seer Clachas

From the East pediment of the Temple
of Zeus at Olympia.
470-460 BC.
Archaeological Museum, Olympia.

Opposite

**Transversal section of the Temple
of Zeus at Olympia**

Drawing by Victor Laloux, submitted
in 1883, plate I.
Ecole Nationale Supérieure des Beaux-Arts,
Paris.

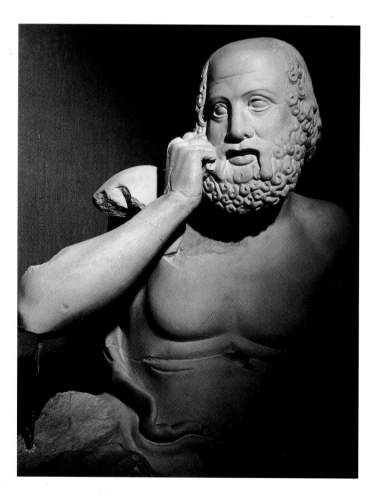

exacted from athletes who had been caught cheating. The sacred precinct opened onto the stadium in which the games were held; outside it were the *palaestra* and the *prytaneum*, where the senators assembled.

The Games lasted six days, the first day being devoted to various ceremonies and rituals, including animal sacrifices. On the following days various contests were held; they varied over the centuries: long- and short-distance foot races, races in full armour, wrestling, boxing, pancratium, jumping, discus- and javelin-throwing, the pentathlon, mounted horse races, chariot races. These events were attended by vast crowds of pilgrims who easily filled the forty-thousand-seat stadium. Victory was considered a gift of the gods. On the sixth and last day, the victors received a crown of olive leaves with ribbons and participated in a procession with the priests around the various altars, to the Heraion and the Temple of Zeus, and finally to the *prytaneum*, where a great banquet was held in their honour.

Now in ruins, the Temple of Olympian Zeus, built between 468 and 456 BC, was a perfect example of the Doric style in architecture. The main body of the building was made of limestone covered with stucco, while high-quality marble from Paros was used for the roof-gutters and the sculptures. The temple was 64.12 metres long and 27.68 metres wide, with six columns on the façade and thirteen along the sides. In the *cella*, two rows of superimposed columns formed a central nave, in the back of which a 12-metre-high gold and ivory statue of Zeus was installed in 448 BC. This monumental work by the famous sculptor Phidias showed the god of gods seated with a figure of Victory on his right hand. But what is most interesting about this temple is its sculptures: the two pediments and the twelve metopes decorating the walls of the *cella* (the metopes of the outer walls were left blank), which together constituted the first example of the Classical Greek style.

The East pediment, above the main entrance, commemorated the most noble of the contests, the chariot races, which in the legends had their origin in a dramatic episode: the deadly race between King Oenomaos and Pelops to decide if he would be granted the hand of the king's daughter, Hippodameia, or be slain. The artist depicted the tense and fateful moment just before the start of the race. Zeus, in the middle of the pediment, has already decided in Pelops's favour, but the mortals in attendance on either side are unaware of this. Their attitudes express the entire gamut of

106

B uilt between 468 and 456 BC, the Temple of Olympian Zeus was 64.12 m. (210 ft.) long and 27.68 m. (91 ft.) wide, and featured a façade with six columns, with a row of thirteen columns along the sides. At the rear of the central nave, composed of two rows of superimposed columns, a twelve-metre-high (39 ft.) gold and ivory statue was erected in 448 BC. This work by Phidias represented Zeus seated on a golden throne, with a figure of Victory resting on his right hand and an eagle-topped sceptre in his left hand. Although executed many years after the temple was built, the statue was too large for the available space. By the end of the fifth century BC, however, architects had found solutions for the display of colossal statues (see p. 124).

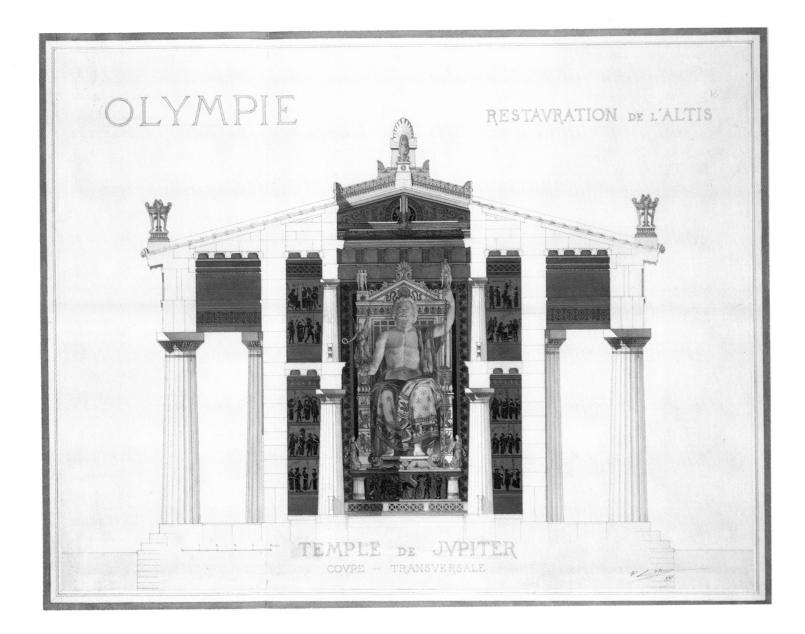

Detail of the Lapith Women

From the West pediment
of the Temple of Zeus at Olympia.
470-460 BC.
Archaeological Museum, Olympia.

Opposite

Heracles

Augras metope
from the Temple of Zeus at Olympia.
470-460 BC.
Archaeological Museum, Olympia.

emotions, from haughty overconfidence and youthful impatience to frank anxiety. The prevalent atmosphere of solemn calm is fraught with apprehension. This scene has been compared to a prologue to a tragedy; thus the master of Olympia and Aeschylus may rightly be said to have "combined their two suns in the skies of Greece at the same hour."[1]

The suspended tranquillity of this scene is counterbalanced by the vicious struggle of the Lapiths and the Centaurs which the artist chose as the subject for the West pediment. This famous mythical battle took place during the wedding feast of Theseus's friend Perithoös, when the Centaurs, seized by a sudden fury, tried to abduct the bride, Deidameia, and her suite of youths and maidens. Their attempt was foiled by the Lapiths thanks to the courage of the two heroes and a little help from the gods. At the two corners of the pediment, we see frightened old servants and water- and wood-nymphs watching the terrible fight, while a majestic Apollo in the middle decides on the outcome.

The metopes depict the most famous exploits of Heracles, the legendary founder of the Games. We see him holding up the celestial vault – with Athena's help – while Atlas brings him the Golden Apples from the Garden of the Hesperides to reward him and grant him vigour and immortality. Another metope shows Heracles struggling with the Cretan bull, which he has stopped in full charge and bound with ropes. The geometric compositional

1. Jean Charbonneaux, *La sculpture grecque archaïque*, Lausanne 1942, p. 92.

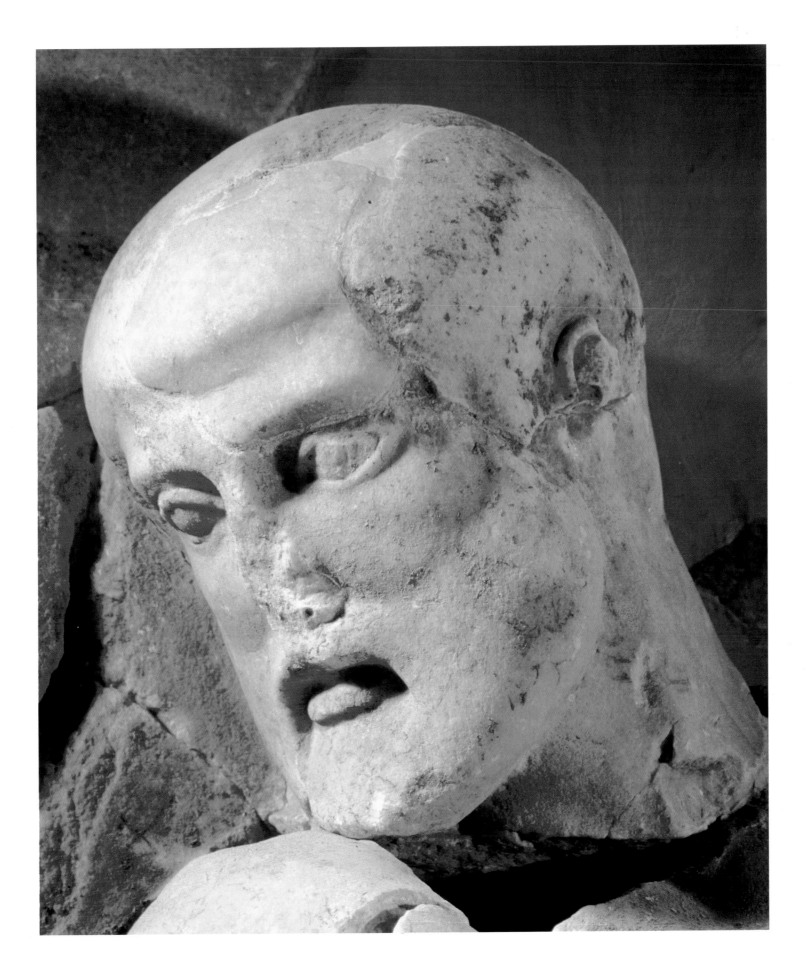

scheme of each scene, with its interplay of vertical parallels and crossed diagonals, is a masterpiece of simplicity. The tilt of the faces, the direction of the gazes, the virility of the muscles, every part of the figures is as true to life as the meaning of the myths they embodied.

The surge and abundance of formal energy which the anonymous master of Olympia and his assistants conferred to every portion of the marble was not yet the Classical ideal, but perhaps something even better. Athletics had a constant and ever-changing influence on the choice and

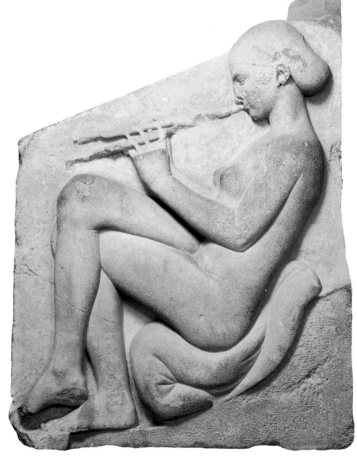

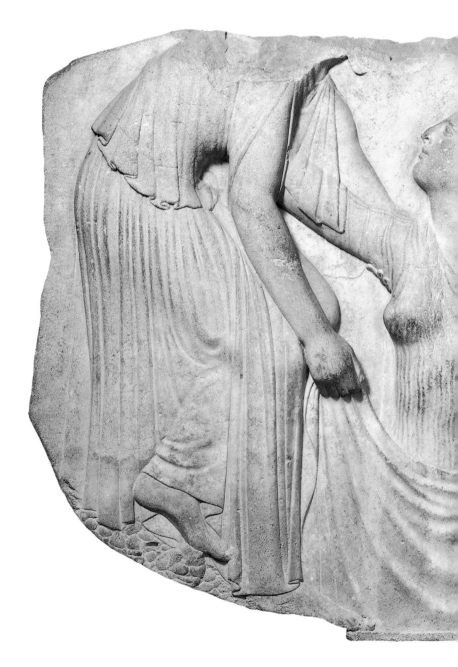

development of forms in Greek sculpture. We shall have occasion to discuss this later in connection with the principal works of statuary from the second half of the fifth century BC.

For now, we can only agree with Jean Charbonneaux's enthusiastic commentary: "Clarity of exposition, depth of religious feeling and pathos, yet nowhere overstressed, an application of the most powerful dramatic principles, but always regulated by an inflexible will to concentration and balance. These are anything but disparate virtues or dispersed

forces. Only a dedicated and focused genius could have dominated with his lucid energy and animated with his spirit such a varied host of gods, heroes and monsters."[2]

These characteristics were in complete opposition to the Ionian style, as we can see from the *Ludovisi Triptych*. The middle panel of these three bas-relief plaques depicts the birth of Aphrodite assisted by personifications of the Hours. The very handling of the marble is like a caress for the eyes, with the drapery flowing like so much water along the body of the goddess emerging from the sea.

THE EPHEBE OF LIGHT:
THE FIRST CLASSICISM

Greek sculpture was born in the stadium, where athletes traditionally competed in the nude. The young Athenians going to the *palaestra* would first wash in a fountain or large stone basin, then cover their entire body with oils and finely powdered sand or dust to protect their skin. Their exercises were accompanied by the playing of a musical instrument, in keeping with the saying: "gymnastics for the body, music for the soul." The athletes themselves were sometimes crass and brutal individuals, and some who became professional sportsmen did not shrink from selling their services to the highest bidder. But there was a strong belief that physical deficiencies caused poor mental health, and so the complete man took care to cultivate his bodily as well as his intellectual faculties. Classical Greek sculpture was a glorification of the healthy, vigorous man; should anything undermine his health, decline was sure to follow.

Myron's famous *Discobolus*, or Discus-Thrower, the first of the major Greek statues that can be studied in other than hypothetical terms, is a perfect example of this glorification. The original work in bronze has been lost, but existing replicas give us a sufficiently good idea of what it must have been like. Among the ancient Greeks, the discus-throwing technique was different from today. The throw was effected in two stages: after having taken the discus in both hands, the athlete leaned back and moved his left foot forward; then, straightening the torso, he pivoted the upper half of his body from left to right, while the right arm traced a large circle, moving from front to back. In the *Discobolus*, the athlete is represented at the peak moment of the action, just

The Ludovisi Triptych

Marble.
Around 470-460 BC.
Thermae Museum, Rome.

Previous page, left
Woman playing the flute.

Previous page, middle
The birth of Athena.

Previous page, right
Veiled woman.

Opposite
Detail of the birth of Athena.

2. Jean Charbonneaux, *op. cit.*, p. 96.

Discobolus, the Discus-Thrower.

h. 155 cm. (5 ft.).
Copy of the bronze original by Myron.
Around 450 BC.
Glyptothek, Munich.

Opposite

Athena

Marble, h. 173 cm. (5 $^1/_2$ ft.).
First-century copy after a fifth-century BC
original by Myron.
Found in the Gardens of Lucullus, Rome.
Liebighaus Museum, Frankfurt.

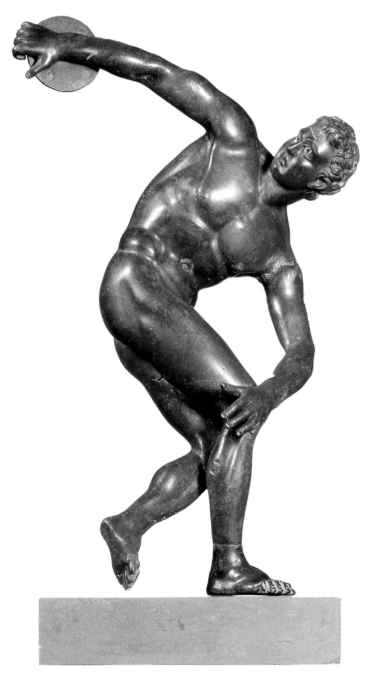

as he is about to throw the discus; yet the discus is shown in the top position, that is, at the beginning of its descent. The statue as a whole presents, not the realistic record of an action, but an artistic condensation of the two successive stages of the throw to create a heightened impression of movement.

This figure marks a profound break with the sculpture of the Archaic period, for such a representation of a discus-thrower would have been impossible without a thorough knowledge of anatomy. The *kouroi* were ideograms of a motionless human body; from their large shoulders down to their feet firmly planted on the ground, their musculature was made for immobility. Here, on the contrary, the deltoids contract, the pectorals swell, the small oblique muscle strains the groin, while the left foot, which had been thrust backwards when the discus was raised, returns along the ground to a forward position with the toes curled. This knowledge of musculature was not gained with a scalpel, but through the acute observation of athletes in motion, which the artist had constantly in front of him.

This is not to conclude, as some have done, that the value of Classicism is to be measured in terms of degrees of verisimilitude. If the Greeks looked closely at the play of forms in nature, it was in order to elaborate a corresponding formal syntax. We have already mentioned in the first chapter that the bodies of the Cycladic idols were divided into four equal parts. The sculptors of the Archaic period were also concerned with proportion: the head of the *Kouros of Tenea* is equal to the length of its foot, and its total height amounts to seven and a half of these units. This tendency became uppermost during the Classical period: the sculptor Polyclitus is recognized as having introduced the *canon*, or fixed series of proportions, that was to govern Greek sculpture for more than a century.

Polyclitus was Myron's contemporary, give or take a few years. Born in Sicyon, in the Peloponnese, he was an apprentice in the workshops of Argos and began working in Athens in 432 BC, just as work on the Parthenon was being completed under Phidias's direction. He seems to have been active over a period of forty years, from 460 to 420 BC, and to have devoted most of his efforts to a single theme: the virile nude. He strove to keep all traces of individuality out of his works in order to arrive at an impersonal art by applying his "canon". In his most famous sculpture, the *Doryphorus*, or spear-bearer, the length of the torso and the width of the shoulders are equal to twice the

height of the head, while the arch of the rib-cage and the inguinal fold form a circle with the navel as the centre. He applied the same principles in his other well-known works: the *Discophorus*, the *Diadumenos* and the *Cyniscos*.

The Archaic smile had long ago vanished, and the long hair falling in layers had become shorter. The faces became serene, with the nose prolonging the verticality of the forehead to create the "Greek profile." The head itself was made as spherical as possible. According to traditional Pythagorean philosophy, the gods had given men a spherical head "in the image of the Universe." Still, there was nothing cold about this sculpture; the use of numbers calculated according to the positions of the stars and planets was no mere abstraction to the ancient Greeks; they constituted mystical figures whose harmony could be read in the stars.

Another significant characteristic of Classical statuary was the *contrapposto* pose, which replaced the static Archaic frontality with a twisting movement. The beginnings of this swaying pose may be seen in such works as the *Athlete of Saphanos* and the *Ephebe 698*, which both display only slight torsion. Starting with Polyclitus, however, the nude ephebes consistently featured four sets of planes opposed in pairs; those of the shoulders and hips, and those of the knees and feet, with the weight of the body resting on one foot. The vertical axis passing though the middle of the neck falls directly on the ankle of this supporting foot, while the other foot touches the ground only with the tips of the toes, as if to maintain equilibrium. This position causes one hip to rise and protrude, and the other to dip down, and vice versa for the shoulders.

Rodin, who studied Greek statuary more closely than any other artist, noted that the Classical ephebes, when looked at from the side, displayed inward-curving backs and slightly protuberant rib-cages so as to accommodate the light streaming down their torsos and limbs. "Translate this technical system into the language of the spirit and you will see that the art of Antiquity expresses happiness, serenity, grace, balance and reason."[3] A happy moment of illumination in Western civilization. And he should perhaps have written "illumination" with a capital I, in contrast to Michelangelo's *Slaves*, with their hollow torsos that celebrate the triumph of darkness and self-absorption.

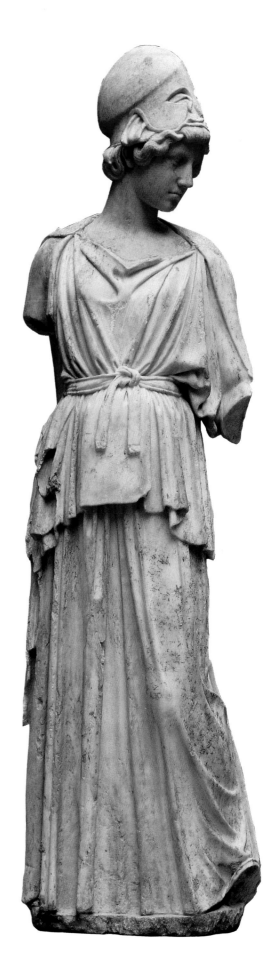

3. Auguste Rodin, *L'Art*, Paris 1911, pp. 191-222; trans. as *Art: Conversations with Paul Gsell*, Berkeley 1984.

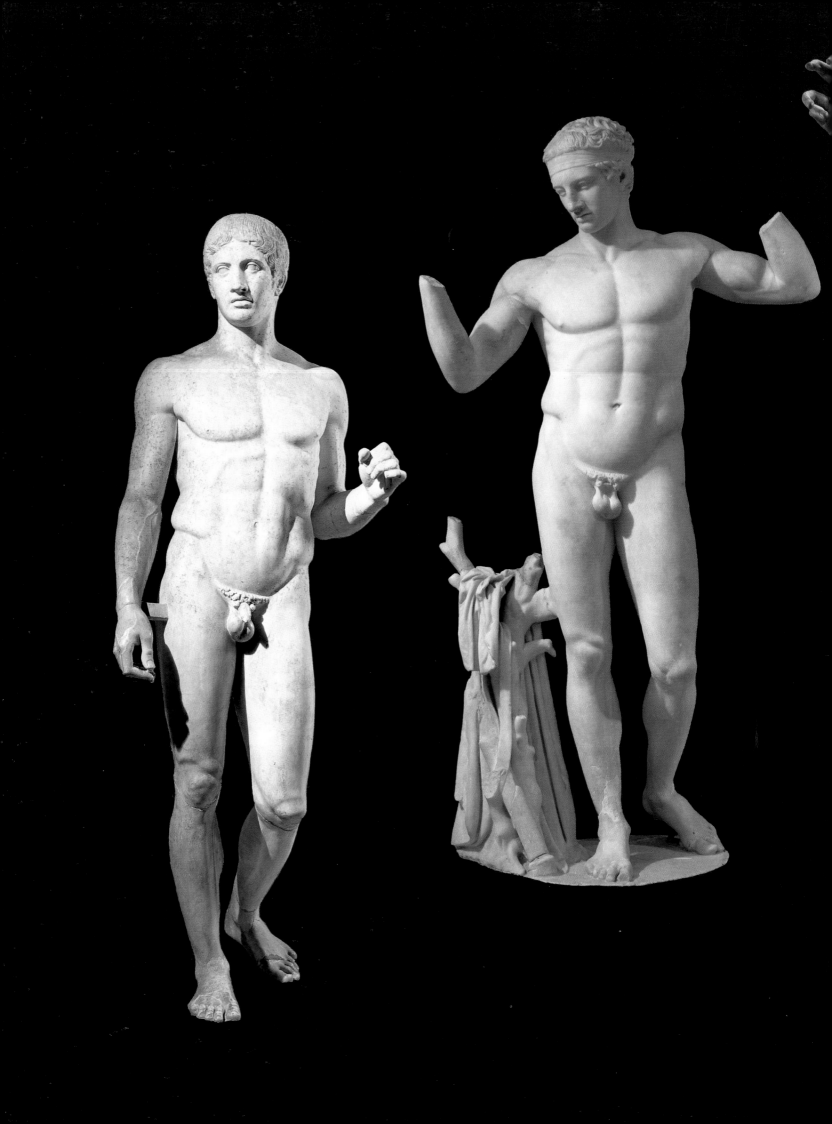

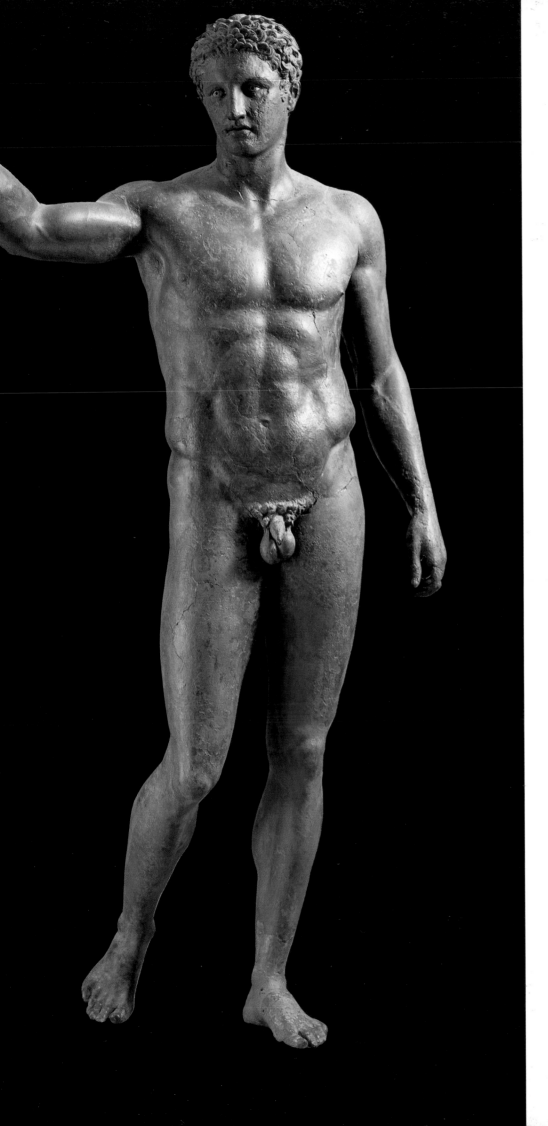

Working in the fifth century BC, Polyclitus, strove to achieve an ideal beauty and developed a canon, or fixed series of proportions, relating the parts of the body to the whole. Thus the height of the head was one seventh of the total height of the body, and half the length of the legs, of the torso and the width of the shoulders. He also allowed his statues to relax the weight onto one leg and broke with the traditional frontality of Greek statuary. Lysippus of Sicyon modified this canon during the third quarter of the fourth century BC. The body took on a slimmer and more ascetic appearance, with the head equal to only one-eighth of the total height.

Opposite, left

Doryphorus

Roman copy of the bronze
by Polyclitus.
h. 2.12 m. (7 ft.).
Around 440 BC.
Archaeological Museum, Naples.

Opposite, right

**Diadumenus,
the Young Athlete**

Marble. Roman copy
of the bronze by Polyclitus.
h. 1.86 m. (6 ft.).
420 BC.
National Archaeological
Museum, Athens.

Left

Youth of Anticytherus

Bronze, h. 1.94 m. (6 ft. 4 in.).
Mid-fourth century BC.
National Archaeological
Museum, Athens.

The greatest artist that ancient Greece ever produced was undoubtedly Phidias. For Rodin, his genius not only stood for Greek sculpture as a whole, but his works were also its highest expression.

He was born in Athens several years before Polyclitus, around 490 BC. Little is known of his early years, but his artistic precociousness is not in doubt: he became proficient in the techniques of casting bronze, carving marble, and also painting, disciplines which put his extraordinary range of talents to best use. His first commission was for a cult statue for the Temple of Athena at Plataea, in Boeotia. This gilded wooden statue was of modest dimensions, with head and limbs of pentelic marble. Phidias was to demonstrate his mastery of the *chryselephantine* technique at the Parthenon and the Temple of Olympian Zeus, where he executed statues made of gold combined with ivory on a timber armature. Thus began a brilliant career that was to earn him the name of "maker of divine images," for he preferred making effigies of the gods to portraying athletes.

Various accounts and stylistic comparisons permit us to attribute to Phidias a whole series of cult statues from his first period; a good example is the *Apollo* in Cassel, marked by a slight Archaic stiffness that reveals the influences of his beginnings. Among the major works in which his artistic personality first came to the fore was the great relief at Eleusis dedicated to the cults of Demeter and Core, part of a decorative cycle celebrating the legend of the two beneficent earth-goddesses inside the Telesterion, whose construction had been entrusted to Ictinus, the future architect of the Parthenon. The subtle play of drapery, the simplicity of the gestures and movements, and the serenity of the faces that grace the relief at Eleusis herald the achievements of his mature period.

Five centuries after the artist's death, Epitectus could write: "Go to Olympia and contemplate the works of Phidias. It would be a pity to die without seeing them." Yet however rich and sumptuous his statue of Zeus at Olympia, it probably did not match the splendour of his *Athena* at the Parthenon, a colossal figure of the virgin patron-goddess of Athens, which has also been lost.

According to descriptions from Antiquity, the goddess was represented standing, clothed in a *peplos*, her chest protected by a breastplate decorated with the Medusa-headed *aegis*.

Portrait-Head of Pericles

Roman copy of an original by Cresilas
from 430 BC.
Antikensammlung, Staat. Museum, Berlin.

118

In her right hand, she held a figure of Victory about four cubits high (1.8 m.), and in her left a spear, with her finger touching a shield resting against her leg. Next to the spear was the serpent Erichthonius. The shield was decorated in relief on the outside with a scene of Amazons in battle; inside was a painting of the Battle of the Gods and the Giants. Even her sandals were engraved with the battle of the Lapiths and the Centaurs. The crest of her helmet was carried by the figure of a sphinx, while the pedestal presented a frieze showing the birth of Pandora – the pagan Eve – attended by a host of gods and goddesses.

Phidias took great pains to ensure that every detail would contribute to the perfection of the whole. We can easily imagine the amazement of the Athenians when they beheld this statue in the *cella* of the Parthenon for the first time in the summer of 438 BC.

PHIDIAS AND PERICLES

Pericles came to power in 461 BC and, except for a brief interruption, remained ruler of Athens until his death from the plague in 429. Because of his enlightened leadership and patronage of the arts, the fifth century BC is known as the "Age of Pericles," although he ruled for only thirty-two years, a third of the century.

According to the Roman historian, Plutarch, Pericles' mother, Agaristae, dreamed that she gave birth to a lion. Several days later, she gave birth to a male child who was endowed with a well-formed body but who had a disproportionately large and elongated skull. Because of this deformity artists almost always portrayed him wearing a helmet. Cresilas showed him thus with a serenely dignified countenance. Pericles possessed the four cardinal virtues required of a great statesman: intelligence, eloquence – he was a powerful orator – patriotism, and complete selflessness.

At the beginning of his rule, the Persians had been decisively defeated at the Battle of Salamis in 480 BC and Athens commanded a vast maritime empire which brought it great wealth and power. But the site of the Acropolis was little more than a cemetery of piles of stones and broken statues. For more than a quarter of a century the reconstruction stopped and started but was never completed.

In 450 BC Pericles put Phidias in charge of the work, which included building four major monuments: the

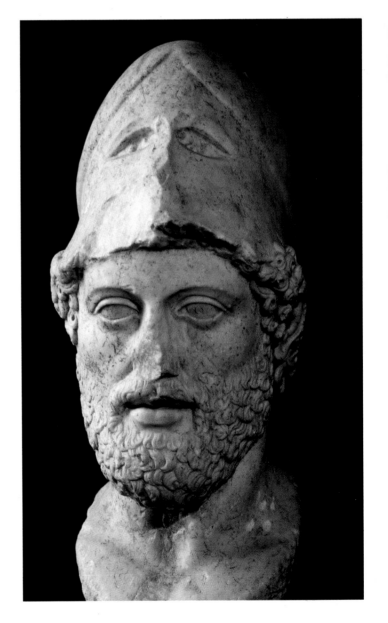

119

Bronze statuary was a major genre in ancient Greece, but most of the works were lost over the centuries when the metal was melted down to make coins or weapons. For a long time, the famous "Charioteer of Delphi" was the only known work to have survived. However, the two figures of nude, helmeted men found in 1972 in the Bay of Riace and attributed to Phidias give us a better idea of the original qualities of this art form.

Charioteer of Delphi

Bronze, h. 1.80 m. (6 ft.).
Figure from a victorious quadriga found in the ruins of the Temple of Apollo at Delphi.
470-466 BC.
Delphi Museum.

Opposite

Head of a Man with Helmet

Bronze found in 1972 in the Bay of Riace, Calabria, Italy. The Greek original has been attributed to Phidias.
Around 460 BC.
National Museum, Reggio di Calabria.

Overleaf

Man with Helmet

Bronze found in 1972 in the Bay of Riace, Calabria, Italy. The Greek original has been attributed to Phidias.
Around 440 BC.
National Museum, Reggio di Calabria.

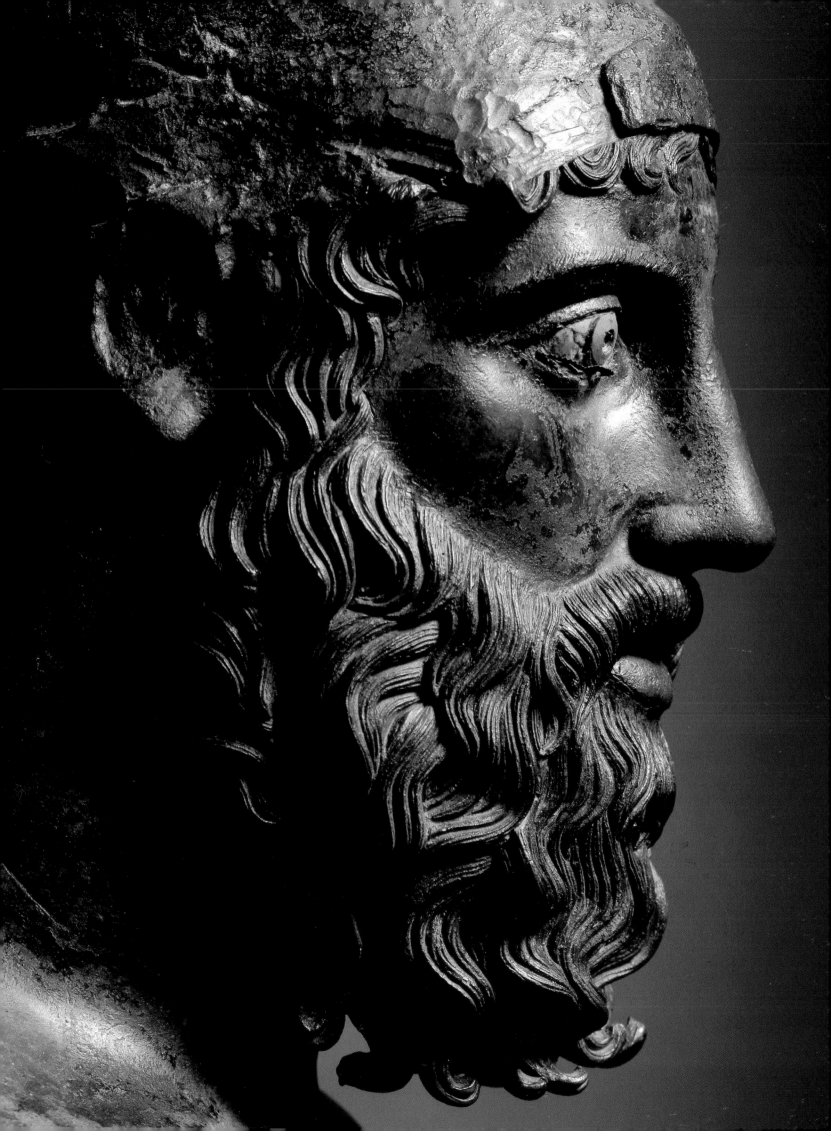

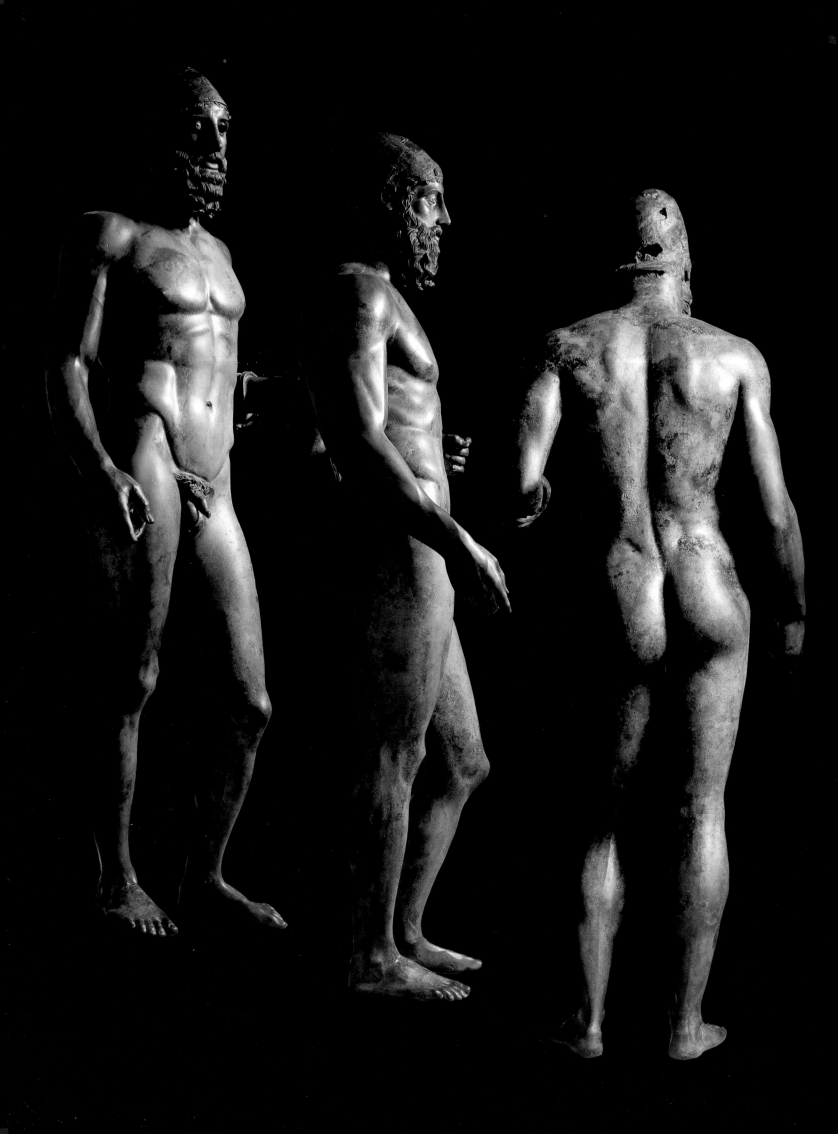

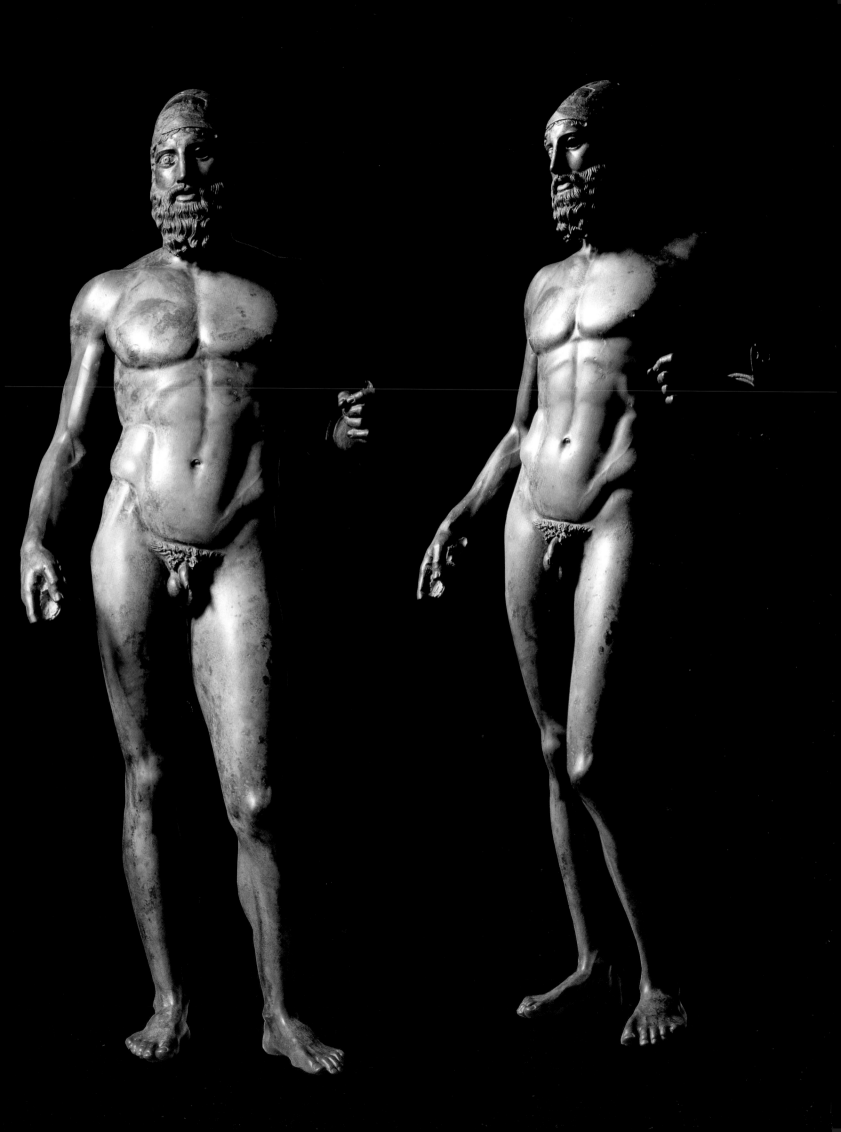

Parthenon, the Propylaea, the Erechtheum, and the Temple of Athena Nike. The sums required for this undertaking were considerable, but it would be a steady source of income for the working classes for twenty years and would guarantee Athens "eternal glory."

The Parthenon, designed by the architects Ictinus and Callicrates, was begun in 447 and finished in 432 BC. It was seventy metres long, thirty metres wide, and built partly on bedrock and partly on the raised foundations of the former temple which it replaced. Pericles wanted a monument majestic enough to house the triumphant figure of Athena, and with enough surfaces to depict the traditional scenes associated with the legends and history of the goddess. The result was an exceptional building made entirely of pentelic marble which immediately ranked among the masterpieces of the world. The heart of the sanctuary was formed by a nineteen-metre-wide *cella* articulated by a central nave formed by two rows of superimposed columns, at the rear of which stood Phidias's chryselephantine statue of Athena-Parthenos. To allow for a wider nave, the façade of the peristyle was composed of eight columns instead of the usual six for Doric temples. The decorative cycle was completed with sculpted pediments and metopes.

The Parthenon was a textbook model of the mathematical aesthetics that called for the optical correction of architectural details. Efforts had already been made in this sense during the Archaic period, but this rationalized illusionism was carried to its maximum degree of refinement here. Traces of these corrections may still be seen in the extant remains of the temple. The four courses of the base are of unequal height; the first course, which rests on the bedrock and forms the foundation, is the lowest, and the last is the highest. The difference is very slight, more easily registered by walking up the steps than by the eye. However, the three steps seem to be of equal height when seen from a distance, and the top course does not appear to be crushed by the weight of the building, as it would if the steps were really of equal height. Nor is the surface of each course flat; it is slightly convex, so that it does not appear to be sagging in the middle.

Similar principles of optical correction were applied to the columns. None of the columns is exactly perpendicular to the ground, nor parallel to the others, for that would have made them appear divergent. The corner columns are

Transversal section of the Parthenon (conjectural restoration).

Drawing by Loviot Benoit, submission from 1879-81. Ecole Nationale Supérieure des Beaux-Arts, Paris.

124

The Parthenon, built by Ictinus on the Acropolis in
Athens between 447 and 438 BC is exceptional
in that its façade has eight columns instead of the usual six
in Doric temples. This created a vast interior space, made
all the wider as the columns were shifted toward the side walls
in order to make room for the eleven-metre-high (36 ft.)
chryselephantine cult statue of Athena executed by Phidias.

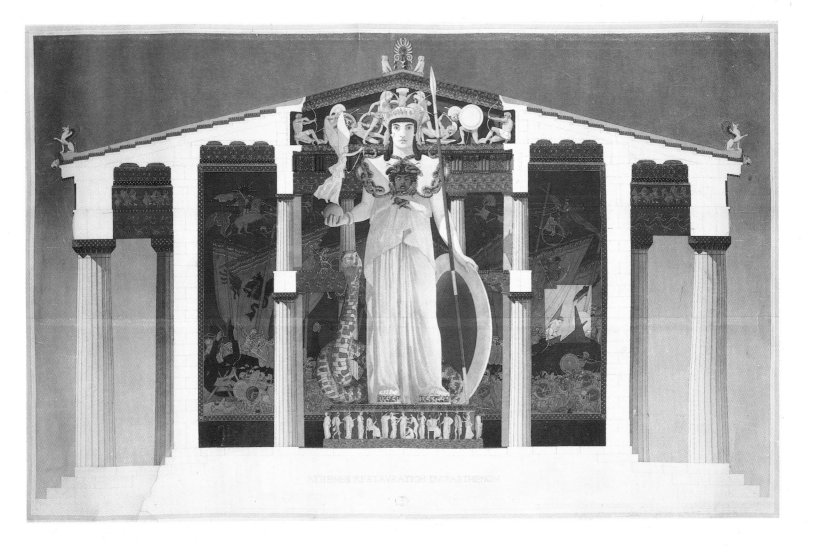

ATHENES RESTAVRATION DV PARTHENON

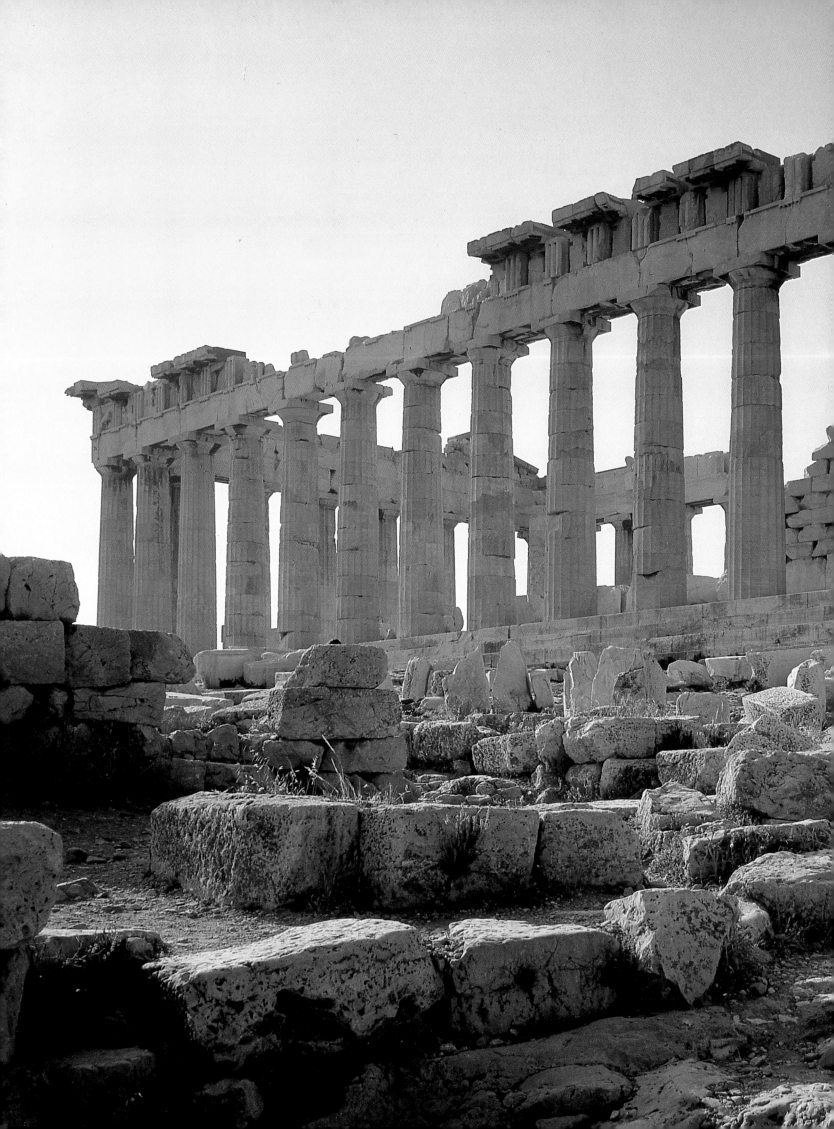

View of the Parthenon

Temple of Athena.
Fifth century BC.
Acropolis, Athens.

Horse of Selene

Pentelic marble. From the East
pediment of the Parthenon.
Fifth century BC.
British Museum, London.

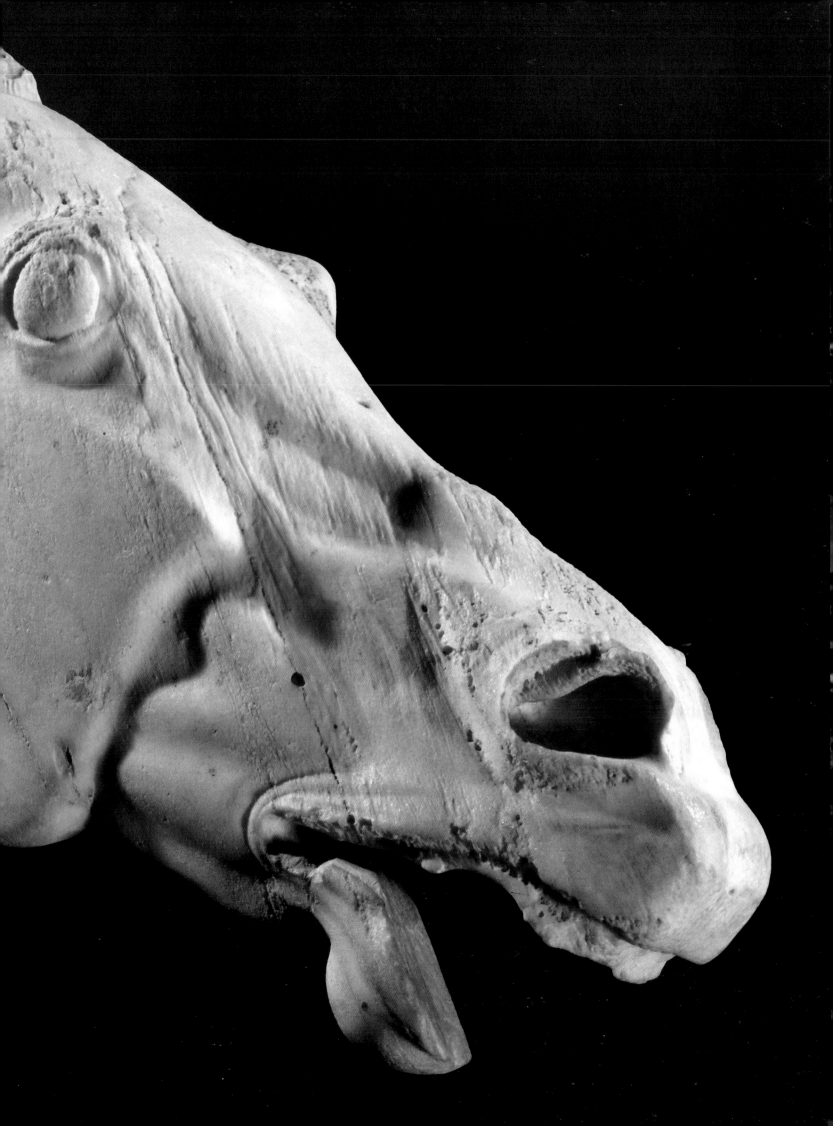

Dionysus

Pentelic marble.
h. 1.30 m. (4 ft.), l. 2 m. (6 $^1/_2$ ft.).
From the East pediment of the Parthenon.
Fifth century BC.
British Museum, London.

Opposite

Bust of Hermes

Pentelic marble. From the West pediment
of the Parthenon.
Fifth century BC.
British Museum, London.

perceptibly closer to the adjacent columns than the others, for an identical intercolumnar space would have created a larger empty space; and the shafts were made slightly fuller so as not to be overwhelmed by the luminous void against which they were silhouetted.[4]

The West pediment, at the back of the building, depicted Athena's conquest of Attica, or, more exactly, the division of Athenian domination between Athena and Poseidon, Land and Sea. The middle of the pediment showed Athena and the

4. André Bonnard, *op. cit.*, vol. I, p. 224 -226.

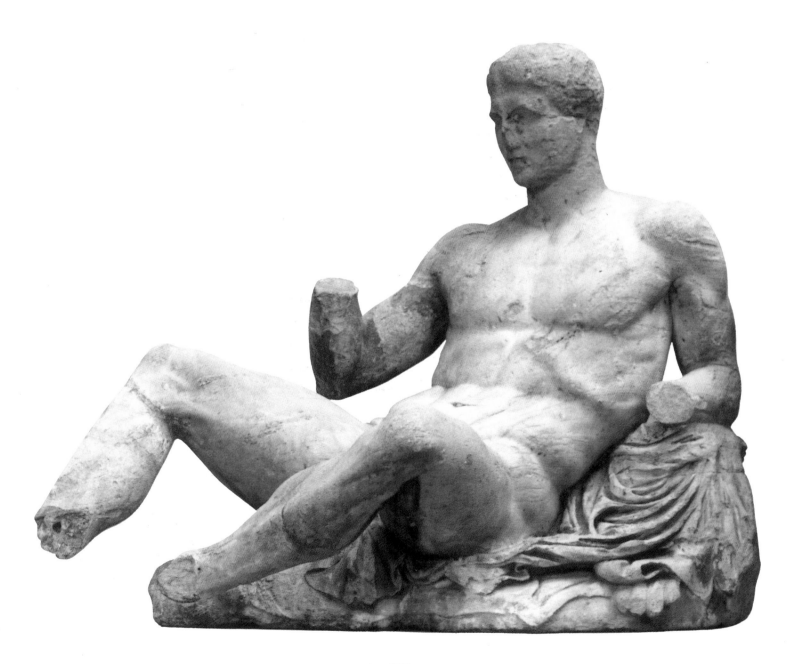

olive tree rooted in the foot of her spear; and Poseidon creating a spring from his trident. Two symmetrically-disposed teams of horses separate them from the other figures: on the right, Hermes, behind the goddess's chariot driven by Nike; on the left, Iris and Aphrodite, the driver of the sea-chariot. On either side stood the families of the ancient heroes of Attica: the Pandionids, the Erechtheids and the Cecropids. Finally, at the corners, two nymphs and two river gods linked the fertile forces of Athenian soil to the heroic drama being enacted.

The East pediment showed the birth of Athena springing fully-armed from Zeus's head, freed by a blow from the hammer of the blacksmith god Hephaistus. This pediment has been almost completely destroyed, with only eight of the original twenty-one sculptures remaining, but it is presumed that this episode was flanked on the left by the figures of Iris, Persephone, Demeter and Dionysus, and on the right by those of Aphrodite and her two companions, Leto and Dione. This scene from the sacred legends was represented in an ideal setting, an abstract Olympus, as if on a theatre stage, with the celestial figures of Helios and Selene presiding in either corner, the fitting cosmic symbols for the dawn of a new age.

The Parthenon pediments were Phidias's most grandiose work. With the benefit of his long experience with religious statuary, it was there that he was able to exercise his mastery of form to the fullest. We can still see the measure of his achievement in the musculature of the *Reclining Cephisus*, so natural with its supple volumes, yet caught in a body of marble, or in the draperies of *Iris*, pressed against her by the wind or whipped up by the rain. In the ease of his poses and the artful composition of his groups, Phidias demonstrated that he was also a master of the dramatic effect, like his contemporary, Sophocles. No wonder that no one, not even Antonio Canova, felt equal to the task of restoring the sculptures that Lord Elgin removed to London at the beginning of the nineteenth century.[5]

The exterior decoration of the Parthenon was presented in distinct tableaux on the numerous triglyphs and metopes. The subjects were the mythical battles between the gods and the Giants, between the Lapiths and the Centaurs, between

5. See introduction.

Overleaf

Bust of Cephisus

Pentelic marble, h. 82 cm. (32 in.).
From the West pediment of the Parthenon.
Fifth century BC.
British Museum, London.

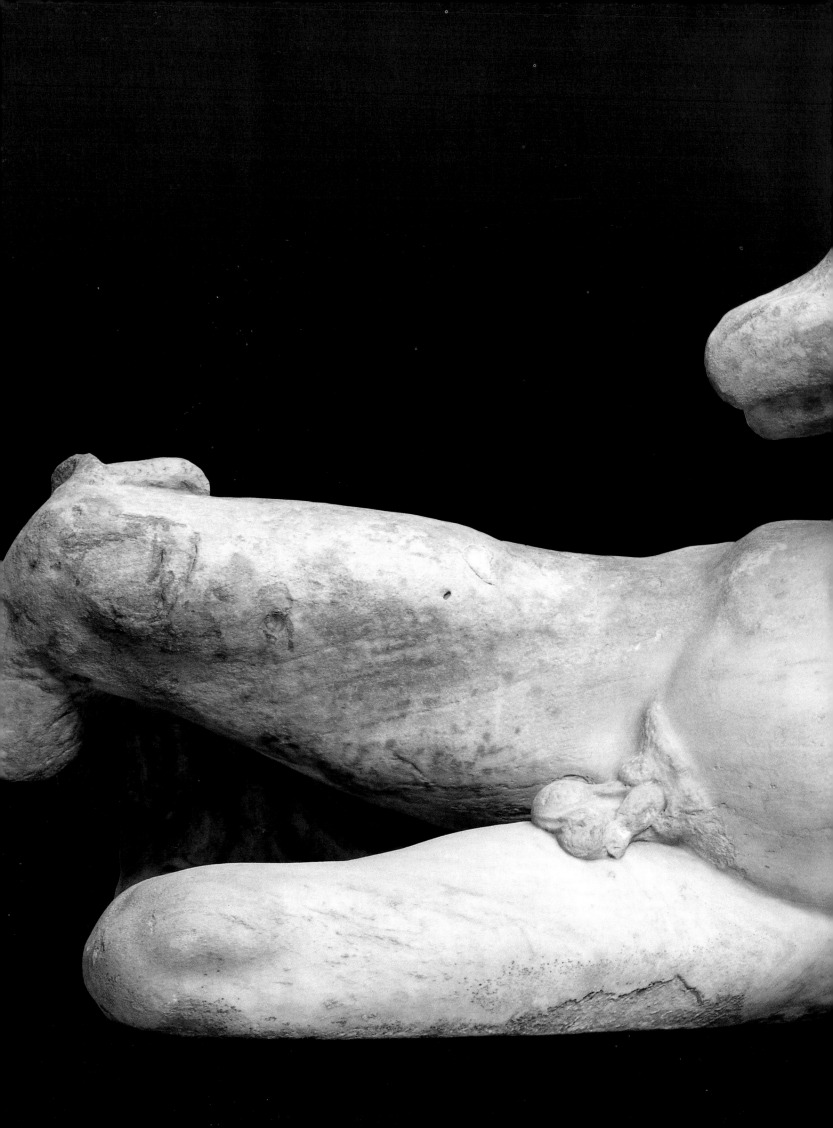

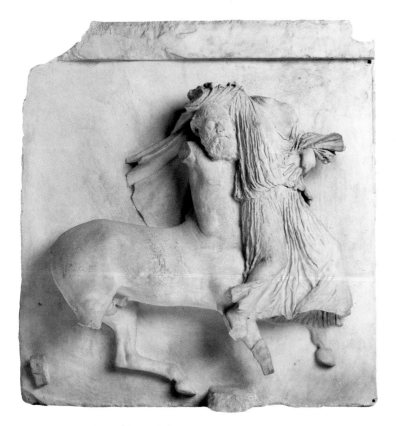
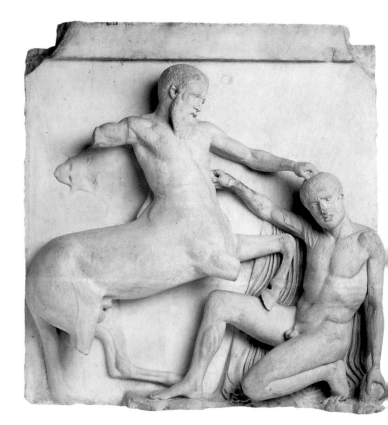

Battle of the Lapiths and the Centaurs

Pentelic marble, h. 1.34 m. (4 ft.).
South metopes 29 and 30.
British Museum, London.

Opposite

Panathenaic Relief

Plaque 7 from the frieze (l. 160 m., 524 ft.,
h. 1.06 m., 3 ft.). on the exterior wall of the
cella of the Parthenon.
Fifth century BC.
Louvre Museum, Paris.

the Greeks and the Amazons, and scenes from the fall of
Troy. The execution of these pieces is visibly not of the same
quality as the rest, for Phidias entrusted them to various
collaborators. There are some exceptions, however, like the
head of the Centaur on the first metope of the south side,
where one could easily imagine the master taking the chisel
from the hands of one of his assistants and showing him
how it was supposed to be done.

The diversity in the execution of these metopes – of
which there were ninety-four – does not detract from the
unity of action that runs through the entire entablature of
the Parthenon. We might single out the series depicting the
various stages of the Battle of the Lapiths and the Centaurs,
which, although still displaying features of Late Archaism,
and even some awkwardness in the junction of the human
torso and equine parts of the Centaurs, and occasionally too
great a disproportion between the protagonists, never-
theless conveys great formal energy. With their many
human and animal figures, the rhythmic interplay of flexed
limbs, the counterpoint of the converging and diverging
curves of the bodies, and the variety of facial expressions,
the scenes on these metopes impress the spectator with
their simple and powerful theatricality.

The bas-relief depicting the Panathenaic Procession,

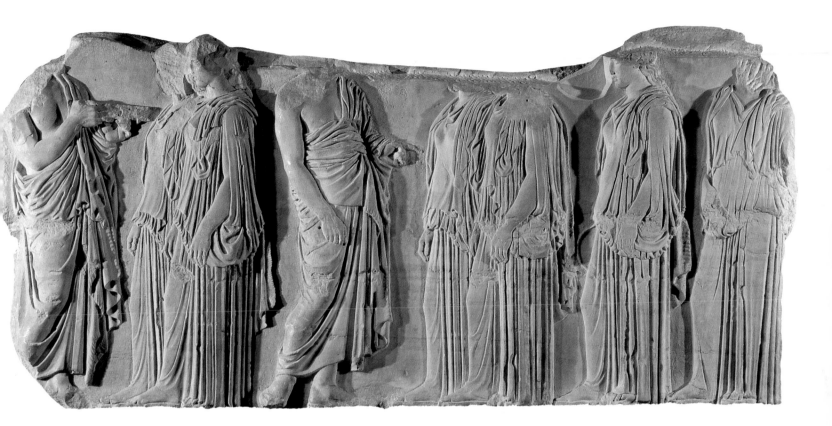

which decorated the outer wall of the *cella* with a 160-metre-long sculpted frieze and represented figures of ordinary mortals for the first time, is as wonderful to behold today as it was for the faithful in Antiquity. The Panathenes walked in procession on the Acropolis every four years to accompany the maidens who had woven the new tunic for Athena, along with other maidens bearing phials and ewers for the libations, and candlesticks and incense-burners; they were followed by the heifers and ewes being led to sacrifice by their keepers, by metics bearing offerings, chariots driven by hoplites, and, bringing up the rear, a contingent of horsemen representing the cream of Athenian youth.

The three hundred and sixty figures and host of animals that people this frieze convey an impression of intense animation. Unlike the metopes, this long bas-relief carved out of the marble with a technique similar to engraving, consistently displays great stylistic unity without ever lapsing into monotony. What more touching sight than the heifer being led to sacrifice and, instinctively sensing its fate, bellowing and trying to struggle free, or the ewe about to suffer the same fate, but seemingly resigned to it? The human figures are no less diverse, and seem to have been drawn from life: they include metics carrying jugs, magistrates, city elders, horsemen and maidens.

Overleaf

Heifer being led to Sacrifice

Marble, plate XL, h. 1.06 m. (41 in.).
South frieze of the Parthenon.
Fifth century BC.
British Museum, London.

Top

Mounted Riders

Plaque 38 from the North frieze
of the Parthenon.
h. 1.06 m. (3 1/2 ft.).
Fifth century BC.
British Museum, London.

Bottom

Horsemen

Plaque 42 from the North frieze
of the Parthenon.
h. 1.06 m. (3 1/2 ft.).
Fifth century BC.
British Museum, London.

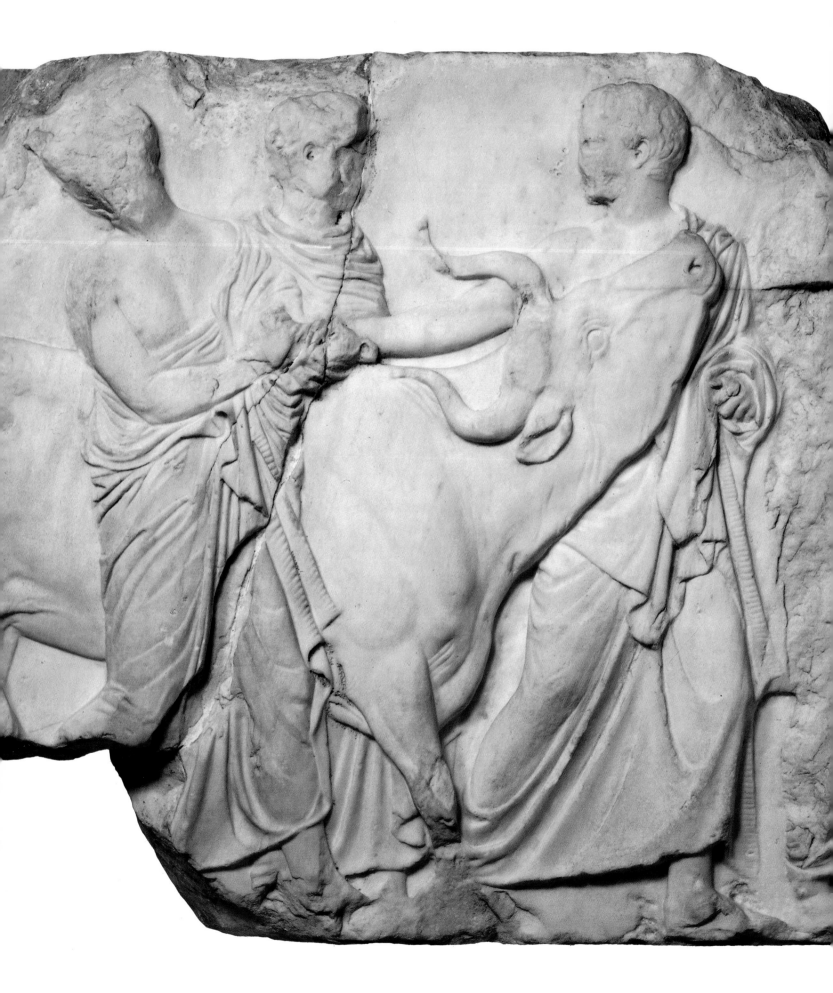

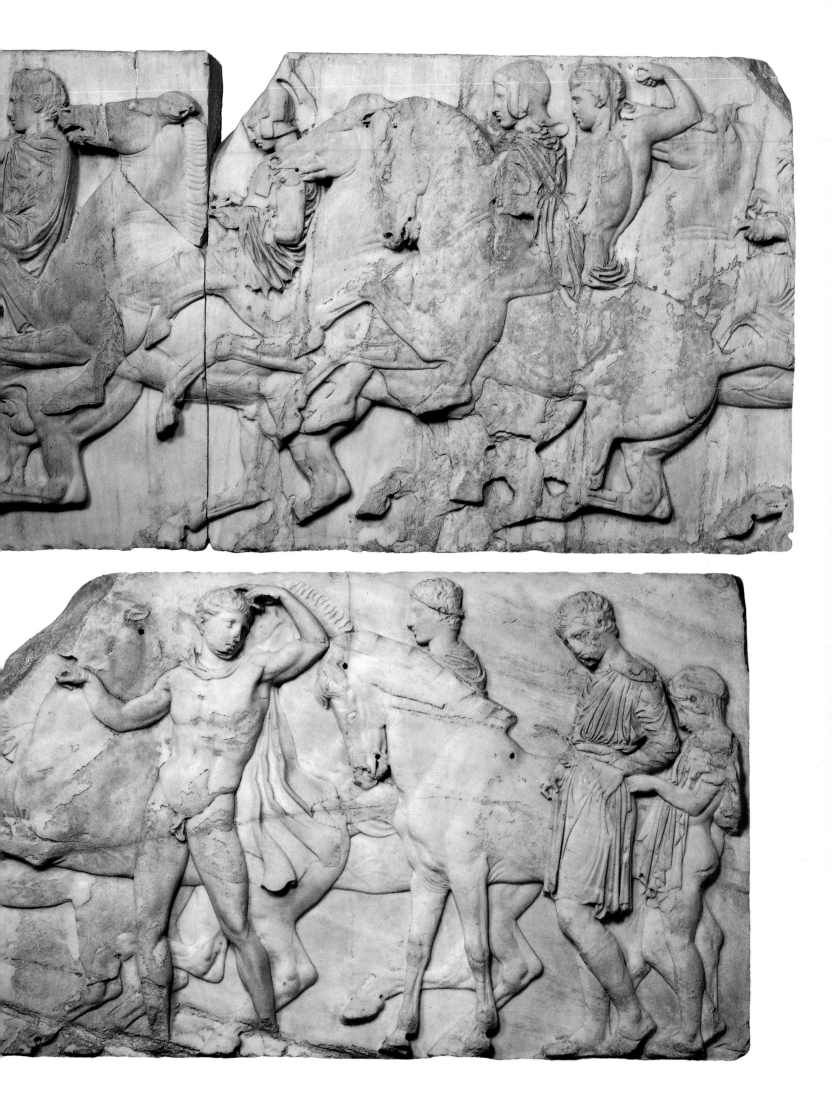

This "century" that lasted thirty-two years gave us three geniuses: Phidias, Sophocles and Pericles. In building the Parthenon, the city of Athens, freed from the Persian threat and finally enjoying freedom, prosperity and a peace that seemed to have been conclusively won, proudly asserted its pre-eminence over the entire Hellenic world.

COMPLEXITY AND VARIATION: LATE CLASSICISM

Phidias, the greatest Greek sculptor of Antiquity, was ultimately ill rewarded for his accomplishments. Many envied his friendship with Pericles and attempts were made to discredit him, and, by association, Pericles. According to Plutarch, a certain Menon, one of the sculptor's assistants, was bribed to accuse him of embezzling some of the gold intended for the chryselephantine statue of Athena. Fortunately, Phidias had taken the precaution of making the plates removable, and so all the gold could be dismantled and assayed. And so he could not be convicted of theft, but was nonetheless thrown in prison, where he succumbed to illness in 433 or 432 BC – unless, as some authors maintain, he was forced to take poison by enemies of Pericles hoping to lay the blame for his death at Pericles' door.

Two sculptors from Phidias's circle are known to posterity: Agoracritus from Paros, to whom the master granted the exceptional favour of attributing some of his own works, and Alcamenes, whom the Ancients ranked in the same league as Myron, Polyclitus and Praxiteles.

Alcamenes, a sculptor of immense talent, was the designer or inspirer of the famous caryatids at the Erechtheum built next to the Parthenon. Although they are columns and exude an impression of immutable and serene power, everything about these female figures is expressed in the language of curves: the bared shoulders, the breasts modelled by diaphanous tunics, the advancing leg appearing as smooth as if it were undraped. To increase their solidity, the artist gave them a thick head of long curly hair which falls on their shoulders somewhat in the manner of the Archaic *korai*. Unlike Phidias, who made a distinction between statuary and decorative sculpture, Alcamenes tended to obscure the boundaries between the two genres. His long drapery is a magnificent ornament for the bodies.

And yet, despite the great skill of Phidias's successors in reproducing the human figure – perhaps even because

of their virtuosity – their forms were lacking in vigour and nobility. This is definitely the case with Callimachus: his *Venus genetrix*, while perfect in purely formal terms, displays a certain preciosity in the way the flexible body is combined with the shifting drapery. Callimachus, a trained goldsmith, was also skilled in chasing metal. During the Late Classical period the imitation of nature permitted stronger expressive possibilities without detracting from the inherent stylistic value. With it appeared a new taste for pathos; that is, the portrayal of extreme states of human passion and pain.

Scopas of Paros, a tormented artist who proved his talent for architecture as well for monumental decoration and statuary, sculpted figures characterized by thick necks, prominent eyebrows and an anxious gaze that communicated deep emotion. One example is the Dresden *Maenad* , a copy of the famous original by Scopas which, despite its mediocre execution, represents the Dionysiac dance, whose frenzy induced ecstasy and oneness with the god.

However, Scopas's most important innovation was the elimination of the traditional poses and the invention of many new ones. In one of his most curious creations, now lost, a representation of Pothos, the brother of Eros and the personification of amorous longing, the facial features were taut with passion and the body, its head leaning to one side, almost unbalanced. Pothos, his legs crossed, rested his hands on a sceptre that may originally have been topped by an erotic emblem; at his feet was an allegorical goose that served to support the drapery falling from his arm and the sceptre, both at an angle but not parallel to the body. In other statues the support was either a tree or a small column. In each case the meaning was the same: those who allowed themselves to be thrown off balance by the violence of their passions were no longer human, in the Greek sense of the word. Once the Classical balance was broken, disaster followed.[6]

Unfortunately, there are no extant works by Euphranor, who, according to ancient sources, was one of the leading artists of the fourth century BC. We do know that he wrote a treatise on symmetry and form and created new figures, more slender than the Classical norm. Another great

Rotunda of the Shrine of Athena Pronaia

Around 380 BC.
Archaeological site of Delphi.

Opposite

Caryatid from the Erechtheum

Marble, h. 2.31 m. (7 $^1/_2$ ft.).
420-406 BC.
Acropolis, Athens.

Page 140

Wounded Amazon

Bas-relief from the altar of Artemis at Ephesus.
h. 65 cm. (26 in.).
Around 350 BC.
Kunsthistorisches Museum, Antikensammlung, Vienna.

Page 141

Maenad in frontal and profile views

Marble by Scopas.
370-330 BC.
Kunstsammlung, Dresden.

6. Jean Charbonneaux, *La sculpture grecque classique*, Lausanne 1942, vol. II, pp. 78-83.

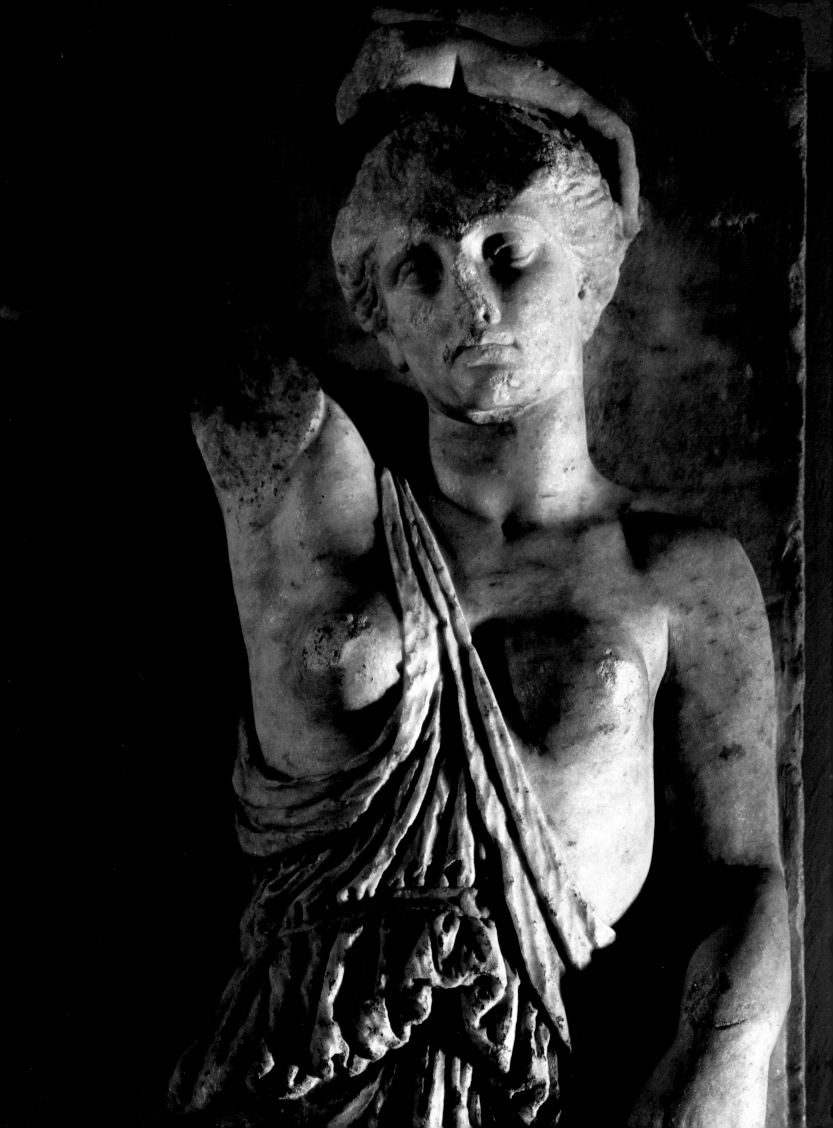

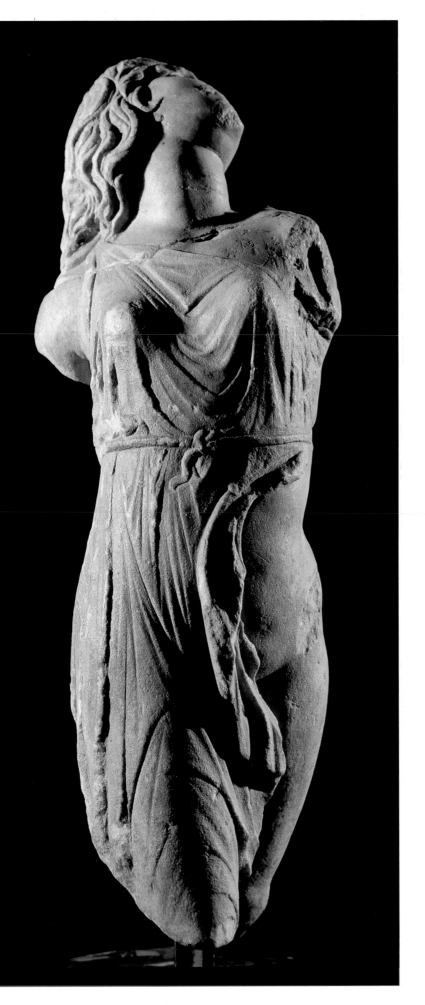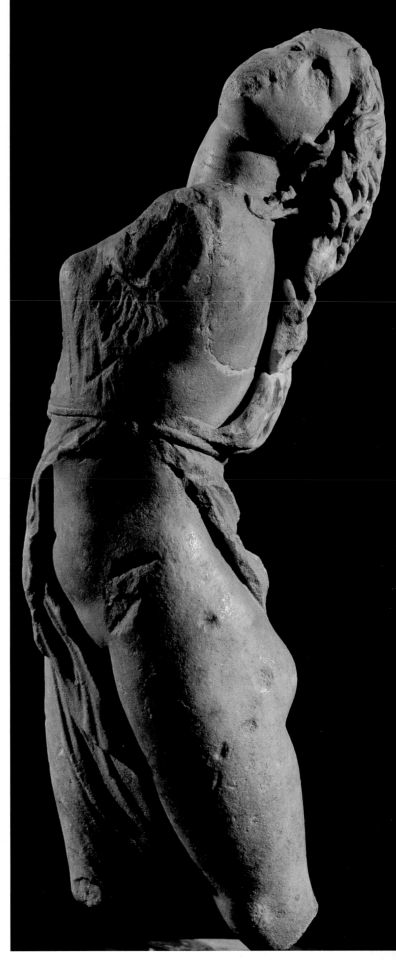

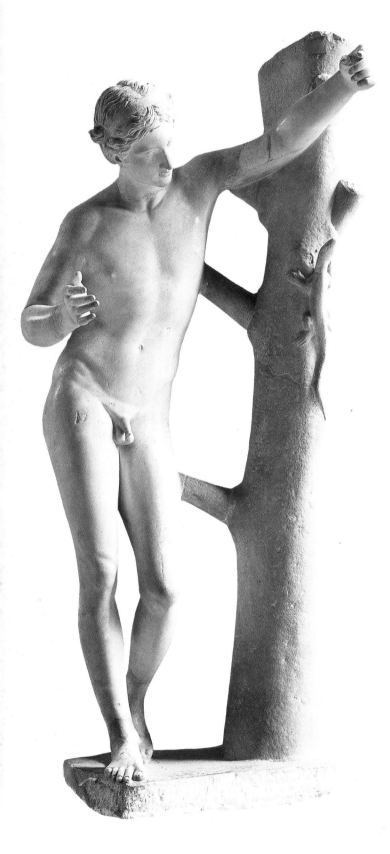

Apollo Sauroctonos

Marble, h. 1.49 cm. (5 ft.).
Ancient copy from an original by Praxiteles.
Fourth century BC.
Louvre Museum, Paris.

sculptor active in the third quarter of the fourth century BC, Lysippus of Sicyon, modified the canon established by Polyclitus. The human figure took on a slimmer and more ascetic aspect, making it seem more elongated: the head constituted only one eighth of the total height of the statues. The hair was also more finely executed. A good example is the *Apoxyomenos*, also known as the *Athlete with a Strigil*, who stretches out his right arm to scrape off it the mixture of dust of the *palaestra*.

This statue was certainly one of Lysippus's masterpieces but is known only from marble copies of the bronze original. With his expert calculation of the proportions he succeeded in creating a new feeling of elegance and symmetry. The *Apoxyomenos* has a vertical rhythm; the body's weight rests on the left leg, which is shifted slightly outwards from the knee, while the free leg moves to the side and the right foot is well behind the left. Both are turned outwards and set firmly on the ground to underscore the stability of the pose, in contrast to the flexible play of the arms. Seen from the side, the back is rounded, but not hunched, giving an impression of relaxation and informality. The face is sad, with eyes averted, staring into the distance. The hair is held by a ribbon and is made up of short locks. The *Apoxyomenos* has nothing in common with the *Doryphorus* – the break with Classicism is complete.

The *Apollo Sauroctonos* of Praxiteles, who is depicted leaning against a tree-trunk about to shoot an arrow at a lizard, despite a pronounced *contrapposto*, belongs to the same new physical type. The Ancients believed that lizards symbolized the evil spirits dwelling underground, and so Apollo's murderous gesture here would seem to have a religious significance. Even so, this composition with the god, tree and lizard only narrowly avoids lapsing into the picturesque.

Praxiteles was the son and grandson of sculptors. His career began in 370 BC, and there is every reason to believe that he was particularly precocious. A true disciple of the Attic tradition, before enthusiastically adopting the *contrapposto*, he began working according to the canon introduced by Polyclitus, as can be seen in his *Satyr Pouring Wine*, which was also originally cast in bronze. The barely pubescent adolescent stands in the pose of a cupbearer or athlete pouring oil; his left hand is held high above his head in order to pour the contents of an *oinochoé* into the cup held in his right hand. Unfortunately, the only marble copies that

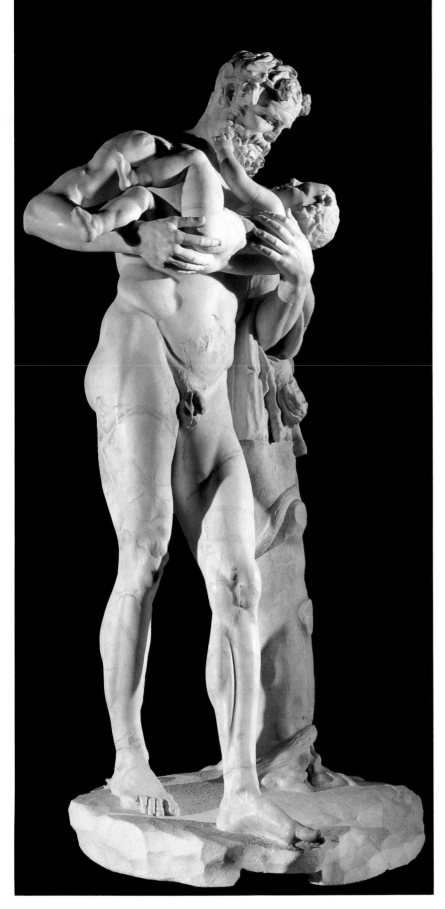

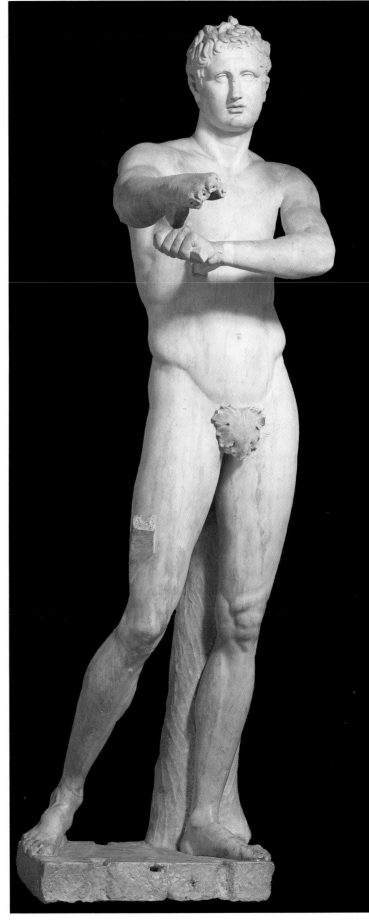

**Silenus
with the Infant Dionysus**

Marble, h. 1.90 m. (6 ft.). Hellenistic
copy after a Greek original from the
fourth century BC., found in Rome.
Louvre Museum, Paris.

Apoxyomenos

Copy after a bronze original
by Lysippus.
h. 2.05 m. (7ft.).
Around 330 BC.
Pio Clementino Museum, Vatican.

have survived are propped up by supports that spoil the aesthetic effect.

Praxiteles is known above all for his famous *Aphrodite of Cnidus*, a statue that was greatly admired throughout Antiquity and even as late as the Renaissance. Supposedly inspired by his beautiful and scandalous mistress, Phrynea, it was the first time that a female nude was celebrated in Greek sculpture. Until then, the female body had been revealed only indirectly, through a complicated play of drapery and pose. As many authors have remarked, the Cnidian Aphrodite is an example of female beauty brought to its most seductive peak of perfection: the softly contoured shoulders and breasts, the masterfully-rendered curves of the back, the flowing lines of the hips and sides, the delightful roundness of the thighs, the three gentle folds in the neck commonly known as "Venus's necklace." It truly deserves Henri Lechat's appreciation of it as "a body in the spring of life."[7]

It must be said that, some time before Praxiteles, during the transition period between the fifth and fourth centuries BC, the sculptor Timotheus had executed a statue of *Leda and the Swan* in which Leda revealed many of her charms by throwing off her drapery in a very theatrical gesture. The Greeks had always preferred male to female nudity; the Athenians, especially, were somewhat prudish as far as the female body was concerned. They were shocked by the open tunics of the young Spartan women, which they said "exposed everything between their thighs and their armpits" when they ran. However, during the fourth century tastes changed. The beauty of the female form in the *Aphrodite of Cnidus* is of an incomparable fullness; she is a voluptuous being in a marble body, just like Phidias's muscular *Cephisus* from the West pediment of the Parthenon.

Praxiteles was also a contemporary of the philosopher Plato; the Academy was the leading intellectual centre in Greece during the Late Classical period. For Plato physical beauty was not the result of skill, but above all the emanation of a *purifying harmony*. Praxiteles was a platonist insofar as his statues derived from an ideally recreated world of appearances. His works brought the philosopher's world of Ideas within reach of the bodily senses.

7. Henri Lechat, *La sculpture grecque*, Paris 1922, p. 117.

144

Leda and the Swan

Ancient copy
from an original
by Timotheus.
First half of the fifth
century BC.
Capitoline Museum,
Rome.

Opposite

The "Venus of Arles"

Roman marble copy
found in the
amphitheatre at Arles.
Copy of an original by
Praxiteles from 360 BC.
Louvre Museum, Paris.

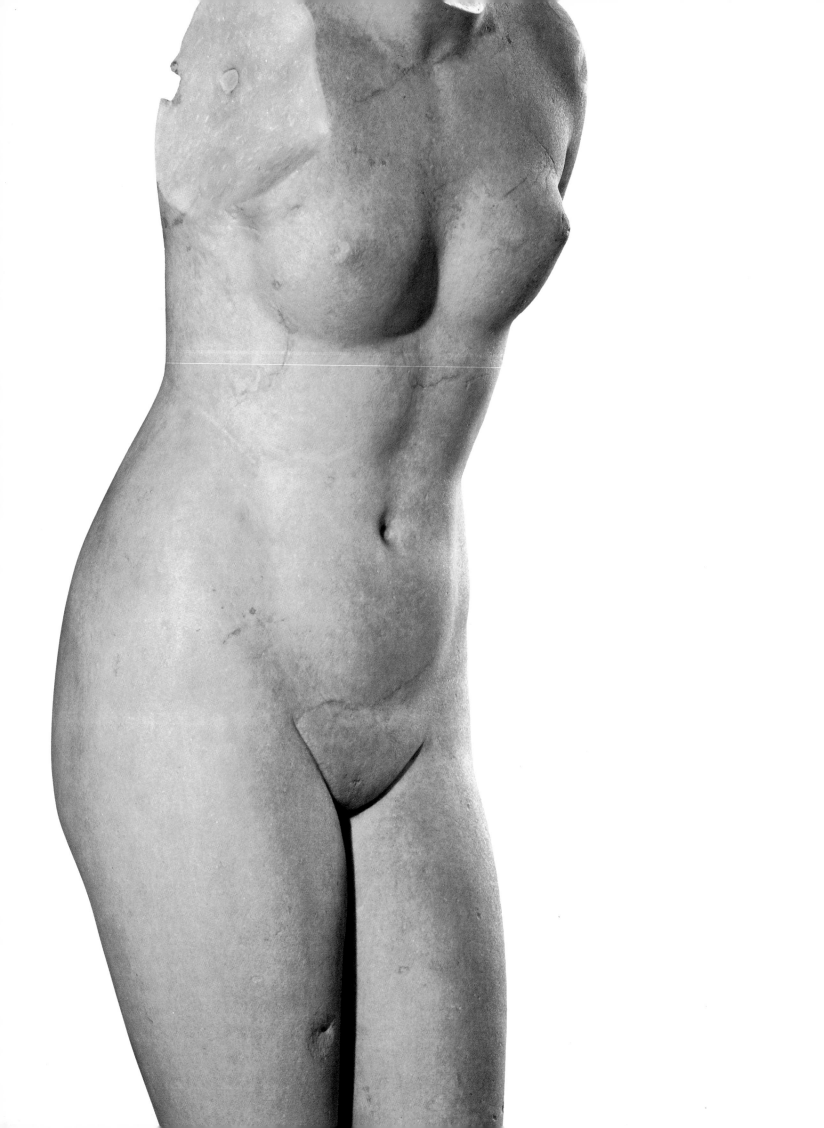

The history of Greek sculpture is not just the progress – however apparent – of naturalism, but rather the visible expression of a faith. As the eminent archaeologist Charles Picard concluded: "Making remarkable progress, the Archaic sculptors patiently re-modelled the nude form of the standing Apollo, the proud and vigorous symbol of the youth of the male gods. In Ionia, they created with equal success the draped female figure, the modest *kore*, a model of strength and grace, worthy heiress to the eternal nobility of the "white-limbed" Olympian goddesses. Then came the great era when Zeus and Athena, divinities of the upper regions, were made larger, represented alone or in groups, and given their rightful places on the sacred grounds of the Acropolis, endowed, thanks to Phidias, with their most stately, eternal aspect. In this generation-long quest for beauty and emulation among artists, after Phidias, it was

Aphrodite of Cnidus

Marble, h. 1.22 m. (4 ft.).
Ancient copy after the original by Praxiteles from 350 BC.
Louvre Museum, Paris.

Below

Back view of the Aphrodite of Cnidus.

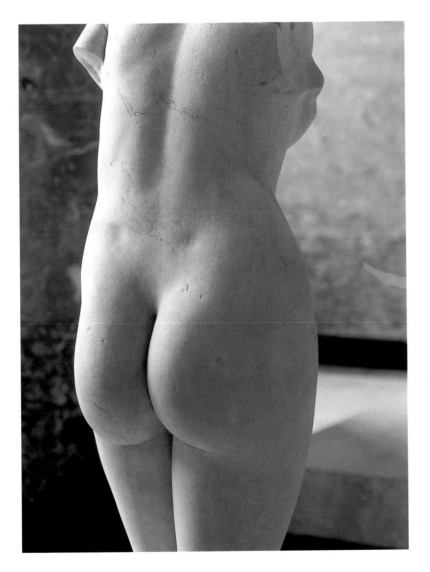

147

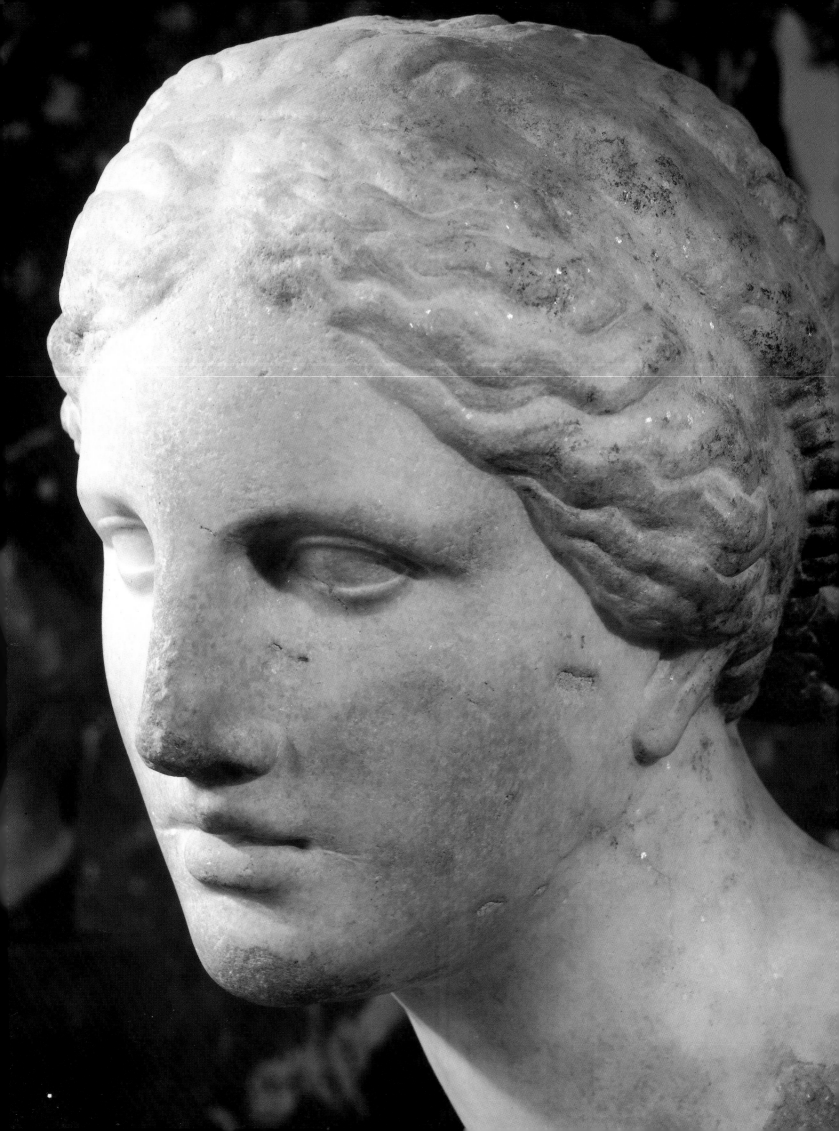

Praxiteles who succeeded in giving the most novel personality – a more nonchalant one, this time, more accessible and altruistic – to certain Images of the Olympian host."[8]

The *Aphrodite of Cnidus* is a goddess. She embodies the discipline of the instincts and the nobility of love, two prerequisites for eternity. When the pilgrims who had come to Cnidus to admire her finally discovered her in her *monopteros* framed by cypress and plane trees, they experienced something that we can scarcely imagine today – a true religious experience.

CLASSICAL PAINTING: THE GRAPES OF ZEUXIS

The famous duel between the painters Zeuxis of Heraclea and Parrhasius of Ephesus is recorded in a classic anecdote: "Parrhasius once challenged Zeuxis to an artistic duel to see who could paint with the most verisimilitude. Zeuxis executed a still life with grapes painted so realistically that birds came to peck at them. Parrhasius's picture, on the other hand, showed only a curtain, which Zeuxis, confident of victory because of the birds' mistake, asked him to draw aside. Only then did he realize his mistake. He openly and modestly conceded defeat, saying that, whereas he had only fooled the birds, Parrhasius had succeeded in fooling him, a painter."

Zeuxis, active around 400 BC was counted among the artists most worthy of admiration, along with Homer for the epic, Sophocles for tragedy, and Phidias for sculpture. His production was considerable, his most famous work being a picture of Helen painted for the Temple of Hera Lacinia at Croton. Legend has it that when he once wanted to paint a masterpiece of ideal feminine beauty, he selected five virgins as models and took from each her best features, for it was believed that nature always left some imperfection even in those it favoured most. Other works depicted *Zeus on His Throne and Heracles in His Crib*; the latter, though still only a babe, is shown throttling huge serpents with his bare hands. Another of Zeuxis's famous works showed *Eros Crowned with Roses*.

Zeuxis was particularly fond of sentimental subjects, which he treated, as far as we can tell, with grace and light-

8. Charles Picard, *Manuel d'archéologie grecque*, Paris 1939-1966, vol. V, pp. 408 et 409.

Opposite

Aphrodite, the "Kaufmann Head"

Marble, h. 35 cm. (14 in.).
Best-known third-century BC copy
of the Aphrodite by Praxiteles.
Louvre Museum, Paris.

Page 150

Attic White-Ground Lekythos

Funerary scene by the Master of the Reeds.
Around 430 BC.
National Archaeological Museum, Athens.

Page 151

White-Ground Lecythus

Detail: Heracles fighting the Hydra of Lerne.
h. 22 cm. (9 in.).
500-480 BC.
Louvre Museum, Paris.

ness. He became fabulously wealthy and was in the habit of giving away his pictures, saying that no price was high enough to do them justice. To spread his fame even more, he paraded at the Olympic Games wearing a cloak embroidered with his name.

No less important in the history of Greek painting were two earlier masters of the First Attic school between 480 and 420 BC, Polygnotus and Agatharchus. Polygnotus invented a new manner of suggesting depth by superimposing many different figures in large compositions such as *The Capture of Troy*. He also introduced landscape elements by depicting a tree, a stream or a pebbled seashore. Agatharchus, on the other hand, was nicknamed "the Scenograph" because he was the first scene-painter. He had a highly developed sense of perspective, and, according to Vitruvius, wrote a theoretical treatise on the subject. His reputation was so great that Alcibiades ordered him to decorate the interior of his house, threatening him with prison if he did not start work promptly. Another painter, Apollodorus, was the first to mix colours and to graduate light and shade in his pictures.

For the Ancients, however, the greatest painter of all was Apelles. Born around 380 BC, he was active at the court of Alexander the Great, who decreed that no other artist was to paint him. His legendary masterpiece was an *Aphrodite Anadyomene*, the model for which was either a certain Pankaspe, one of the Persian emperor's concubines, or Phrynea, Praxiteles's notorious mistress. The picture showed the goddess of beauty rising out of the water from which she was born, still shimmering with sea-foam and wringing the salty water out of her hair. It is said that "every line was alive... as in all the works from the hand of this Ephesian painter."

Several years ago, at the site of Paestum, once part of Magna Graecia (Greater Greece), the excavation of a tomb revealed frescoes displaying a remarkable expressive power. And yet these scenes painted in flat colours in no way corresponded to the great paintings described by the authors of Antiquity. In addition, the Roman copies of these paintings displayed such profound stylistic modifications that, except for the subject-matter, nothing, or next to nothing, remained of the originals. For this reason, and despite the inevitable disparities resulting from the differences between the two mediums, we must again turn to the contemporary pictorial record of ceramics to get a better idea of the art of painting during the Classical period.

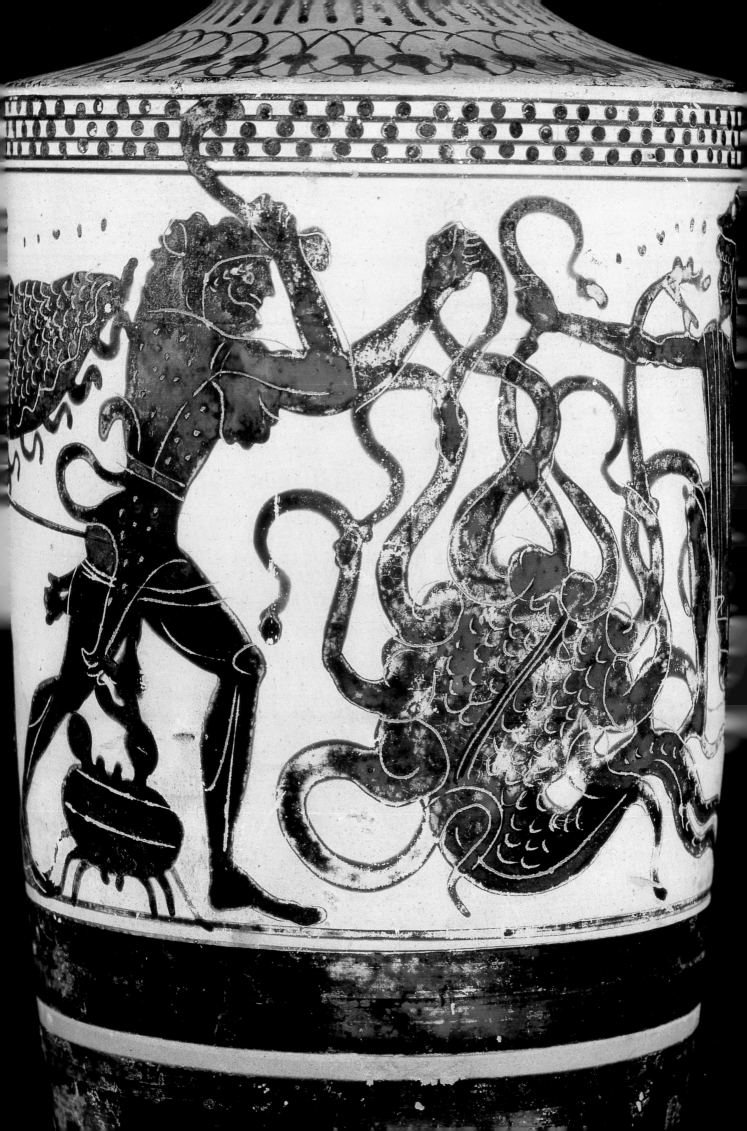

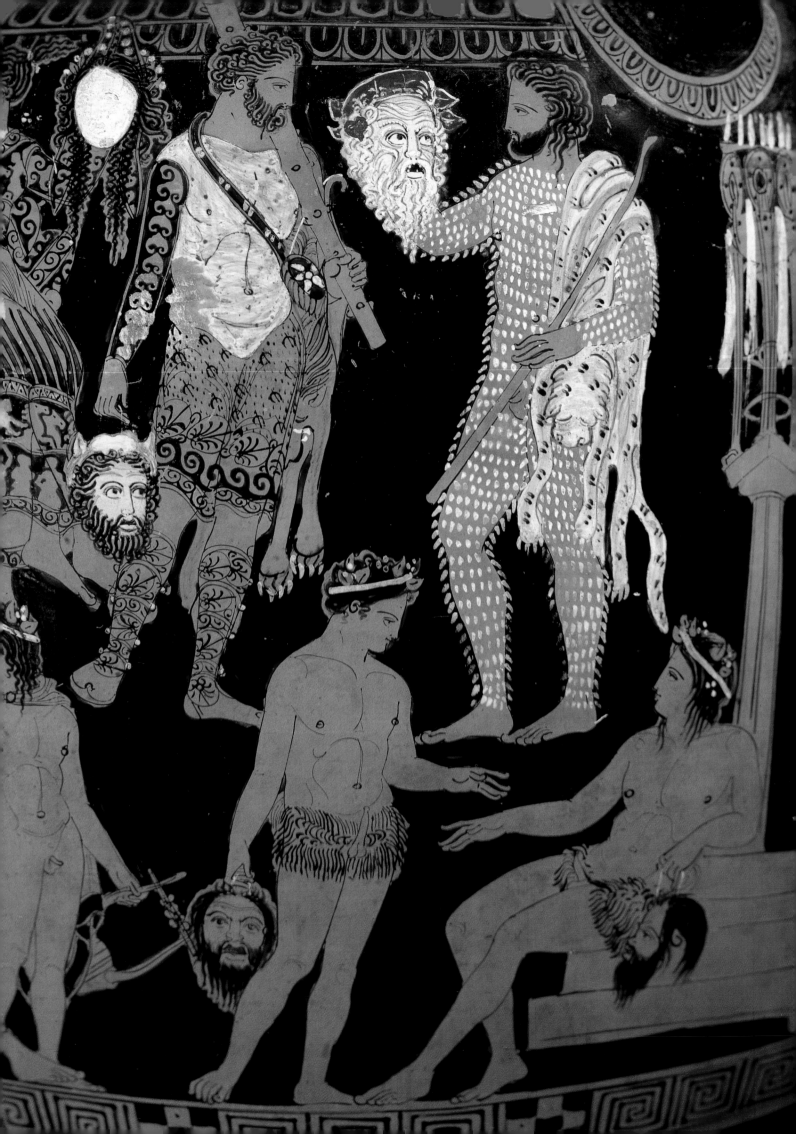

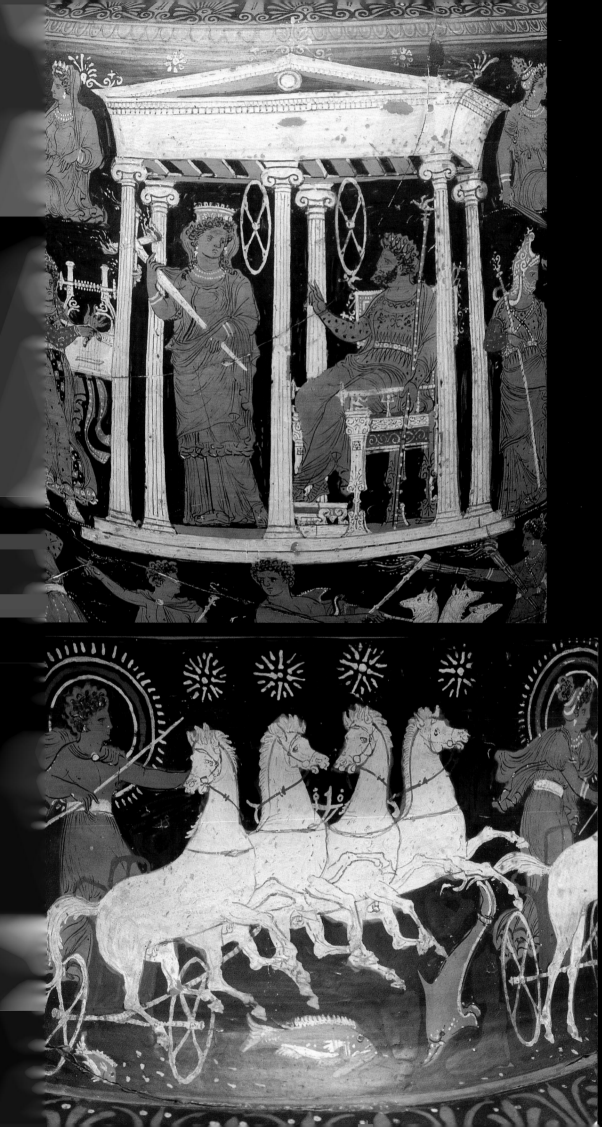

Monumental Vase

Found at Canossa, Italy.
330 BC.
Antikensammlung, Munich.

Above

Detail: Hades and Persephone in their underground palace.

Below

Detail: Helios in his chariot.

Opposite

Crater from Ruvo

Detail: Preparations for a satyric drama. Attributed to the Pronomos Painter. h. 75 cm. (29 in.). Around 410 BC. Archaeological Museum, Naples.

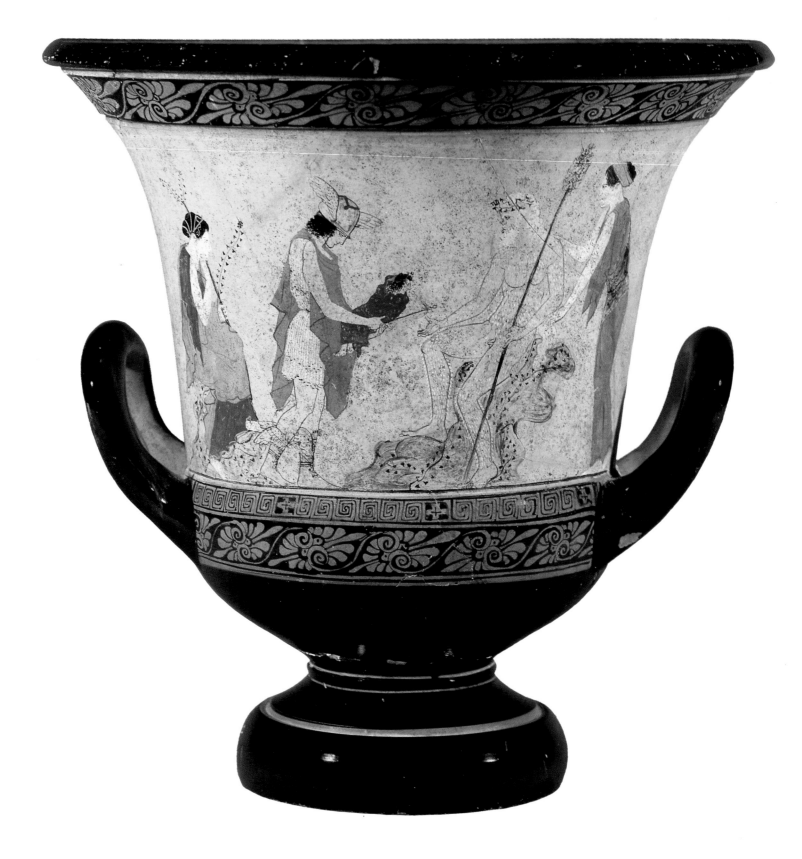

The best examples for this purpose are probably the medium-height *lekythoi*, special vases that contained scented oils used only for funeral rites. As in the wall-paintings, the figures stand out against a plain white background and, like them, are very lifelike. There is something quite new about the way in which they have been drawn: in profiles the eye is no longer depicted frontally but in profile. There are also figures in three-quarter view and boldly foreshortened. Finally, the artist visibly strove to create expressive poses and gestures to suggest emotion. In such works as *Hermes Greeting a Dead Woman in front of Her Tomb*, by the Phial Painter, and the *Dead Woman in front of a Stele*, by the Reed Painter, in which the faded colours accentuate the linearity of the figures, we can see from the shading of certain colours and the harmony of the colour-schemes that these works belong more to the realm of painting than that of pottery.

A work such as the *crater* depicting *The Massacre of the Niobids* presents numerous elements that bear little relation to the traditional art of ceramics: for example, large groups of figures superimposed in several planes and registers, or an irregular ground made up of lines that represent rocks, and a tree in the background to denote a landscape. The striking thing about these figures – apart from their theatricality, another aspect derived from classical painting – is their incongruous monumentality compared to the size of the *crater*, as if too many heroes had been crowded in too narrow a space.

According to eminent specialists such as François Villard and John Boardman, such defects might explain why similar efforts were gradually abandoned in the Attica and the South Italian workshops in favour of more domestic subjects, a tendency that was linked to the changing status of women in Greek society and the future art of the fourth century BC. "Soon, the toilette of the Athenian woman, and even her gestures while bathing, would have no more secrets for us. We see, among other things, a flock of tiny cupids busily adjusting a veil or holding a mirror. Dionysus himself has become an un-bearded, effeminate youth, while his maenads have been transformed into well-behaved dancing-girls, and his satyrs into elegant ballroom dancers."[9] Costumes were decorated with rich embroideries and bodies adorned with all sorts of

White-Ground Calyx-Crater
Hermes entrusts Dionysus to the Nymphs of Nysa. Attributed to the Master of the Phial. h. 35 cm. (14 in.).
Around 440 BC.
Museo Etrusco Gregoriano, Vatican.

9. John Boardmann, *Greek Art and Architecture*, New York 1967.

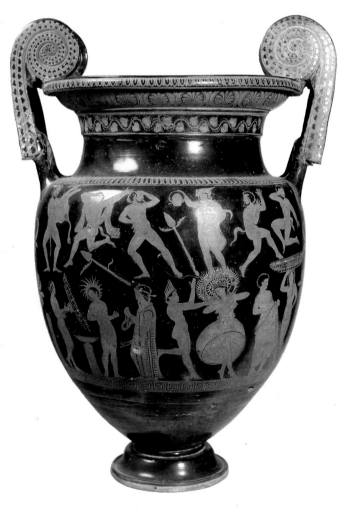

jewels: diadems, necklaces, bracelets, often represented in relief by a gilded paste. These were the beginnings of what has been called the Florid Style.

At the same time, the ceramists continued to be concerned with the problems of classical painting, and most of all, with those involving perspective. In his depiction of *Ajax Assaulting Cassandra*, the so-called Lycurgus Painter situated the action in a small open building constructed – awkwardly still – according to the principles of perspective, offering a view of the interior space with the beams clearly shown in foreshortening. Similarly, in the central motif of *Patroclus on His Funeral Pyre,* a work attributed to the Darius Painter, the funeral pyre is shown in perspective and the logs with a corresponding oval section. Another foreshortening effect may be seen in the representation of Athena's two horses in *The Meeting of Heracles and Cycnus*, which, according to John Boardman, alludes to Pliny's description of a painting by Pausias depicting the sacrifice of oxen. In Pliny's words: "Although he wanted to show the length of the ox, he painted it seen not from the side, but from the front, yet the animal's length is easy to grasp."

This was in fact not a frontal representation, as on some Archaic vases, but an instance of true foreshortening. To be sure, the perspective effects devised by the ceramists were only partial and still somewhat precarious, if only because of the limitations imposed by the curvature of the vases, but they attest to a general modification of the Greek way of seeing.

Crater with Volutes

Attributed to the Karneia Painter.
Around 410 BC.
Archaeological Museum, Tarentum.

Opposite

Detail showing dancer during the Tarentine feasts.

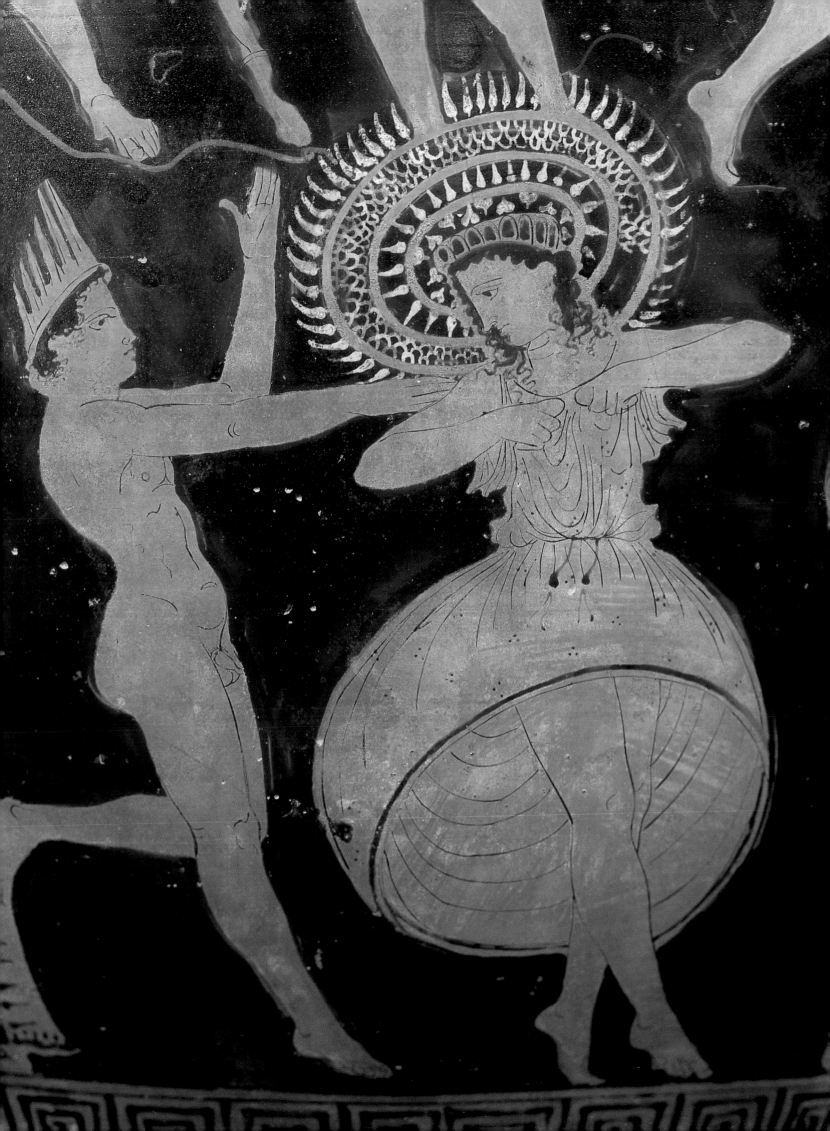

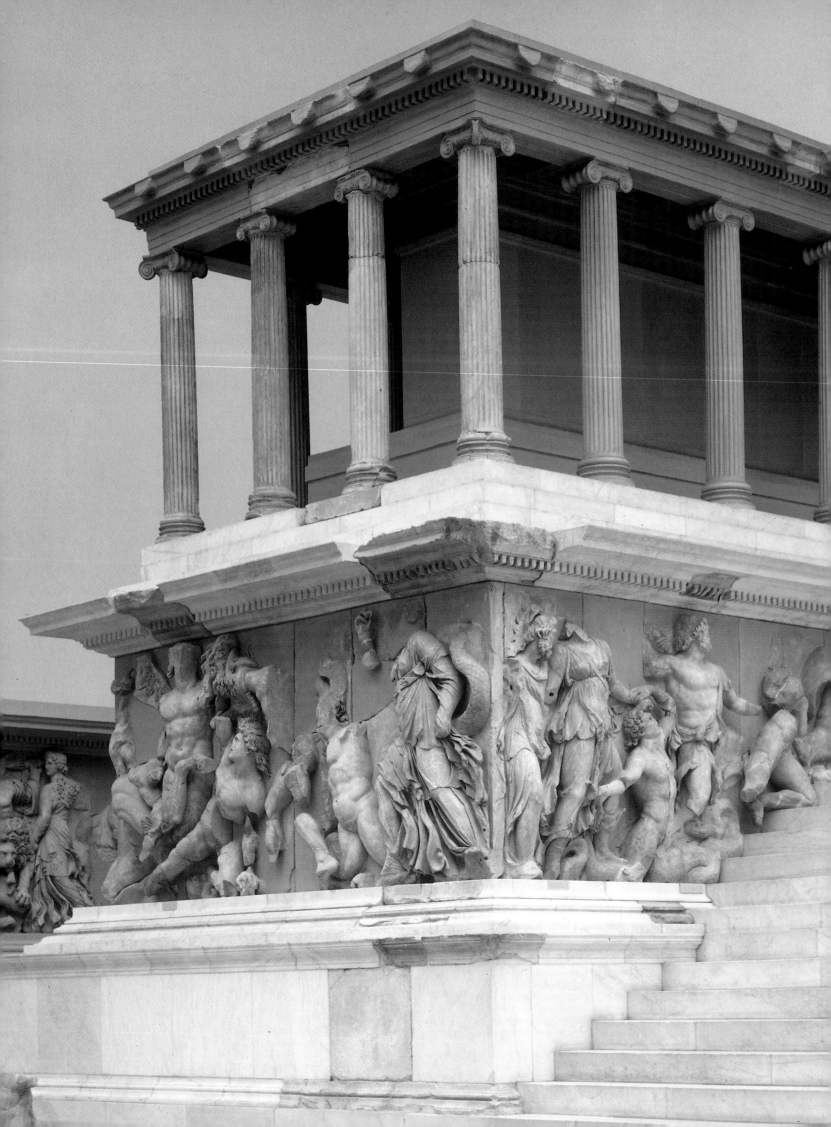

4. HELLENISTIC ART

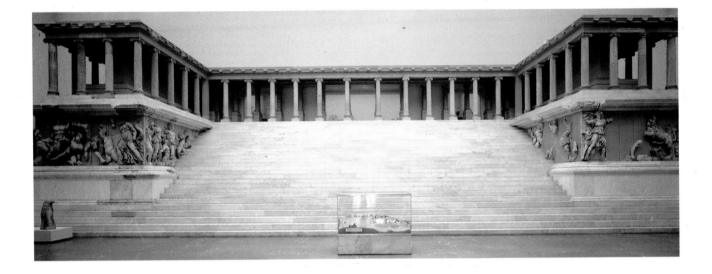

PERGAMON: THE GIGANTOMACHY

The rise of Hellenistic art was favoured by the establishment of a large number of small kingdoms in Asia Minor from the ruins of Alexander the Great's empire after his death in 323 BC. Greece itself was in full crisis, with commerce and industry steadily on the decline. While in Greek cities there were civic assemblies to discuss projects, weigh common needs and husband the public treasury, in the new kingdoms of Asia Minor the sovereigns could lavish large sums unimpeded on erecting monuments to display their power or otherwise celebrate their personal glory.

The most creative Hellenistic kingdom in the realm of the arts was that of the Attalids with its capital at Pergamon. This kingdom developed out of the betrayal of a Greek officer, Philetairos, who defected to the side of Seleucus I in 282 BC. The latter ruled over a territory that stretched as far as present-day Afghanistan, and it was further expanded during the next century by Attalus I, who defeated the Galatians, took on the title of king and wisely concluded an

The Great Altar of Zeus

General view. Built by Eumenes II around 180 BC.
Frieze on the pedestal: Gigantomachy.
Platform frieze: the Myth of Telephus.
Scale model of Pergamon in the central display-case.
Staatliche Museum, Pergamonmuseum, Berlin.

Opposite

Pedestal frieze, North side.
Staatliche Museum, Pergamonmuseum, Berlin.

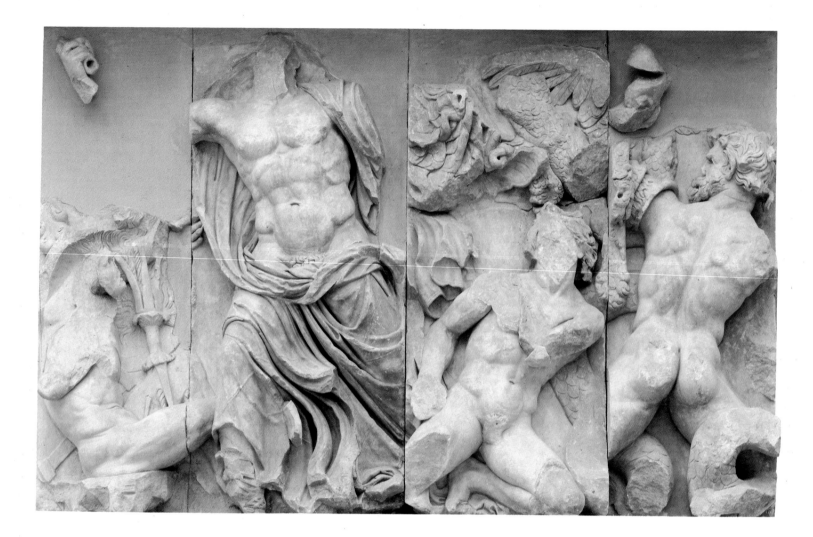

Great Altar of Zeus

Pedestal frieze, detail: Zeus and Porphyrion during the Battle with the Giants.

Opposite

Pedestal frieze, detail: Athena fighting with the son of Gaea, the Earth-Goddess, who rises from the ground and reaches out to her son.

alliance with Rome. Pergamon was located in the province of Mysia in northwest Asia Minor, thirty kilometres inland from the coast facing the island of Lesbos. It was situated on a rocky spur and particularly difficult to develop because of the uneven terrain. The Pergamene architects solved the problem by building the city on three different levels forming a series of monumental masses that harmonized perfectly with the site and its dark obsidian rock. The third and lowest level, spreading fan-like at the foot of the promontory with an amphitheatre at its focus, offered an especially spectacular sight.

The ambition of the Attalids was to create a new Athens and although their rule was relatively short-lived – only a century and a half – their efforts were not without result. The library at Pergamon boasted two hundred thousand volumes and rivalled Alexandria's; its memory is preserved in the word "parchment," derived from *Pergamena charta*.

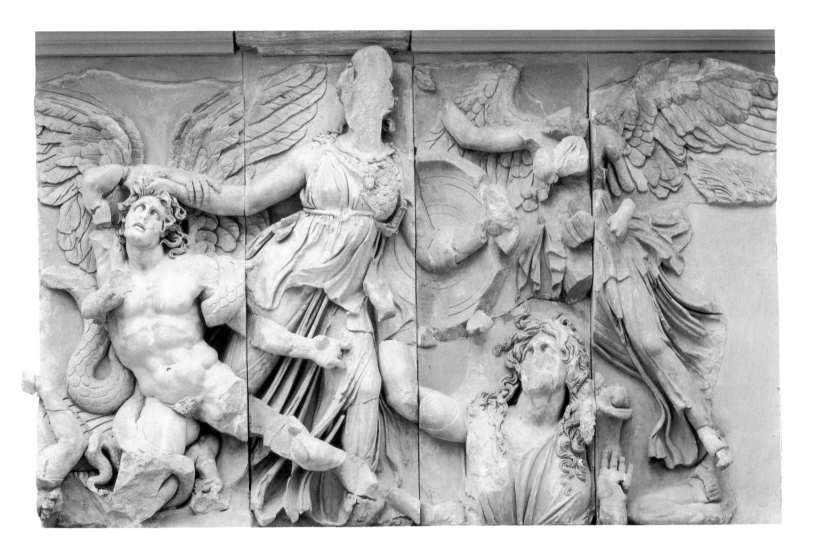

The king's palace housed a veritable museum, while the fame of the city's school of rhetoric and its sculpture workshops was well deserved; and its actors, working under royal patronage, brought the dramatic arts to unprecedented heights of excellence. Its major achievement, in the eye of posterity, however, is the colossal frieze that covered the base of the Great Altar of Zeus. With its swirling, dynamic compositions and dramatically contorted figures, it is a perfect demonstration of the spirit of Hellenistic art.

Discovered by the German engineer and archaeologist Carl Humann at the end of the nineteenth century, the Altar of Zeus was transferred to Berlin and housed in a specially-built room of the Pergamon Museum. The altar itself, which stands on a raised platform, is surrounded on three sides by a wall and an external colonnade which extends into two wings that frame the broad stairway. The famous frieze around its pedestal is one hundred and twenty metres long

Great Altar of Zeus

Pedestal frieze, detail: the Lion-goddess
fighting a Giant.

Opposite

Detail: a dying Giant thrusts his sword
into a lion's side.

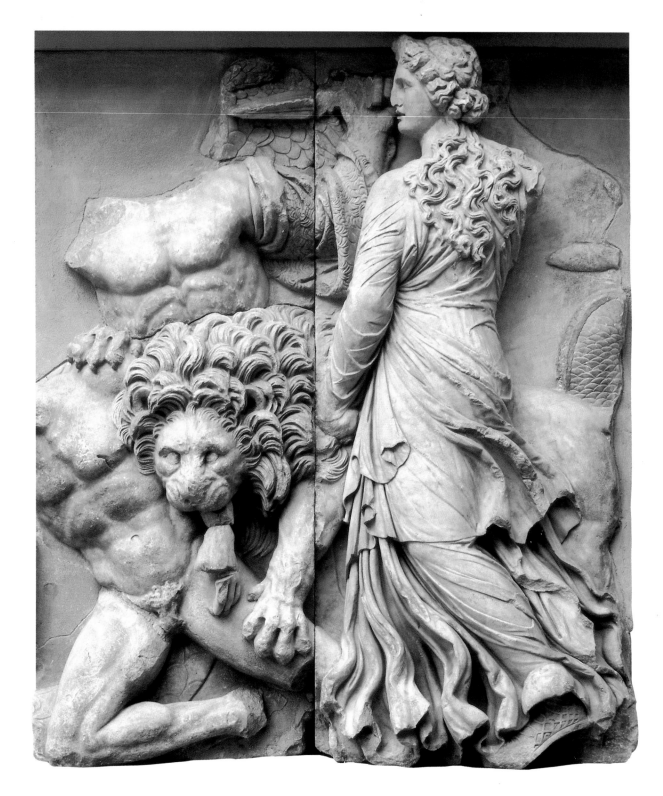

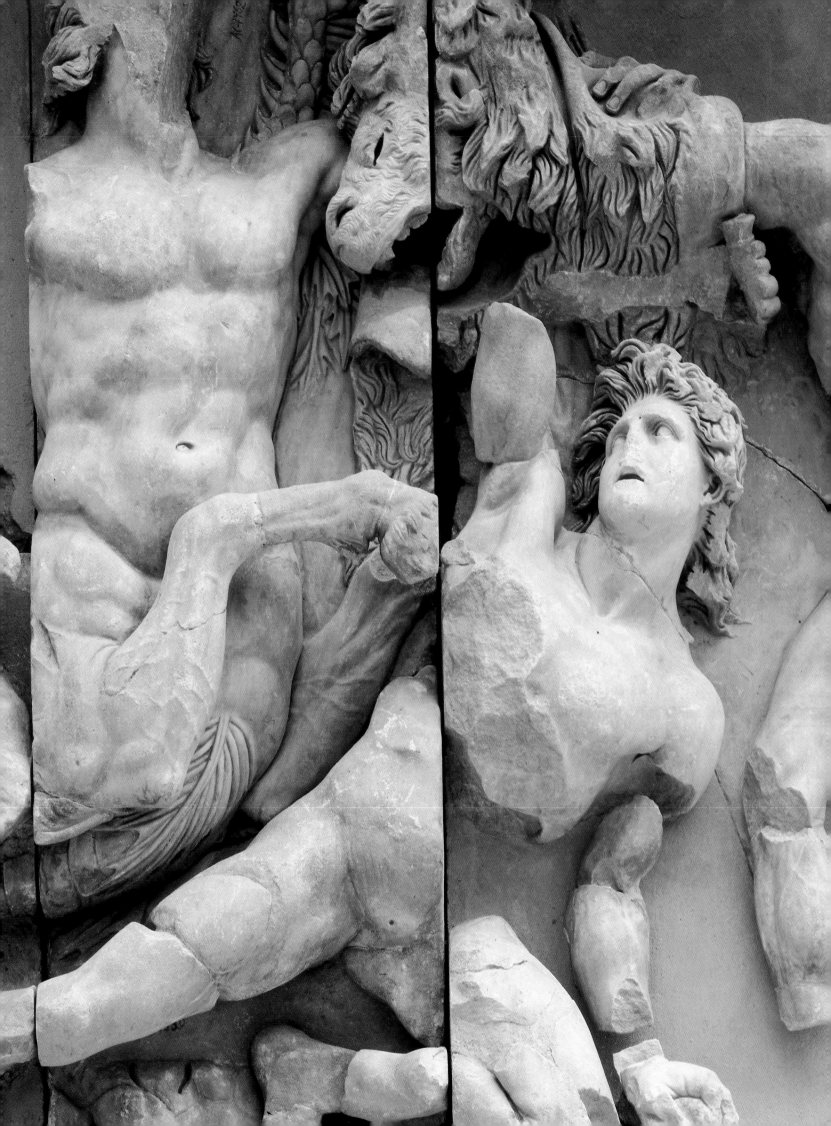

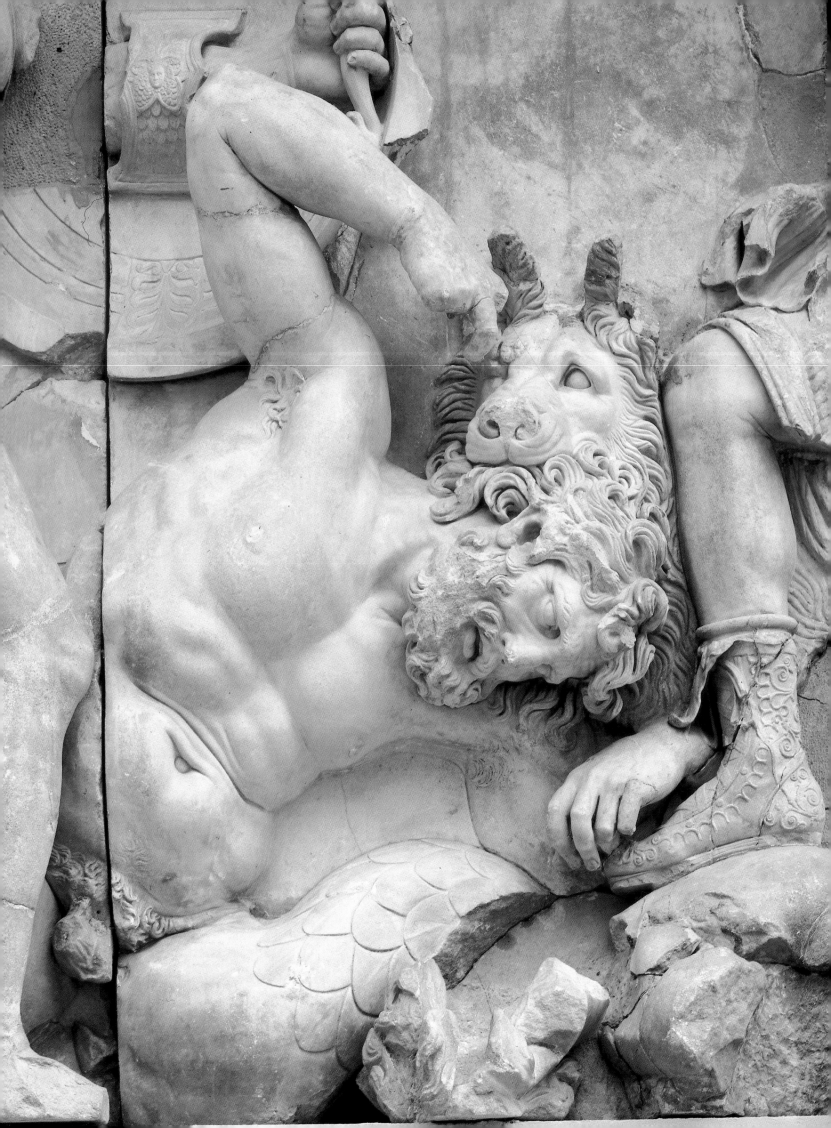

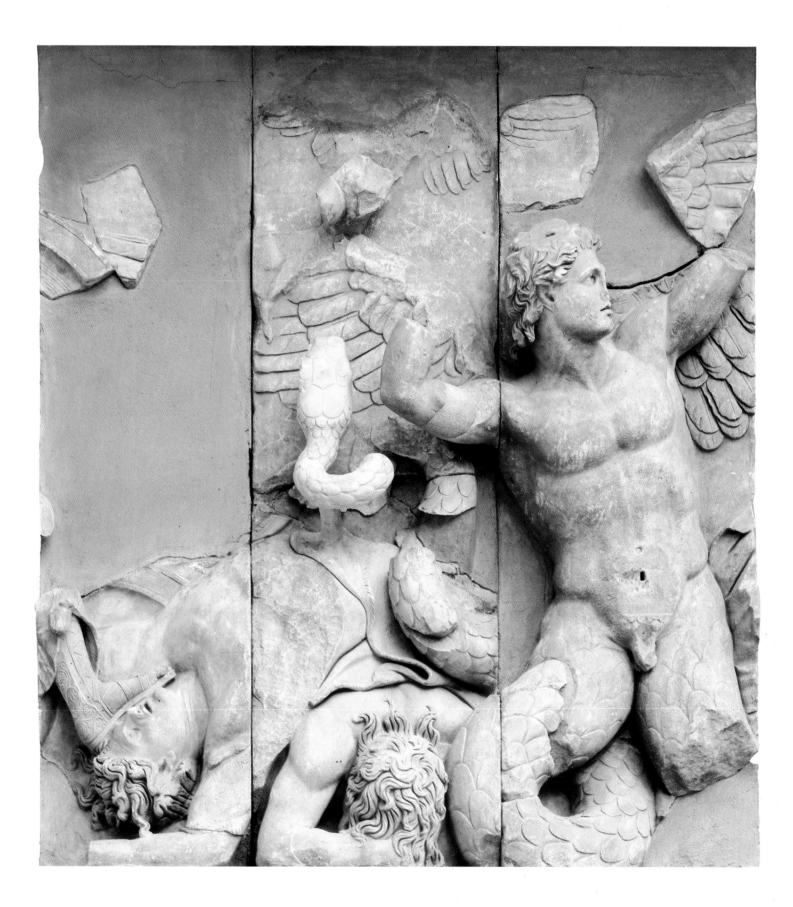

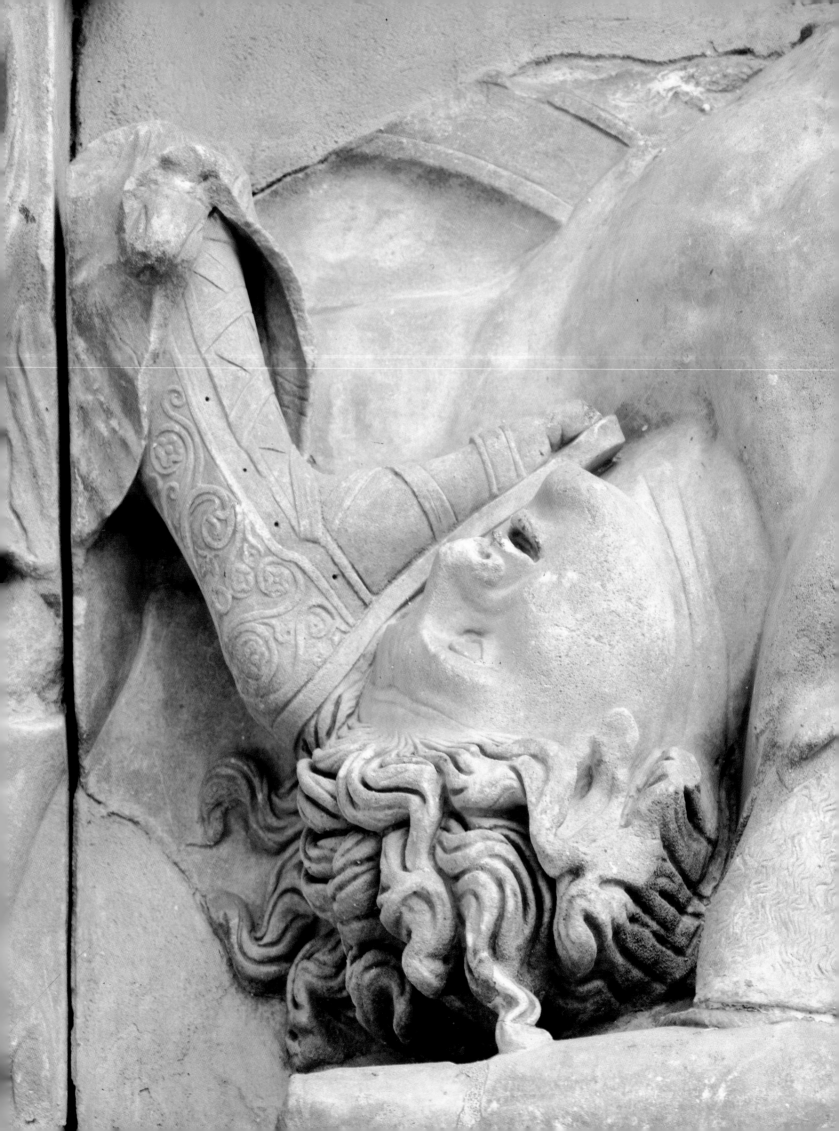

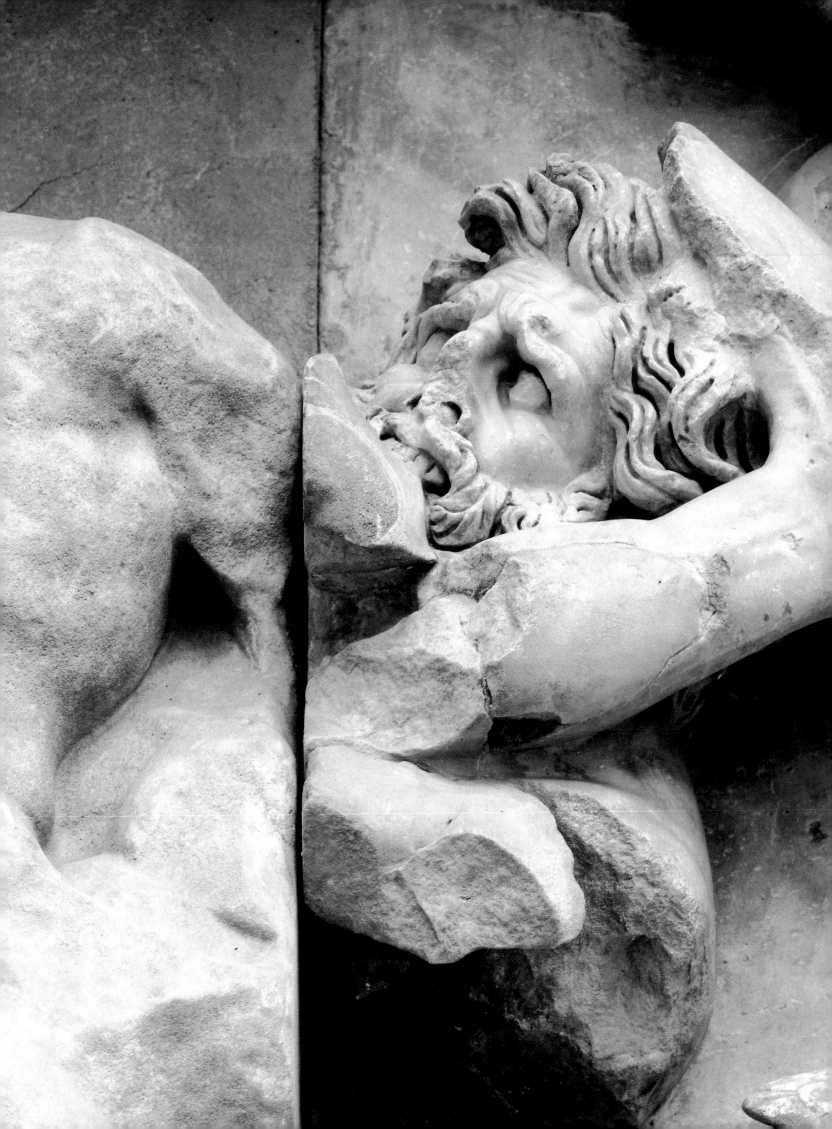

Great Altar of Zeus

and a little over two metres high; it is decorated with scenes illustrating the Battle of the Gods and Giants.

According to Jean Charbonneaux[1], the subject-matter of the frieze was an obvious allusion to the victory of the Attalids over the Galatians, but it was also connected to a long tradition, for it took up one of the most glorious episodes in Greek mythology. The legend relates how the twenty-four Giants, furious when confined to Hell by Zeus, mounted an all-out assault on the Olympian heights, hurling boulders and flaming oak-trees, only to suffer a crushing defeat. In keeping with the wishes of King Eumenos II, who commissioned the altar, the mythic cycle executed by the Pergamene sculptors included the figure of Athena, the patron-goddess of both Athens and Pergamon.

The frieze presents a monstrous spectacle indeed, with the human form displaying the most bizarre metamorphoses: Giants with the heads and claws of wild beasts, legs that become snakes, bodies covered with scales, heads with bulls' horns and gaping jaws. The gods themselves are all draped and some have wings. This curious mix of human and animal figures is further confused by the presence of lions, horses and dogs assisting the Olympian gods. The goddesses, represented with a great variety of drapery and hairstyles, hurl themselves into the fray with the same vigour, ferocity and deadly effect as their male companions. Male and female figures are represented on the same scale.

In this monumental work and in the free-standing groups of the late third century BC, we can observe the progress in anatomical knowledge achieved through the dissections conducted by the physicians Herophilus and Eristratus. It is thanks to their dedicated efforts that the male nude could be represented here with such analytic precision, such supple movements and so perfect a play of surfaces carved in high relief. This, despite the somewhat excessive virtuosity in which the sculptors sometimes indulged. This virtuosity, however, does not prevent us from discerning in the works of these many artists of unequal talent the whole history of Hellenism. The entire frieze is a long series of rhythmic oppositions between individual figures, converging and diverging diagonals, movements of advance and retreat, suspended in space

1. Jean Charbonneaux, Roland Martin, François Villard, *Grèce hellénistique*, Paris 1970, pp. 265-286.

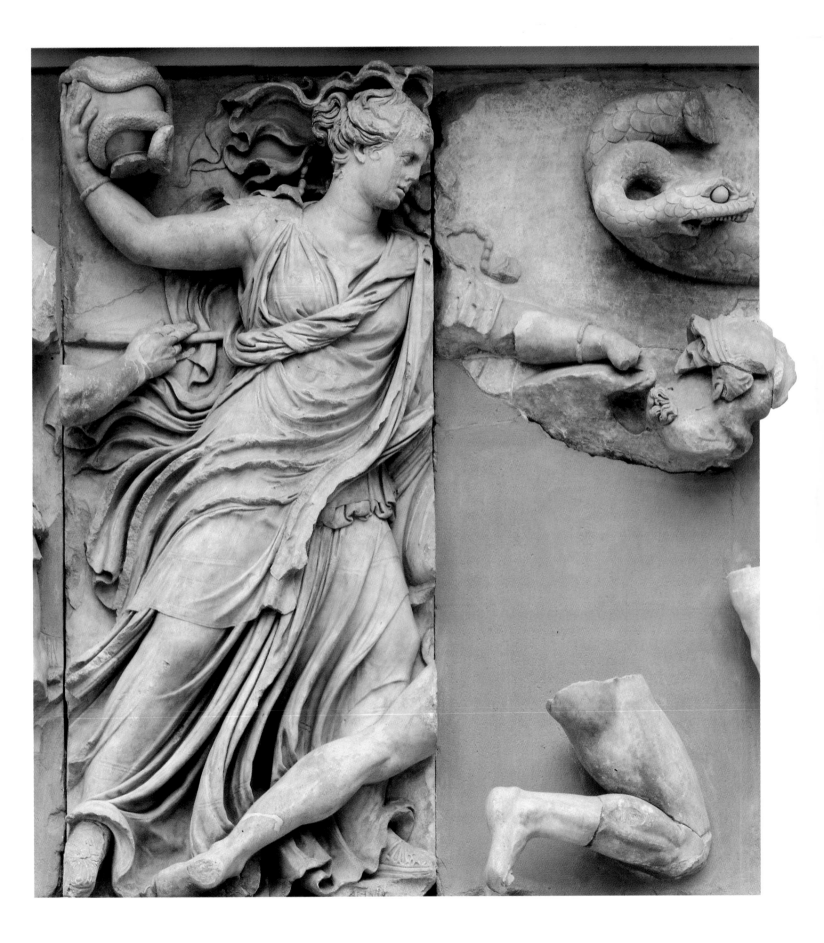

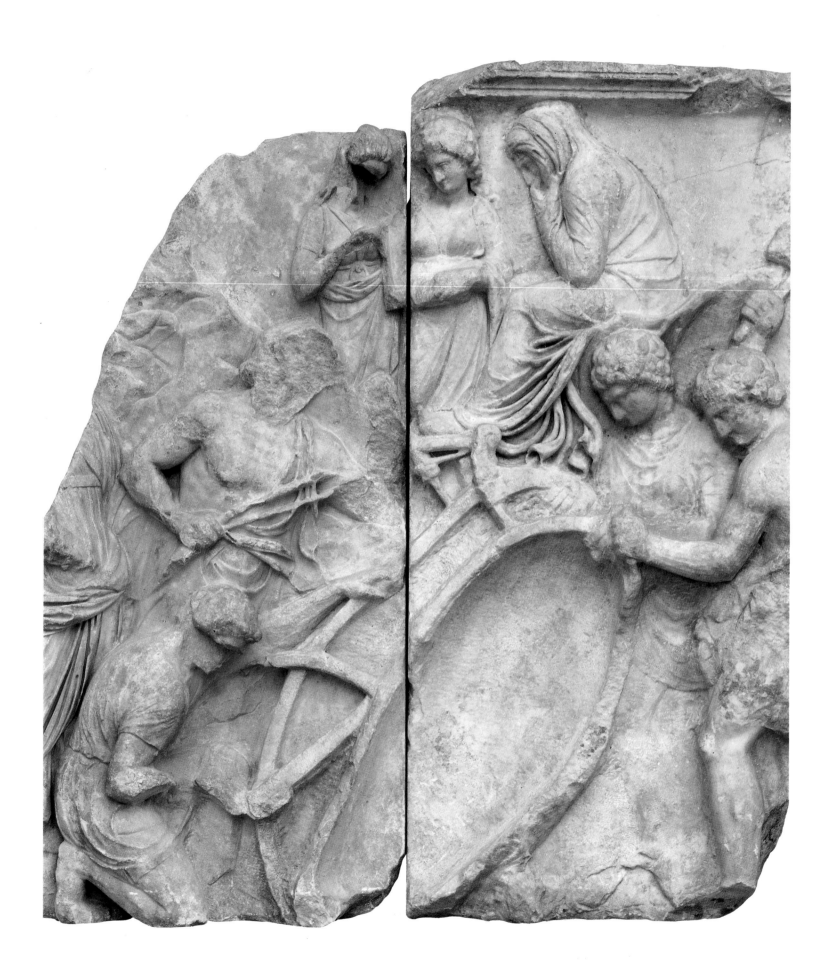

here and there by a broad gesture. This superb and powerful work gives the lie to the reproach of theatricality that has often been levelled at Hellenistic art. If anything, it displays more of an epic sense that makes it a distant ancestor of Rude's *La Marseillaise*, sculpted on the Arc de Triomphe in Paris two thousand years later, although the French artist certainly had no prior knowledge of this frieze.

At the back of the portico which frames the upper platform of the altar on three sides, there is a smaller frieze executed in quite a different manner. It depicts the myth of Telephus, a son of Heracles, who was miraculously transported from Arcadia to Mysia, where he became king. By associating his own dynasty with that of Telephus, Eumenos was claiming that he was descended from the gods, for Heracles was the son of Zeus.

The upper frieze presents a chronicle in a series of scenes separated by such devices as a tree, a column, or even two figures placed back to back. According to Jean Charbonneaux, this peculiar disposition was a radical departure from the traditional differentiation of painting and sculpture. These bas-reliefs were not only painted, as were so many Greek sculptures, but composed according to specifically pictorial principles, inasmuch as colour, and not volume, was the overriding consideration. But because the pigments have long since disappeared, we can no longer judge its original aesthetic qualities.

There is, however, spontaneity and variety: each figure has the attitude and gestures that correspond to their actions and sentiments, or social rank. To quote Charbonneaux once more: "The newly-rediscovered epic mode replaces the tragic one: but it is an anecdotal and familiar epic, completely in line with the spirit of alexandrine poetry, such as we know it from the works of Theocritus and Callimachus. It is a romanesque epic with episodes involving oracular predictions, unexpected meetings and predictable recognitions, and the spectator is left in suspense until the very last moment. In this frieze, as in the related poems, the legend takes on the colours and appearances of everyday life; it is full of picturesque details, as well as humorous and sentimental notations that take the edge off the cruel and tragic events. The spectator follows the episodes not so much with emotional involvement as with curiosity."[2]

2. Jean Charbonneaux, *op. cit.*, p. 285.

Great Altar of Zeus

Platform frieze: Augea, raped by Heracles, gave birth to a son, Telephus, who had to be abandoned on a mountainside; here, Augea observes the preparations for the abandonment.

The Laocoön Group

Marble, h. 2.42 m. (8 ft.).
Second half of the second century BC.
Vatican Museum.

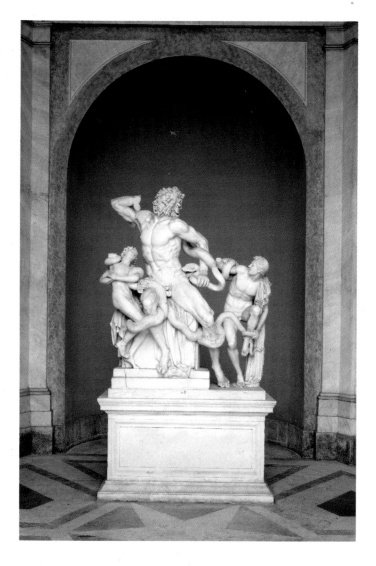

FREE-STANDING SCULPTURE.
ECLECTICISM AND DREAMS OF STONE

The famous *Laocoön* group, which was discovered on an estate near Santa Maria Maggiore in Rome – and overwhelmed Michelangelo to the point of tears – seems to be derived from the same inspiration as the Pergamon *Gigantomachy*. In it we find the same power and the same exacerbated movement. Pliny, who ascribed it to three artists from Rhodes, Agesander, Polydorus and Athenodorus, said that "of all the paintings and sculpture, it was the most admirable."

Winckelmann, in his *History of Art among the Ancients*, rejoiced that destiny had preserved such a great masterpiece from destruction and allowed it to serve as eternal proof of the magnificence of beauty. According to Winckelmann, the group of statues depicting the priest Laocoön and his two sons being set upon by sea-serpents offers the spectacle of human nature at a moment of maximum agony. It presents the image of a man striving to marshal every ounce of his strength to overcome his fate. He described Laocoön's furrowed brow as expressing courage, his mouth as taut with anxiety, "while the excess of suffering swells his muscles and strains his nerves." He concluded enthusiastically that the three artists could not embellish nature in so dramatic a scene, and so they strove to "depict it in its rawest state, at the instant of the greatest effort within its power." The *Laocoön* group was so perfect a work of sculpture in his eyes that he did not hesitate to date it – quite erroneously – from the "purest times," in other words the period of Alexander the Great, during the fourth century BC.

This dating, based solely on the evidence of aesthetic feeling, is no longer accepted today. Contemporary archaeologists have assigned its origins to some time after the middle of the first century BC. This is substantiated by the fact that Virgil narrated this particular episode in Book II of his *Aeneid*. The scene takes place in front of the walls of besieged Troy; two enormous sea-serpents emerge from the depths and lunge at the priest and his two sons, wrapping their huge coils around their bodies and constricting them, while Laocoön desperately tries to free himself from their grasp. But it could also be that Virgil and the sculptors of this statue took their inspiration from an older literary source that has since been lost, or even that the existing group is a copy of an earlier original, as is often the case with other Greek sculptures.

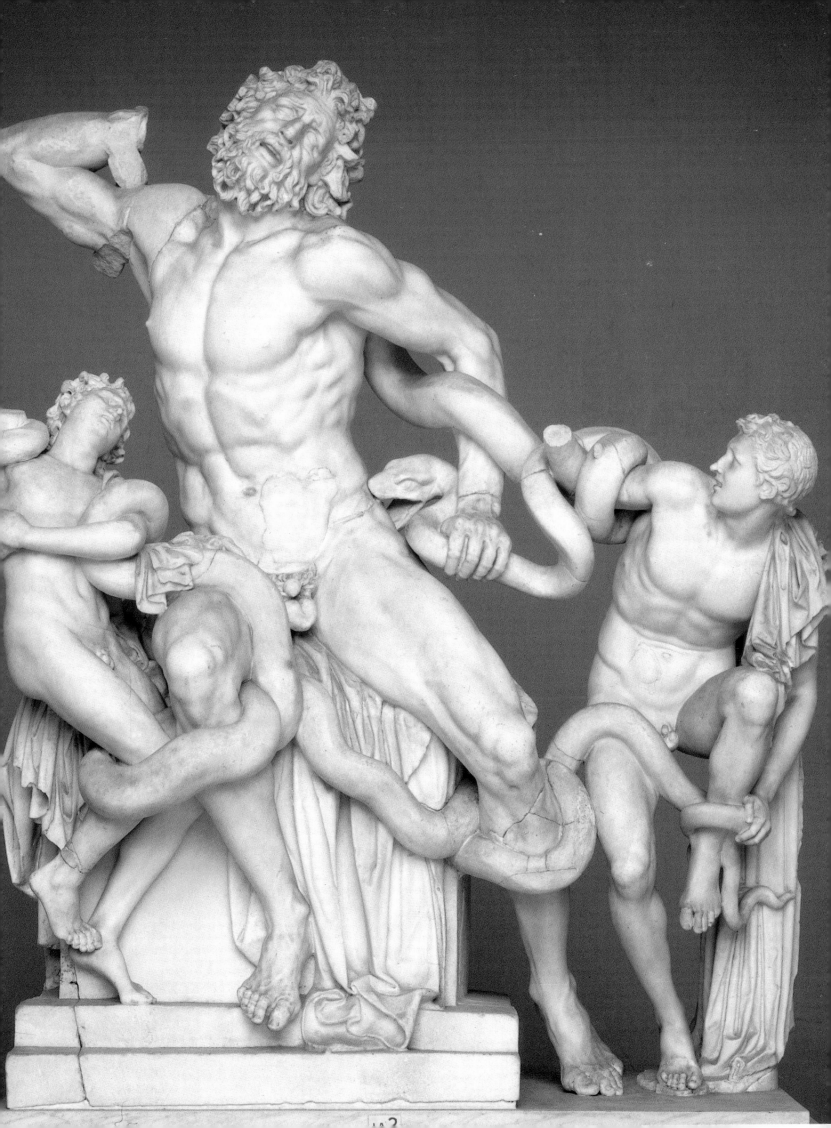

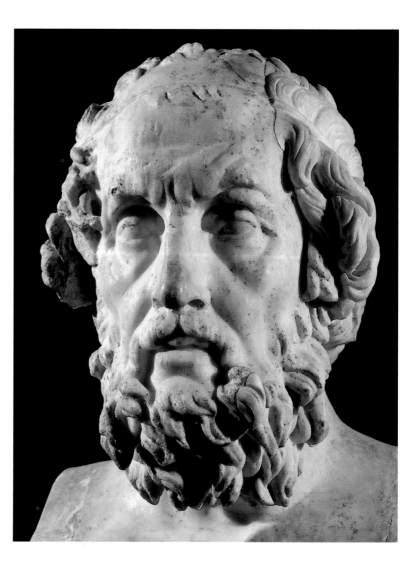

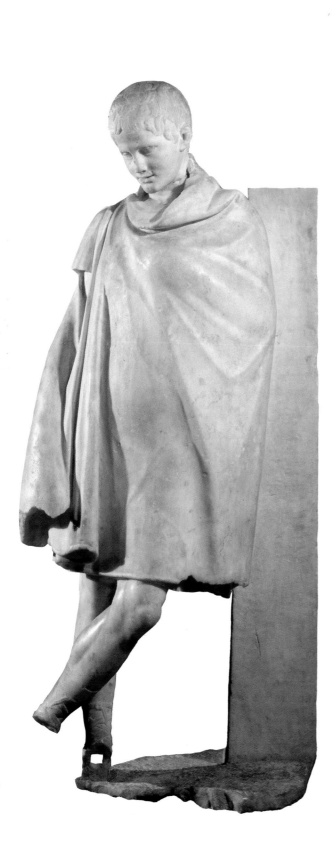

Following the *Socrates* of Lysippus with its Silenus-like countenance, an art of portrait-busts stressing psychological character and expression was developed during the fourth and third centuries BC. The likenesses most often represented were those of famous poets and philosophers. The days when sculptors followed the Polyclitan canon and excluded all signs of individuality from their work had, by then, become a thing of the past. The head of *Homer* portrays him with wide-open, but unseeing eyes in a haggard and wrinkled face. A seated statue of the Stoic philosopher *Chrysippus* which shows a stooped old man with deeply etched features, pulling his mantle over his bony back for warmth, clearly symbolizes the idea that individual thought was no longer shored up by ancestral certainties. The bust of the ascetic and sickly *Epicurus* presents not just a sum of naturalistic details, but also expresses the concentration of a thinker who sought to re-

174

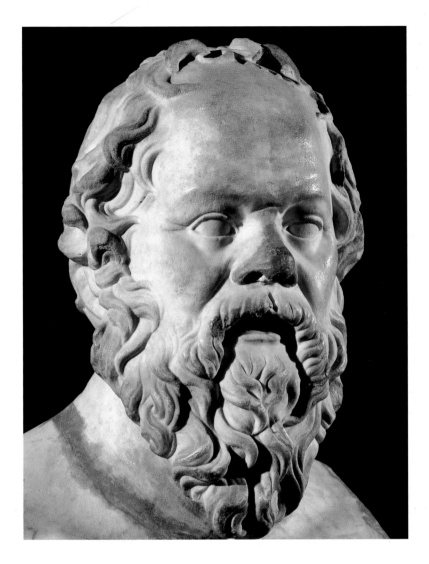

Portrait-Bust of Socrates

Marble, h. 55 cm. (22 in.).
Antique copy of an original attributed
to Lysippus.
Fourth century BC.
Louvre Museum, Paris.

Opposite, left

Youth Draped in a Chlamys

Marble, h. 145 cm. (5 ft.).
From Thralles.
Third century BC.
Archaeological Museum, Istanbul.

Opposite, right

Bust of Homer
(imaginary likeness).

Marble, h. 55 cm. (22 in.).
Found in Rome.
Early second century BC.
Louvre Museum, Paris.

Page 176

The Stoic Philosopher Chrysippus

Marble, h. 116 cm. (4 ft.).
Late third century BC.
Louvre Museum, Paris.

Page 177, top

Sleeping Hermaphrodite

Roman copy after a Greek original.
Found in Rome.
Second century BC.
Pillow and mattress carved by Bernini
in the 17th century.
Louvre Museum, Paris.

establish rules of proper human conduct in the midst of a turbulent and changing world.

All this has similarities with and yet is very different from the physical sufferings that would wrack the Giants in the Pergamon frieze and from Laocoön's desperate struggle. During the Hellenistic period, which lasted about three centuries, we find neither outstanding masters creating characteristic works, nor distinct stylistic schools, but a diverse and active artistic production which is difficult to categorize. In addition to the ideological changes which strongly marked this period and led to a re-definition of the sacred and divine, new maritime and overland trade routes were established, enabling artists to leave the impoverished cities of Attica and the Peloponnese and travel to where their skills were in demand, which in turn created the possibility for further contacts. Gone were the days of Myron, Polyclitus and Phidias, who were known mostly within a relatively

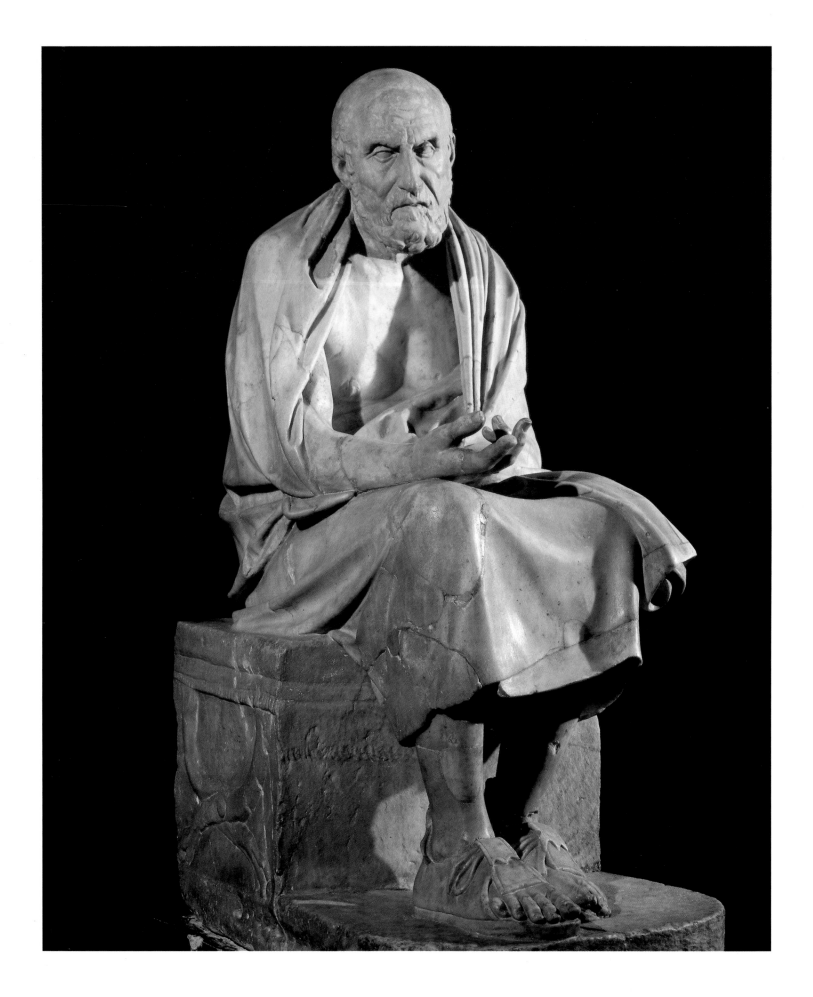

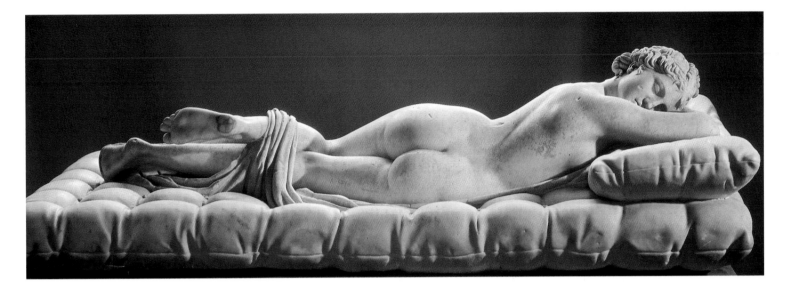

small circle which, in the age of Pericles, was restricted to a few capitals.

The eclecticism achieved by the Hellenistic sculptors also resulted in new genres. It was no longer just a matter of depicting in marble or bronze the ideal forms of a prepubescent or virile youth, even if physical education continued to be highly valued, as we can see from the number and luxury of the gymnasiums built in Asia Minor. Unlike the sculptors of the Classical period, who devoted their skills entirely to the glorification of the healthy and vigorous athlete, the Hellenistic artists turned their attention to bodies afflicted with abnormalities or deformed by illness and age. They produced such unprecedented works as the *Sleeping Hermaphrodite* or the *Sleeping Satyr* –also known as the *Barberini Faun*– which would surely have been considered decadent in the days of Pericles.

Favourite subjects were chubby infants with rounded bellies, fleshy arms and thighs full of dimples. We see them in every sort of pose: gambolling, running, fishing, riding dolphins, playing with dice, or lying still, wrapped in their shirts and asleep. A major reference was the *Child with a Goose* in the sanctuary of Asclepius at Cos, which was so lifelike that, in a sketch by Herondas, known for his lively mimes about the lower classes , two women stop to admire it and one of them exclaims: "Look at the child strangling a goose! If you couldn't see the marble right there, in front of you, you'd swear that it could talk!" This essentially picturesque type of subject inaugurated a long and varied series of cupids and other figures of Eros or Heracles in their infancy, which

Child with a Goose

Marble, h. 62 cm. (24 in.).
From the vestibule
of the gymnasium at Ephesus.
Copy of a Greek original
from the third century BC.
Kunsthistorisches Museum,
Antikensammlung, Vienna.

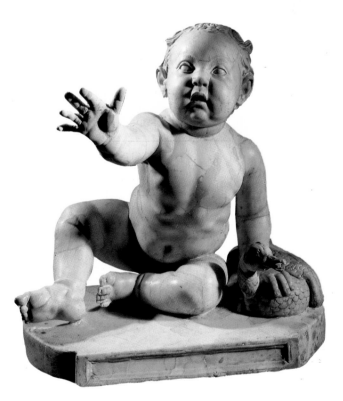

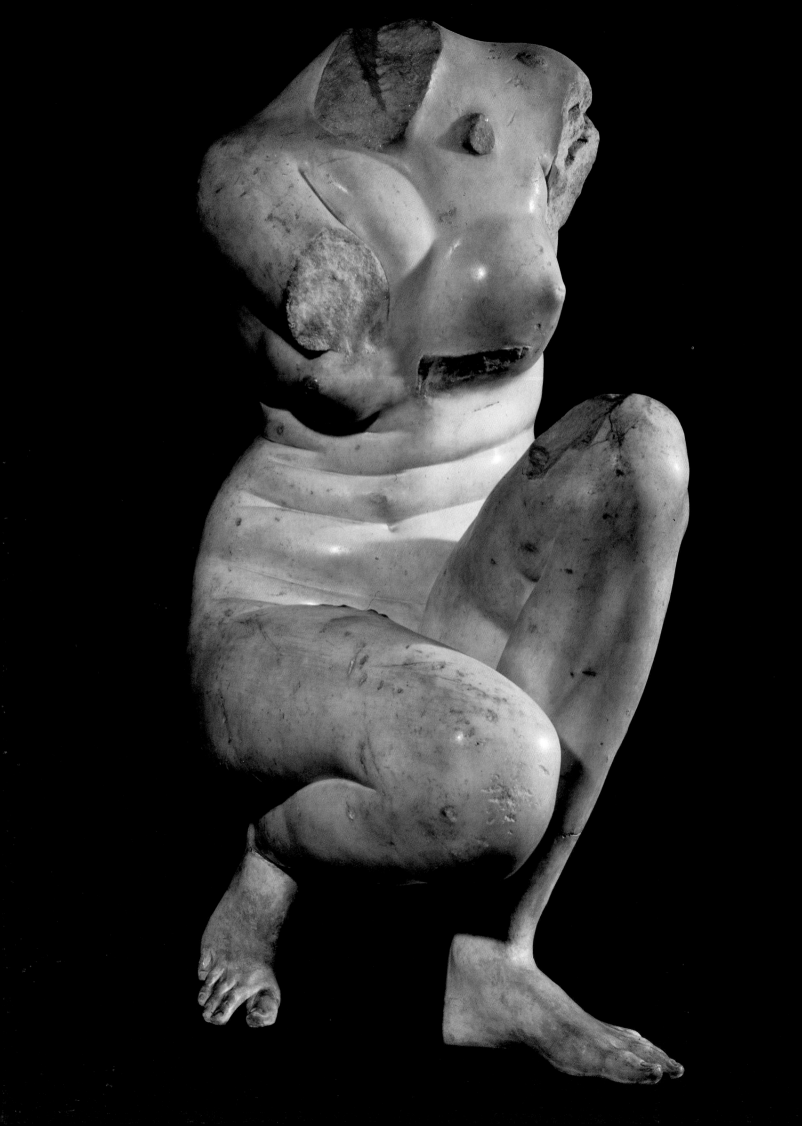

continued to be in favour well beyond the Hellenistic period and into the Roman era.

The *Laocoön* and the frieze of the Giants at Pergamon were not the only masterpieces of Greek Hellenistic sculpture. From this same period date the *Winged Victory of Samothrace* and the *Venus de Milo* which, no less than the Parthenon frieze at the British Museum, continue to draw appreciative crowds from all over the world.

The *Winged Victory* was discovered in 1862 on the island of Samothrace, a rocky pyramid set in the Aegean Sea, northwest of the Dardanelles. This graceful figure, still radiating strength and majesty despite its fragmentary state, is thought to have been sculpted between 150 and 180 BC by a student of Lysippus or Scopas. It stands on a pedestal representing the prow of a Greek bireme (a galley with two banks of oars) that was originally set on the side of a hill, so that it could be seen from a distance and low vantage point by pilgrims arriving at the port of Samothrace. The figure in this votive monument seems to have been inspired by a medallion celebrating the naval victory of the king of Macedonia, Demetrius Poliorcetes, over the king of Egypt, Ptolemy, at Salamis. Although the head and arms have been lost, it is thought that she carried a wreath or blew into a trumpet.

What remains of the figure suggests that the artist wanted to depict her winging down from the heavens to take her place on the prow of the victorious ship, her drapery buffeted by a strong sea wind. Cézanne, who admired it at the Louvre, wrote to his friend Gasquet: "It is an idea, an entire nation, a heroic moment in the life of a nation, yet the drapery clings to her body, her wings are beating, her breast swells. I do not need to see the head to imagine her gaze, because all the blood that courses and flows through her legs, hips, and every part of her body, has rushed through her brain to her heart. The blood flows, and it is the movement of a whole woman, a whole statue, of the whole of Greece. When the head broke off, the marble surely bled." The purists long scorned this statue as a mere show of virtuosity, but the *Winged Victory of Samothrace* is still a stirring expression of the pride of triumph, and her damaged state enhances the life that it has miraculously preserved.

The *Venus de Milo* was discovered by chance in 1820, not far from an ancient amphitheatre, by a peasant digging

The creation of human figures according to an ideal of beauty during the fifth century BC slowed the development of portraiture, based on individualism and realism. This art form was able to prosper only in the fourth century BC. As Jean Charbonneaux explains "The influence of the theatre, which transmitted the memory of the heroes of the past, the importance of philosophy, which discovered a divine nobility in the thought of the unsightly Socrates, must be added to the natural curiosity of the Greeks for the exotic and the strange to account for the progressive renunciation of abstraction, the introduction of certain physiognomic details, and finally the expression of an individual personality in statuary."

Kneeling Venus

Marble, h. 98 cm. (38 in).
Found at Colombe, near Vienne, France.
Around 250 BC.
Louvre Museum, Paris.

Overleaf

Winged Victory of Samothrace

Marble, h. 3.28 m. (11 ft.).
Found on the island of Rhodes.
Around 190 BC.
Louvre Museum, Paris.

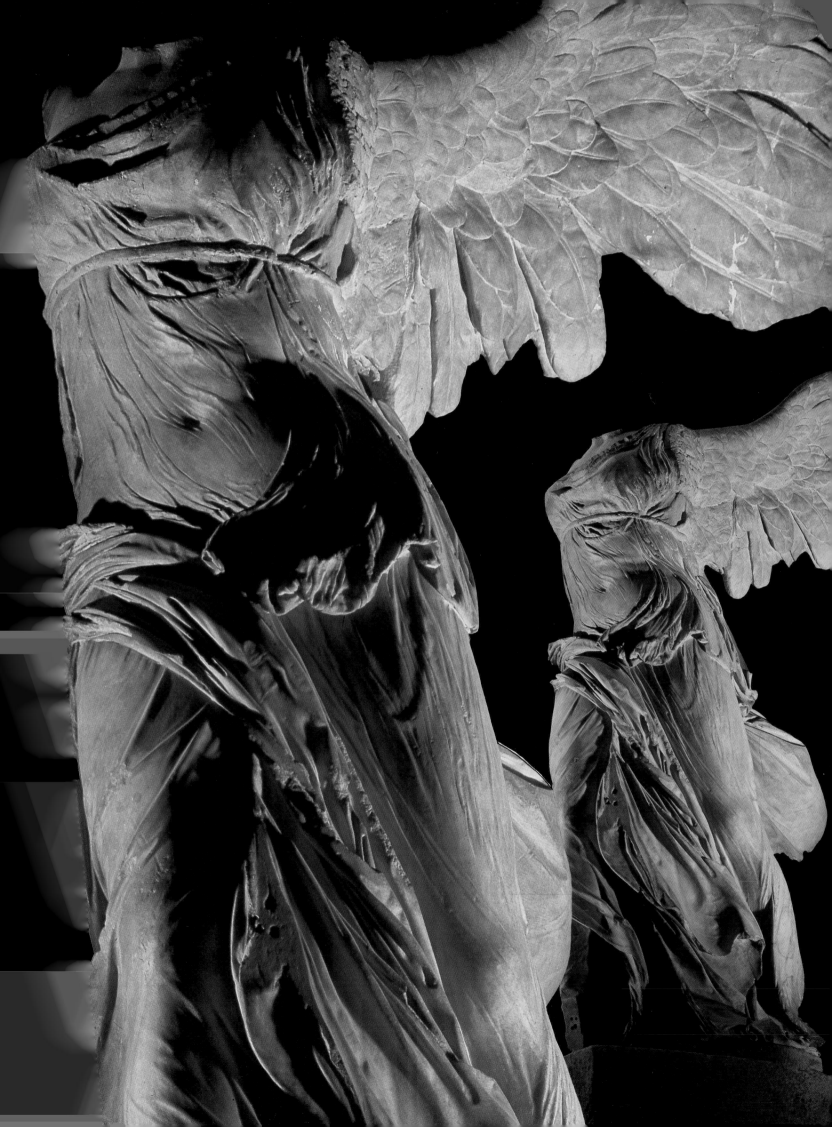

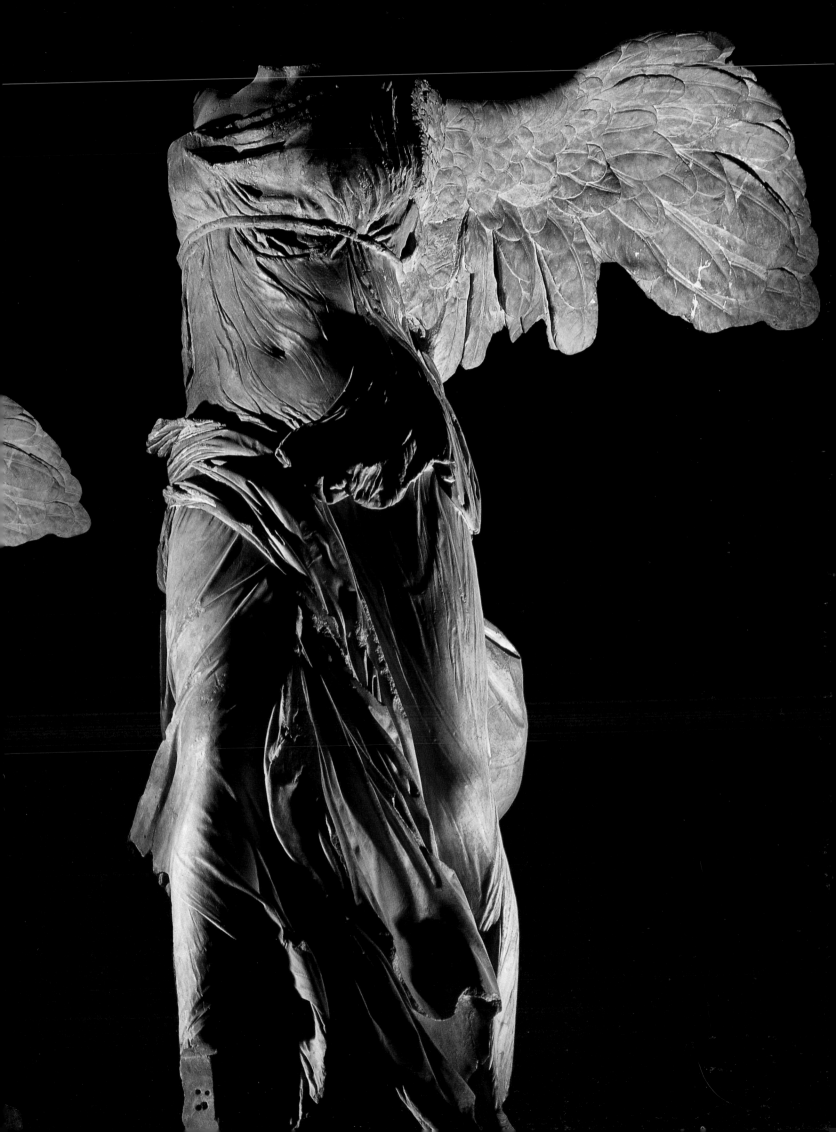

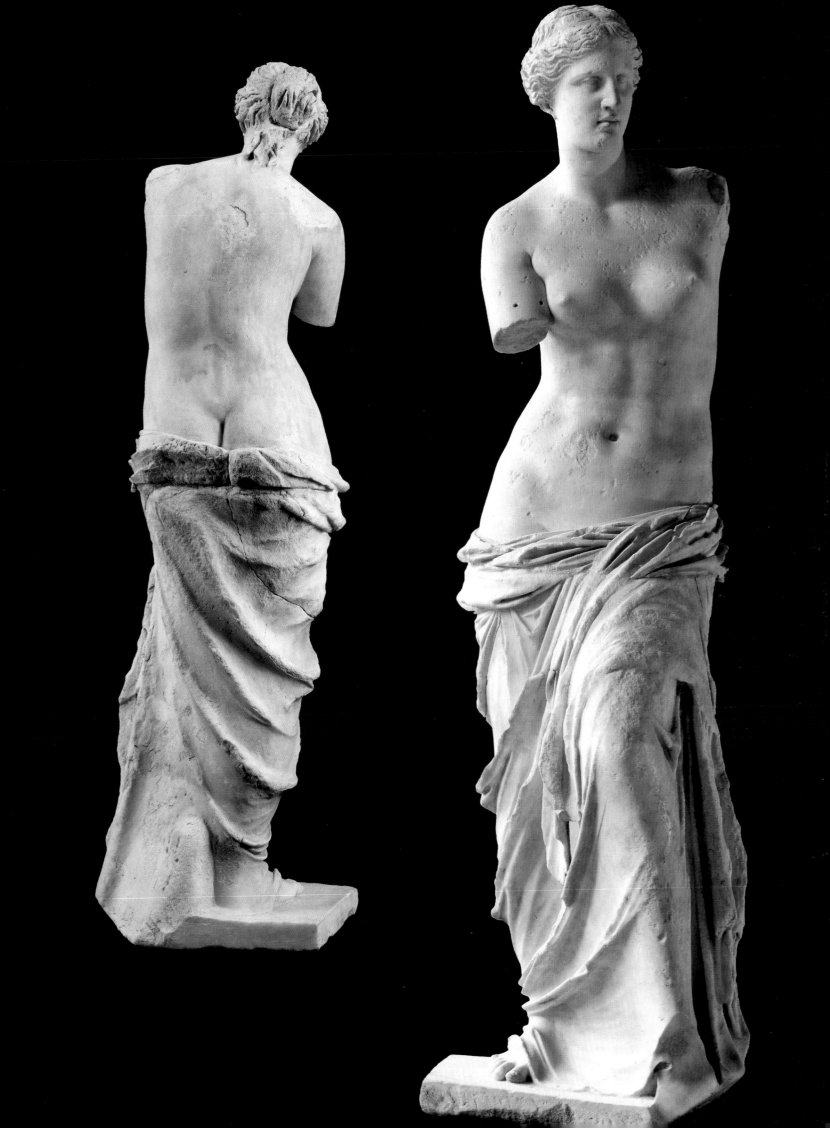

in his field for rocks to build a wall. "Milo" is the modern name of Melos, an island in the southwestern part of the Cycladic archipelago, and the statue commonly referred to as Venus is more accurately identified as a representation of the Greek goddess of Love, Aphrodite.

Quatremère de Quincy, the great French arts administrator and an advocate of imitating Antiquity, hailed this find in a speech made at the Académie Royale des Beaux-Arts on 21 April, 1821, referring to it as an outstanding example of the Greek genius. He described the statue's merits in such superlatives as "grandeur of style," "breadth of forms," "ideal character," "purity of line," "truth," "life and movement," and, admiring the superior handling of the marble, he even went so far as to grant it first place among the surviving masterpieces of Antiquity. Speculating on the figure's pose, he reasoned that everything about her attitude, from the shape of her body to the position of her head, indicated that she was originally one of a group representing Venus triumphant over the fierce temper of Mars. He based this interpretation on the fact that in Greek mythology, Aphrodite, the goddess of tender feelings overcoming the bloodlust of battle, was a personification of peace after war.

The Marquis de Rivière, the French ambassador to the Sublime Porte, purchased the statue from its finder so that it went to the Louvre, instead of Constantinople. His own theory was that this was a statue-portrait of the notorious Phrynea, the mistress of Praxiteles and, as we have already mentioned, the presumed model for his *Aphrodite of Cnidus*. Comparing their half-open eyes, their voluptuous mouths, their flaring nostrils, he was convinced that it was the same face in both cases, except that the *Venus de Milo* was the faithful likeness of a beautiful woman, while the *Aphrodite of Cnidus* conformed to an ideal type of beauty. Likening the former to "a rose in bloom," he confirmed her identity as Venus by the fact that a sculpture fragment of a hand holding an apple – the fateful apple given to her by Paris – was found on the same site, carved in the same marble, presumably by the same sculptor. Later scholars speculated that she was Aphrodite holding a mirror, or a crown, or a dove; and still others have argued that she was a warrior holding a spear, but we have no way of confirming such hypotheses.

More important is the fact that we can now date this statue with more precision and certainty: on purely stylistic grounds, the *Venus de Milo* appears to belong to the Late

Overleaf

Venus de Milo

Parian marble, h. 2.02 m. (6 $^1/_2$ ft.).
Found at Milo.
130-120 BC.
Louvre Museum, Paris.

Opposite

Aryballistic Lecythus in the Gnatian style

Woman holding a mirror.
Last quarter of the 4th century BC.
Archaeological Museum, Tarentum.

Classical age, but it has now been established that it is a work of the late second century BC. Hellenistic sculpture, as we have seen, had a taste for profuse and contorted forms, but it was no less obsessed – like most eclectic phases – with Classical references. Of all the images of female beauty which Greece has bequeathed to us, few are as pure in every detail as this one: the raised left foot, the broad undulation which courses through the entire figure, the way it leans to the right with the bust pivoting slightly to the left, the bearing of the head, the masterful counterbalance of shoulders and hips, with every part contributing to the harmony of the whole. Except for the drapery, which is held in place only by the pubis and seems to be on the verge of exposing her charms, there is no trace here of the mathematical proportions once so cherished by Polyclitus.

HIGH SCULPTURE, FUNERARY PAINTING AND MOSAICS

The three centuries of the Hellenistic period were a time of intense creativity in the field of painting no less than in those of architecture and sculpture. The focus of vitality was no longer ceramics, but the fine art of painting, principally fresco and easel painting. The potter's art, although essentially in decline, continued to produce remarkable works, especially in the workshops of Southern Italy and Sicily. There were some major achievements, like the *Aryballistic Lekythos* from Tarentum, which is decorated with the figure of a young beauty sitting and holding a mirror, or, in an entirely different vein, the depiction of a *Drunken Heracles*, slumped at the door of an old woman who is dousing him with water to sober him up. The second scene, inspired by the parodic theatre, is full of humour, but at a great remove from the former perfection of the black- and red-figure styles.

Similarly, the two *Polychrome Pyxids* in the New York Metropolitan Museum of Art display considerable pictorial quality: the pastel tints – pale blues, pinks, purples and yellows – which grace their surfaces attest to a true sense of colour, and the figures have been rendered with great vividness and a feeling for three-dimensional space. However, there is reason to believe that these were not original creations, but rather interpretations or even copies. At any rate, as François Villard remarked: "The concern for plastic form, modelled in detail by highly-nuanced effects of light

Cupola in the Tomb Chamber of a Thracian Prince

Fresco. Detail showing servants bearing offerings.
300 BC.
Kazanlak.

Opposite

Detail showing a groom and quadriga.

and shade was a characteristic of Hellenistic painting at its apogee."[3]

As we have seen in Chapter III, the leading exponents of Late Classical painting, among them Parrhasius and Apelles, had developed techniques for perspective, elaborating colour-schemes, and orchestrating the play of light and shade which raised their craft to the status of a major art form. The Hellenistic artists were the beneficiaries of this legacy, but, inevitably, their works have been lost over the millennia. They are known today principally from the descriptions of ancient authors and, except in the case of

3. François Villard, *op. cit.*, p.133.

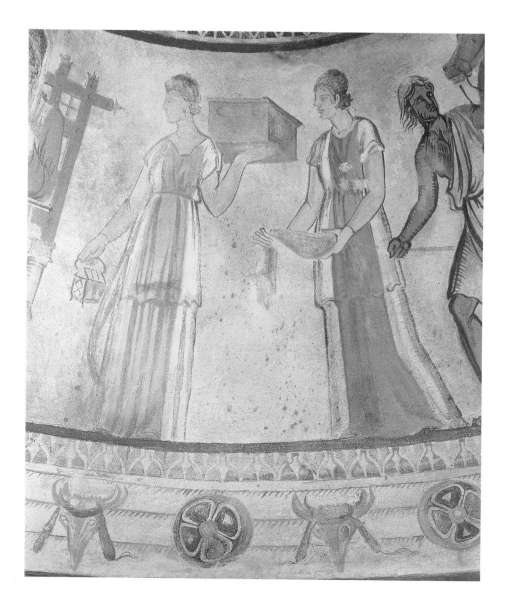

ceramics, from the better protected funerary paintings, the more resistant mosaics, or through Roman copies perpetuating the most popular subjects. Among the more famous painters, we may cite Theon of Samos, famous for the figure of a hoplite charging into combat with a temerity that was particularly expressive; Metrados, a recognized authority in the fields of both painting and philosophy, and Nealkes of Sicyon, who gained immortality in the history of art thanks to Plutarch's famous anecdote concerning his *Foaming Horse*:

"The story is told that Nealkes once painted a horse with forms and colours entirely to his satisfaction, except for the effervescent foam around the bit and the steaming breath coming out of its mouth. Although he tried again and again, each time he ended up effacing what he had done, until he became so

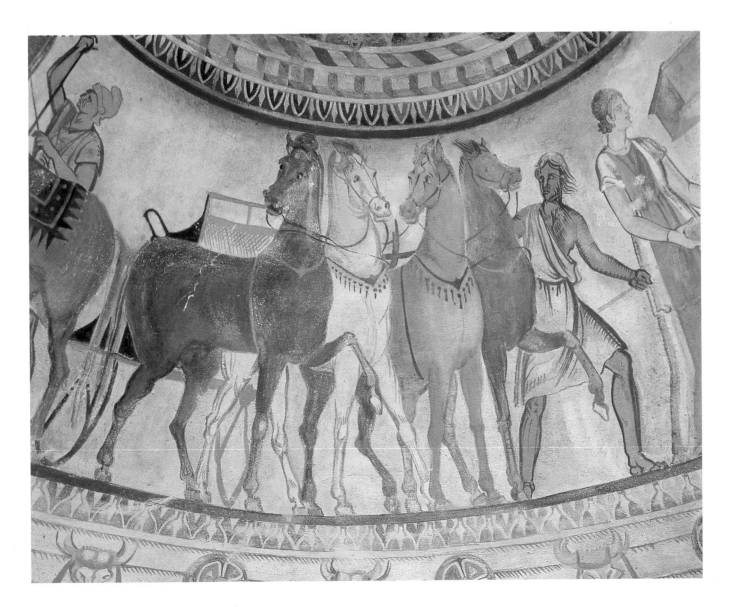

Lion Hunt with Krateros and Alexander the Great

Pebble mosaic.
Late fourth-century BC.
Pella Archaeological Museum.

angry that he threw his pigment-soaked sponge at the painting. The sponge, hitting the painting squarely on the troublesome spot, produced exactly the effect he had been searching for." We are not very far from Leonardo da Vinci, who, a millennium and a half later, looking at stains of humidity on a wall, imagined all sorts of things, such as human heads, animals, battle scenes, rocks, the sea, clouds and trees.

Another artist, called Euanthes, a member of the Alexandrian school known to us through descriptions of his paintings in written sources, seems to have excelled at many things, especially the depiction of nature. One of his works, a pair of panels that decorated the opisthodomus of the Temple of Zeus at Kasios in Pelusia, represented the related episodes of *Andromeda and Prometheus Chained*, and included a boulder so perfectly rendered that it gave the impression of having been created not by a painter, but by the earth itself. Another of his works, executed for the temple at Sidon and depicting the *Rape of Europa*, showed a beautiful young woman being carried away to Crete by Zeus transformed for the occasion into a white bull. It was said to have been a veritable hymn to the plant kingdom, with flower-dotted fields, many different kinds of plants and trees, and sprouting vegetation intertwined with foliage to make a canopy of greenery. The mythological subject had become the pretext for a new genre in painting: the landscape.

In Hellenistic painting there are many examples that abound in sacred groves, rivers, springs, mountains, seashores, all derived from the attentive observation of natural forms. In a painting like *The Rape of Hydas*, the very realistically-rendered trees seem to be trembling in the wind, while clouds cross the sky and a storm threatens. In other works, we see a combination of vegetation and architectural elements. But the works in question, painted on the walls of Herculaneum and Pompeii in the first century AD, although based on Hellenistic originals, bring us to the very limits of the Greek world, and even leave it behind.

The funerary paintings, on the other hand, were more authentically Greek, although coarser than the works just mentioned. At Vergina – the ancient Agai – capital of the kings of Macedonia, a major example of this genre was unearthed in the form of the lintel of a tomb entrance decorated with a frieze-like, three-metre-long fresco. It shows

three colourful figures against a white ground, probably representations of the deceased flanked by allegorical figures. At Paestum, about a hundred sarcophagi with painted interiors have been brought to light, and, except for the heroic figure of a deceased mounted on his horse and a woman shown in profile with a vase celebrating a ritual, the depiction of ornamental vegetation predominates.

These were not the work of the great masters, most of whom painted almost exclusively easel paintings, and more often than not on marble. One possible exception seems to have been the master who painted the funerary chamber excavated at Kazanlak, in modern-day Bulgaria: the underside of the cupola is decorated with the representation of a chariot drawn by four horses, a princely couple and attendants paying homage. The work as a whole displays an uncommon feeling for space and light.

Another feature of the Hellenistic period was the formidable development of the mosaic as an art form. At first made entirely of pebbles, most mosaics were later made of small glass cubes, or *tesserae*, which permitted the rendering of subtle shades of colour. A prime example is the famous mosaic showing *Dionysus Riding a Panther* in the House of the Masks at Delos. Executed during the second half of the

**The Battle of Alexander the Great
and Darius**

Mosaic found in the "House of the Faun"
at Pompeii.
Second half of the second century BC.
Copy after an original dating from 300 BC.
National Museum, Naples.

Opposite

Detail showing Darius on his war-chariot.

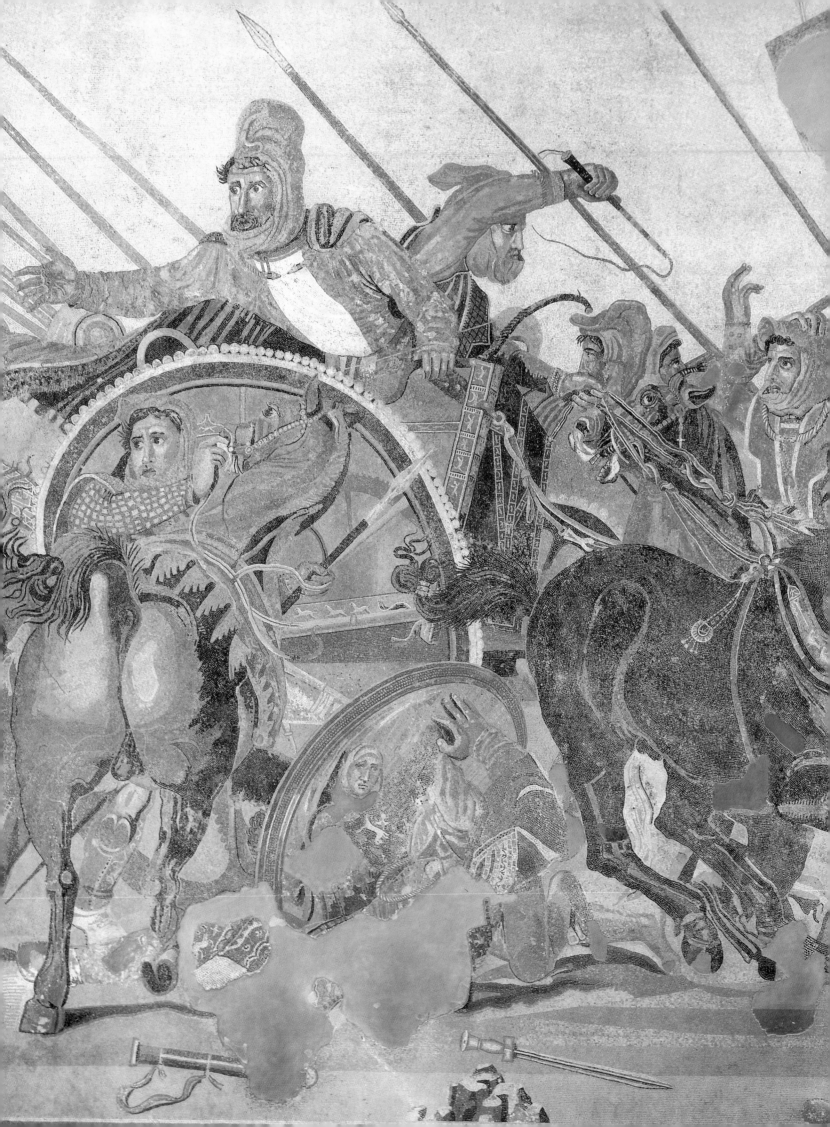

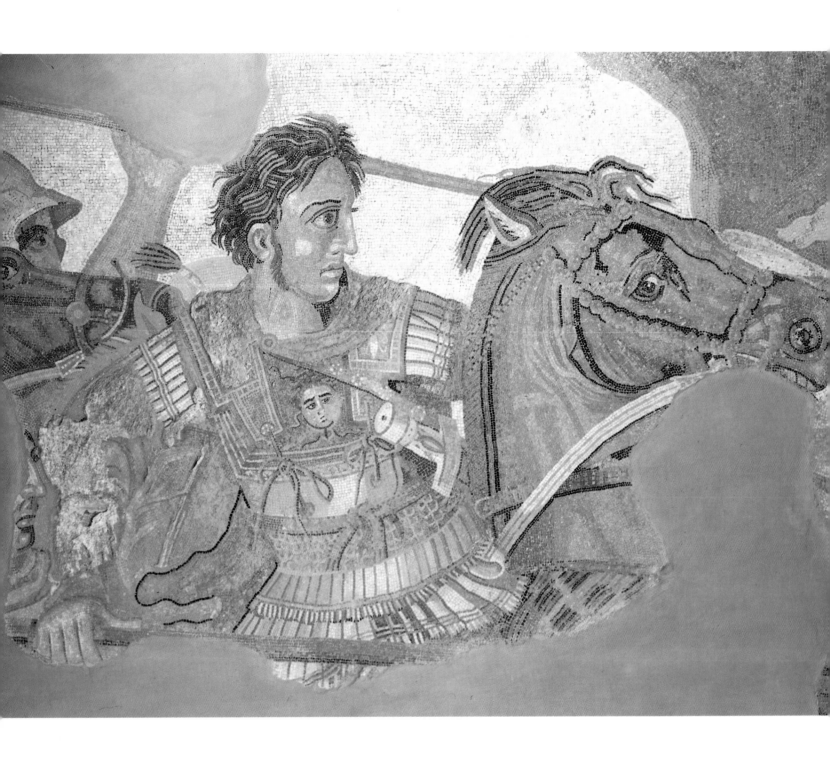

**The Battle of Alexander the Great
and Darius**

Detail showing Alexander of Macedon.

second century BC, this work takes up with greater complexity a subject that had been treated two centuries before at Pella, the ancient capital of the Macedonian monarchs, in an essentially graphic manner using light- and dark-coloured pebbles. The panther, with its aggressive gaze, menacing teeth, outstretched claws and a collar of leaves around its neck, presents a contrast to the relaxed figure of Dionysus riding side-saddle on its back, apparently leading the wild beast without any effort. In this work and an earlier one like the *Stag Hunt*, with its convoluted forms and fluttering drapery, we are not far from the achievements of great sculpture.

Still life was another new genre created by Hellenistic painting. The best example in the field of mosaic is *Doves at a Fountain*, a highly celebrated work executed by Sosus of Pergamon which further contributed to the fame of the city in Antiquity. This work, which shows four doves perched on the edge of a richly-ornamented metal bowl or vase, existed in several copies. We owe one description of it to Pliny, who wrote: "In this mosaic we can admire a dove drinking and colouring the water with the shadow of its head. Other doves are basking in the warmth of the sun and scratching themselves on the rim of the vase." In his most unusual work, *The Unswept House*, which shows scattered cherries, figs and nuts given a remarkably tangible quality by the distinct shadows cast on the ground, Sosus demonstrated his keen powers of observation and mastery of illusion.

But the most complex and accomplished mosaic of the Hellenistic period was undoubtedly *The Battle between Alexander and Darius*, which has come down to us through a copy made after an original dated around 300 BC.

This large-scale work is preserved in the National Museum in Naples and depicts a fierce combat with two main protagonists, Alexander the Great mounted on his charger, and Darius in his war-chariot, leading his troops into battle and indicating the enemy with his outstretched right arm. Horses stamp and fall wounded to the ground, while warriors engage in deadly, implacable hand-to-hand combat. Abandoned weapons disposed in perspective litter the ground, the pikes brandished by Darius's soldiers thrust their diagonals above the fray. In the foreground, we see faces expressing a whole gamut of emotions, from fury and fear to impassivity. The forms are defined by colours and

Page 194

Doves on a Vase

Mosaic by Sosus.
Second century BC.
Capitoline Museum, Rome.

Page 195

The Unswept House

Detail of a mosaic.
First-century AD copy after an original from the second century BC.
On loan to the Museo Latreano, Vatican.

highlights, with shades ranging from black to bistre, while the greys and browns give the composition a contained power that balances the tumultuous clash of figures. With its compositional tension, and details such as the rounded hind-parts of the horses and the linearity of their harnesses, this admirable mosaic prefigures Uccello's famous *Battles*.

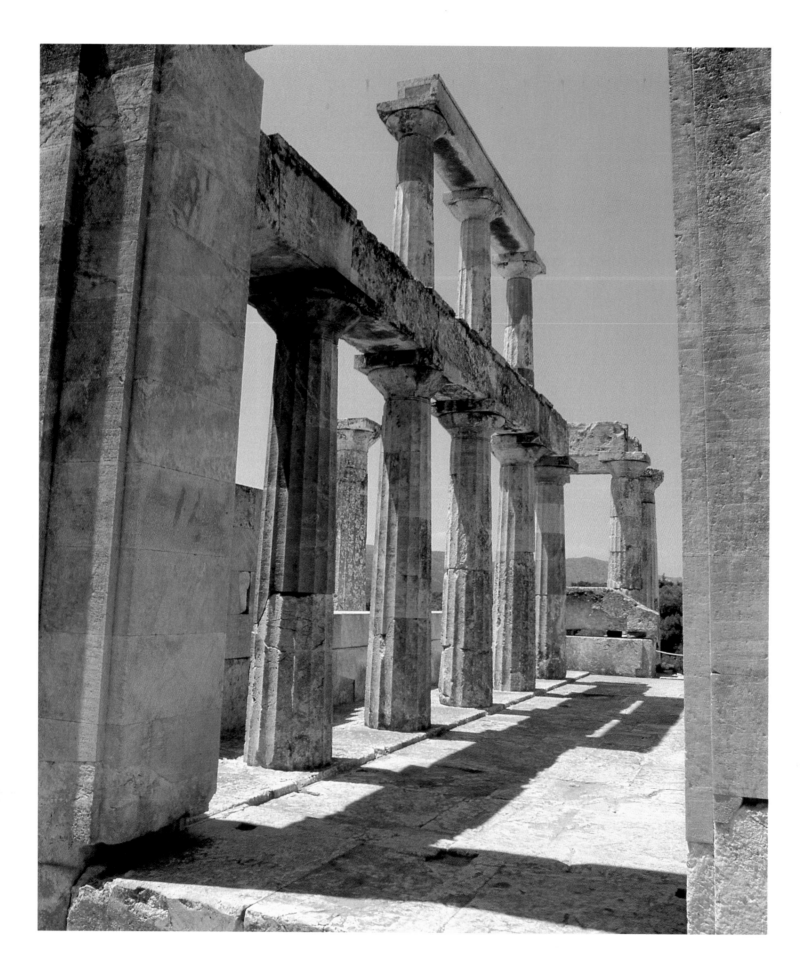

AN IMAGINARY GREECE?

This is the art of ancient Greece. Or, more accurately, this is how we perceive it. But what was it really like, and to what extent have we changed its image? And how will this image change in the next hundred, or even thousand years, in the light of changing tastes and new discoveries?

Originally, the magnificent *Aphrodite of Cnidus* was not the mutilated body we admire today: Praxiteles represented her in the act of bathing, with a piece of drapery in her left hand and modestly covering her sexual parts with the right. Worse, she has suffered more than any other statue from the disappearance of the colours that once softened her, judging from the accounts of ancient authors who report how attached the sculptor was to this colouring, which he entrusted to the famous Nicias, one of the greatest Athenian painters of the fourth century BC, who painted in encaustic, that is, with pigments mixed in a melted beeswax and resin medium that was applied hot with an iron. Nearly all Greek statues were painted in this way.

We know only pieces or ruins of ancient Greece and they are very different from the reality. What would we think of Greek temples if their walls were still standing and their roofs covered with flat tiles? Consider the *stoa* of Attala that was rebuilt in the Agora of Athens a few years ago: the columns are no longer abstract figures silhouetted against the sky, but functional architectural supports; the roof is no longer a symbol or sign, but a covering, and the wall takes on its original function as a definer of space. The *stoa*, a vast hall measuring some hundred and twenty metres long looks like a shopping-mall – which is exactly what it was. Its decoration of griffons and lion-headed gargoyles, however, is at variance with our ideas about traditional Greek architecture.

In the presence of a statue, a vase, the remnants of a painting, or an ancient edifice in ruins, each may and must reconstruct his or her own image of Greek art. Helping us with this task is a remarkable array of forms, a great formal treasury which, despite the outrages of time and fortune, never stops proclaiming its beauty, even, as Lord Elgin understood so well, in its smallest fragments.

Temple of Aphaia

13.77 x 28.81 m. (45 x 94 ft.).
Detail of the interior double-colonnade.
500-490 BC.
Archaeological site of Aphaia, Aegina.

197

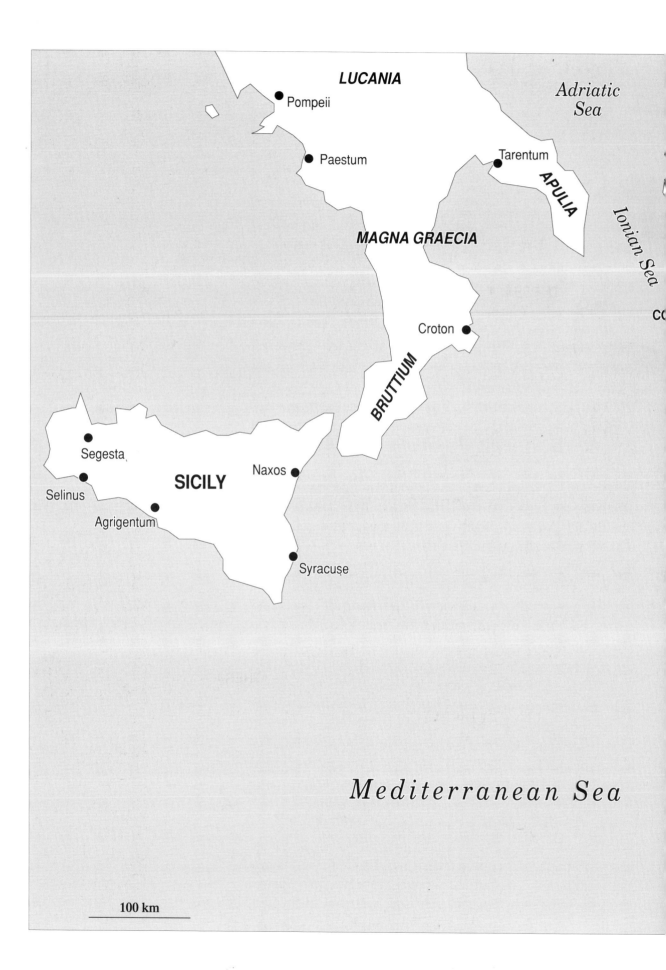

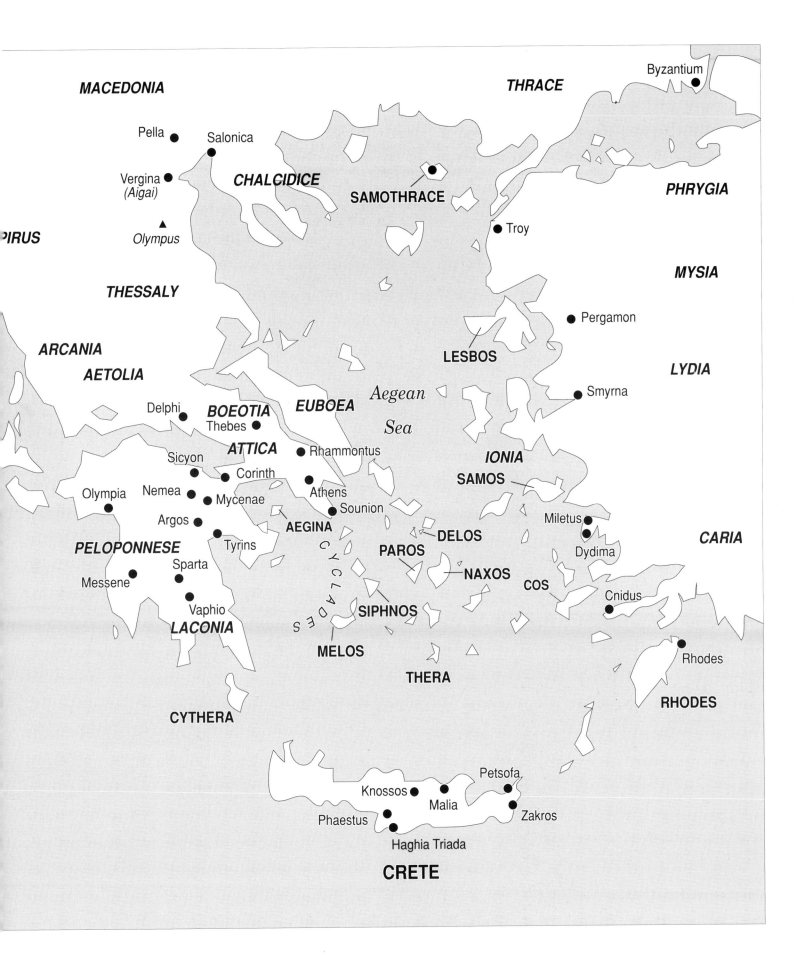

MACEDONIA

THRACE

Byzantium

Pella ● Salonica

Vergina ●
(Aigai)

CHALCIDICE

SAMOTHRACE

PHRYGIA

▲
Olympus

Troy ●

PIRUS

MYSIA

THESSALY

Pergamon ●

ARCANIA

AETOLIA

LESBOS

Aegean
Sea

LYDIA

Smyrna ●

Delphi ● BOEOTIA EUBOEA
Thebes ●

Sicyon ATTICA Rhammontus ●

Corinth ● Athens ●

IONIA

SAMOS

Olympia ● Nemea ● Mycenae ●
Argos ●

Sounion ●

Miletus ●

CARIA

AEGINA

Dydima ●

DELOS

Tyrins ●

PELOPONNESE

PAROS

NAXOS

COS

Messene Sparta ●

Cnidus ●

Vaphio ●

LACONIA

SIPHNOS

MELOS

THERA

Rhodes ●

CYTHERA

RHODES

Petsofa ●

Knossos ● Malia ●

Phaestus ● Zakros ●

Haghia Triada

CRETE

GLOSSARY

Abacus: the upper part of a capital; a square (Doric) or rectangular (Ionic) block supporting the *architrave*.

Acropolis: hilltop citadel of the ancient Greek cities, it had fortifications and sanctuaries.

Agora: multi-purpose public area in a city; at first a plain vacant space, it developed into a square bordered by civil, religious, commercial and cultural buildings.

Amphora: two-handled vase or jar resting on a flat base.

Architrave: lower part of the *entablature*; it rests directly on the columns and carries the frieze.

Askos: small vase with a lateral spout and basketwork handle.

Bas-relief: sculpture carved in low relief against a plain ground.

Canon: set of established rules used as a model to determine the proportions of statues according to an ideal standard of beauty.

Capital: decorative element of the Doric, Ionic or Corinthian order supported by the shaft of the column.

Cella: Latin term designating the inner sanctuary of a Greek temple, where the cult statue is worshipped.

Chiton: a long, thin tunic made of pleated linen.

Chlamys: a short wool mantle; worn pinned at the shoulder, leaving one arm free.

Chryselephantine: a technique in sculpture combining inlays of ivory and gold on a wooden armature.

Crater: large, wide-mouthed vase used to mix water and wine served at banquets.

Crépis: the stepped base of a temple.

Demos: the citizens of a Greek city; the word "democracy" is derived from this term.

Dipteran: refers to a type of Ionic temple with a *peristyle* formed by a double row of columns; found predominantly in Asia Minor.

Distylar: with two columns; refers to an edifice with two columns on the façade; many treasuries were built with this arrangement.

Dripstone: cornice projecting strongly above the *entablature* to protect it from water running off the roof.

Dromos: hallway leading to the entrance of a monumental tomb.

Echinus: moulding element situated under the *abacus* of a Doric capital.

Encaustic: paint made from pigments mixed with melted beeswax and resin and applied with heat.

Entablature: part of the temple held by the columns and composed of an *architrave*, a frieze and a cornice.

Entasis: technique used in the Doric order to reduce the diameter of a column, especially in the upper third section.

Ewer: ancient type of water pitcher, with handle and beaked spout.

Gigantomachy: work in which the subject-matter is the Battle of the Gods and the Giants.

Glyptic: the art of engraving precious and semi-precious stones.

Griffon: composite mythological creature with the body of a lion and the head and wings of an eagle.

Gutta: small cone-shaped ornaments found on Doric *entablatures*.

Haut-relief: sculpture carved in very high relief, but not detached from the ground.

Hecatompedon: temple measuring one hundred Samian feet in length.

Himation: wool mantle, worn over the *chiton* by women and without an undergarment by men.

Hoplite: heavily armed infantry; the hoplites went into battle in tight formations called phalanxes.

Hydria: closed jar with three handles used by women to carry water from fountains.

Kore: (pl. korai) statue of a standing, draped young woman; placed in the shrines of goddesses during the Archaic period.

Kouros: (pl. kouroi) statue of a standing nude youth; placed in the shrines of male gods during the Archaic period.

Lecythus: small cylindrical vase with narrow neck used to hold scented oils.

Megaron: main hall and foyer in a Mycenaean palace, preceded by a vestibule; subsequently used to designate a grand hall or building.

Metope: sculpted slab separating two *triglyphs* on a Doric frieze.

Monopteral: building without walls, consisting only of columns supporting a roof.

Naos: see *cella*.

Necropolis: monumental cemetery, built above or under the ground.

Oenochoe: wine jar with a trilobe spout and handle.

Opisthodomus: in a Greek temple, a closed space behind the *cella* ; usually not connected to it.

Palaestra: public area reserved for gymnastics or wrestling training.

Pancratium: ancient Greek sports contest combining wrestling and boxing.

Pediment: triangular element surmounting the façade of a building; consisting of two oblique segments of the cornice, with the entablature as base.

Pentathlon: sports event practised by the Greeks and Romans: it consisted of five events: running, jumping, wrestling, throwing the discus and the javelin.

Peplos: long woollen garment worn by women; held by a belt, which it overlapped, and pinned at the shoulder (Dorian).

Peribolus: wall enclosing a sanctuary.

Peripteral: refers to a temple plan featuring an exterior colonnade; unlike the *dipteral* plan, there is only a single row of columns.

Peristyle: a colonnade surrounding a building or court.

Phial: votive cup without handles or base.

Pithos: very large terracotta jar, sometimes decorated with reliefs and often kept half-buried in the ground; used for storing non-perishable goods.

Polis: town or city unit; after the fifth century BC, the Greek world consisted of hundreds of independent *poleis*.

Portico: open gallery supported by two rows of columns, or by a wall and a row of columns.

Pronaos: in a temple, the vestibule that leads into the *cella* or *naos*.

Prytanaeum: building housing assemblies of the senators appointed by the city council; in Athens, they constituted the permanent section of the Council of the Five Hundred.

Pyxid: rectangular or cylindrical terracotta box with a cover.

Quadriga: chariot drawn by four horses.

Rhyton: ceremonial drinking horn; made of metal or ceramic, often given the shape of a human or animal head.

Sima: the gutter on the gables or flank of a building, decorated with painted or sculpted ornaments.

Scyphus: drinking cup with two horizontal handles.

Stoa: portico usually walled at the back and with a front colonnade.

Strigil: a scraping tool used by the Greeks to clean or rub their bodies.

Stylobate: the last course of steps forming the base of the temple.

Symmetria: the right proportion of the principal elements of a building, based on the use of a module in the ground-plan and elevation.

Telesterion: edifice in a sanctuary used for special rituals; at Eleusis, the hall of initiation to the Demetrean Mysteries.

Temenos: sacred precinct defined by stone markers.

Tempera: paint made from pigment mixed with water and a binder.

Thalassocracy: state founded on the domination of seaways.

Tholus: building with a circular ground-plan from the pre-Hellenic period; used for civil or religious purposes.

Torus: a large moulding of convex profile.

Triglyphs: in the Doric order, decorative fluted elements that alternated with the *metopes*.

Tumulus: mound of earth above a tomb.

Xoanon: statue made of carved wood; later used to refer to ancient and primitive statues.

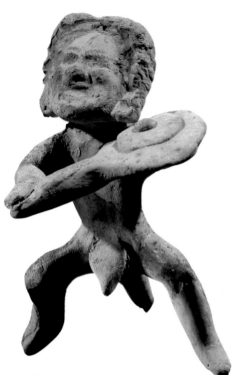

Grotesque Dwarf

Terracotta figurine from Thebes.
h. 8 cm. (3 in.).
Sixth century BC.
Louvre Museum, Paris.

CHRONOLOGY

BRONZE AGE (2350-1050 BC)

1900-1600	first Cretan palaces
around 1550	volcanic eruption at Thera
around 1450	destruction of the second Cretan palaces; Mycenaean domination.
around 1250	destruction of Troy by the Mycenaeans.
around 1150	decline of Mycenaean civilization.

GEOMETRIC PERIOD (1050-700 BC)

800	Homer's epic poems, *The Iliad* and *The Odyssey*.
776	first Olympic Games
733	foundation of Syracuse by the Corinthians

ARCHAIC PERIOD (700-480 BC)

682	fall of the Athenian monarchy.
657-629	tyranny of Cypselos in Corinth
605	foundation of Agrigentum
around 600	foundation of Marseilles by the Phoceans
600-590	first religious war at Delphi
594	Solon's reforms in Athens
561	tyranny of Pisistratus in Athens
561-546	Croesus, king of Lydia
557-530	reign of Cyrus, founder of the Persian Empire
534	first tragedy contest in Athens
533-522	tyranny of Polycrates on Samos
528	death of Pisistratus
514	assassination of the Athenian tyrant Hipparchus
510	flight of Hippias, the last Athenian tyrant
508	democratic reforms in Athens by Cleisthenes
506	defeat of the Spartan coalition against Athens
499-494	capture and destruction of Miletus by the Persians
490	First Persian War: the Athenians defeat the Persians at Marathon.
486-461	Xerxes, king of Persia
483	Themistocles develops the Athenian fleet

Bread Seller

Terracotta figurine from Boeotia.
h. 10.5 cm. (4 in).
550 BC.
Louvre Museum, Paris.

CLASSICAL PERIOD (480-338 BC)

480	Second Persian War: • Athens occupied and destroyed by the Persians • naval victory at Salamis led by the Athenians
479	defeat of the Persian forces at Plataea (Boeotia) by the Greek coalition
478	foundation of the Delian League, directed by Athens
469	Greek victory over the Persians at Eurymedion
459	Athenian expedition against Egypt; war between Corinth and Athens
457	war between Athens and Sparta
451	five-year truce between Athens and Sparta
449	the "Peace of Callias" between Athens and Corinth
446-431	the "Thirty Year Peace" lasts fifteen years
443-429	Pericles re-elected strategist in Athens each year
431-404	Peloponnesian War between Athens and Sparta
430	plague epidemic in Athens
429	death of Pericles
411	oligarchic revolution of the Four Hundred
410	democracy established in Athens
405	Athens besieged by Sparta; Lysander imposes peace and institutes the Thirty Tyrants
403	democracy re-established in Athens.
401-400	expedition of the Ten Thousand (mercenaries) to Persia
399	trial and death of Socrates
378	Athens founds a great maritime confederation
376	Athens dominates the Aegean Sea
371-362	Theban supremacy in continental Greece
360-336	reign of Philip II, King of Macedon
357-355	sacred war against Athens by the Allies
c. 347	death of Plato
338	Athens and its last allies defeated at Chaeronea by Philip II, King of Macedon

HELLENISTIC PERIOD (338-330 BC)

337	institution of the Corinthian League, led by Philip II
336-323	reign of Alexander the Great, King of Macedon
335	destruction of Thebes by Alexander; beginning of Alexander's campaign against Persia
331	foundation of Alexandria
330	Alexander in Central Asia
327-326	Alexander in India
323	death of Alexander the Great at Babylon
323-277	power struggle between Alexander's generals for the partition of his empire
322	deaths of Demosthenes and Aristotle
317-307	Athens governed by Demetrios of Phalaerus
306-287	Demetrios of Phalaerus rules Macedon
215-205	first war between Rome and Macedon
200-197	second war between Rome and Philip IV of Macedon
196	Flamininus emancipates the Greek cities
171-168	Third Macedonian War
148	Macedon becomes a Roman province
146	Rome destroys Carthage and Corinth
133	the last king of Pergamon, Attalus III, allies himself with Rome
121-63	reign of Mithridates VI, King of Pontus, Rome's last Greek adversary
87-83	Sulla subdues the Greek revolt against Rome; sack of Delos and Athens
64	Syria becomes a Roman province
51-30	reign of Cleopatra VII, the last independent ruler of Egypt
31	naval defeat of Mark Antony and Cleopatra at Actium
30	Cleopatra's suicide; Octavius annexes Egypt
27	Octavius proclaimed Augustus; beginning of the Roman Empire

GREEK GODS AND GODDESSES

another continent, as yet unnamed, to which she was promised by Zeus. Transforming himself into a white bull, Zeus carried her on his back to Crete and gave this continent her name.

❖

Achilles: son of Peleus and Thetis. His mother plunged him as an infant into the Styx to make him invulnerable; only the heel by which she held him remained unprotected. After fighting heroically against Troy, he was slain by an arrow aimed at his heel by Paris.

Aeacus: son of Zeus and king of Aegina. Renowned for his sense of justice, he was made one of the judges of Hades with Minos and Rhadamanthys.

Ajax: the son of Telamon, king of Salamis.

Amazons: fierce woman warriors, the daughters of Ares and the nymph Harmony. They hated men and accepted them in their midst only once a year. Male children were either given back to their fathers or killed. Maidens had their right breast ablated so as to be able to shoot their arrows better.

Andromeda: the daughter of Cepheus, king of Ethiopia, and the too beautiful Cassiopeia, whose vanity so incensed the gods that they unleashed a sea-monster to devastate the land. According to an oracle, only the sacrifice of Andromeda would appease the gods. She was waiting, chained to a rock, to be devoured by the monster when she was saved by Perseus. He vanquished the beast by exposing it to the head of Medusa, freed Andromeda and married her.

Antaeus: a monstrous giant, the son of Gaea and Poseidon. He lived in the Libyan desert, feeding on lions and wayfarers, whom he killed mercilessly in order to keep the promise he had made to his father that he woul build a temple to him made entirely of human skulls.

Aphrodite: goddess of Love, the daughter of Dione and Zeus. There were many sanctuaries devoted to her cult; the most famous were Cnidos, Delos, Paphos and Sicyon.

Apollo: the god of both punishment and healing, he could endow mortals with the gift of prophecy. He ruled the winds and protected sailors, built cities and inspired poets and musicians.

Argonauts: Greek heroes who sailed to Colchis in search of the Golden Fleece on the Argo. They numbered about fifty, including Heracles, Castor and Pollux, and were led by Jason.

Ariadne: the daughter of Minos, king of Crete, and Pasiphae. According to some legends, she died on the island of Naxos when Theseus abandoned her. According to others, Dionysus, touched by her beauty and despair, gave her the wine of oblivion and made her his wife.

Artemis: the goddess of the plant and animal kingdoms; her attributes were the dog, the stag, the bow and the torch.

Athena: symbolized by an owl and an olive tree, this martial virgin goddess was celebrated in many Greek cities. She was chosen as patron goddess of Attica, because the people there believed that the olive tree she offered them would be more useful than the horse given by Poseidon.

Atlas: the son of Iapetus and the oceanid Clymene. This giant and his brothers fought against Zeus; as punishment, he was condemned to carry the Heavens on his shoulders.

Atreus: the son of Pelops and Hippodamia; he harboured undying hatred for his brother Thyestes.

Atridae: an ill-fated family whose members were driven to commit heinous crimes and nourish deep hatreds.

Cassandra: the daughter of Priam and Hecuba, king and queen of Troy.

Centaurs: composite creatures with a human torso on the body of a horse; they fed on raw flesh and lived like wild beasts in the forests of Thessaly. Feared by mortals, they revelled in wine and women.

Cercopes: mischievous and evil gnomes who attacked Heracles. When he tied them to a staff with their heads hanging down, they saw that the hero's buttocks were black and began to laugh. Disarmed by their mischief, he relented and let them go.

Core: name given to Persephone.

Cyclops: one-eyed monsters, or blacksmiths who helped Hephaestus with his work.

❖

Demeter: daughter of Cronus and Rhea, she was the goddess of fertility; her attributes were a crown of wheat, a cornucopia, and a veil as a reminder of her annual mourning for Persephone.

Dione: her love affair with Zeus led to the birth of Aphrodite.

Dionysus: son of Zeus and Selene, he was the god of wine, sensual pleasures and nature. During the Classical period, he was worshipped as the god of the good life, games and feasts, which he celebrated with the bacchantes.

❖

Erechtheus: conceived from the semen of Hephaestus which soiled the virgin thigh of Athena and fell to the ground, he was born flanked by two serpents. When he became king, he established the cult of Athena and founded the Panathenaic festival.

Eros: son of Aphrodite. As the god of love, he was celebrated during feasts called the Erotidia. According to one myth, Eros was the second god –after Gaea– to have emerged from the original Chaos.

Eumenides: term signifying the "benevolent ones." They manifested their benevolence when a murderer repented of his crime. In the tragedies of Aeschylus, they are characterized as the goddess of earthly fertility.

Europa: daughter of Agenor, the king of Phoenicia. Her destiny was revealed to her in a dream: two continents vied for her love, Asia, where she was born and which claimed her as its own, and

Gaea: she emerged one day from Chaos and gave birth to a son, Uranos. Together, they became the original couple. As the Earth-Mother, she was the fertile source of all living things and was celebrated as the guardian of human reproduction.

Gorgons: three sisters of terrifying aspect: huge heads, vipers for hair, long teeth and wings of gold. Whoever ventured to gaze upon them was turned to stone. They lived in unknown places, not far from the Realm of the Shades. Medusa, who was slain by Perseus, was the only mortal among them.

❖

Helen: daughter of Zeus and Leda. Aphrodite promised to give Paris the most beautiful woman in the world. This happened to be Helen, the wife of King Menelaus; Paris seduced her and carried her off to Troy, thus provoking the Trojan War.

Helios: the sun god, divine source of light and heat. He was Zeus's servant and coursed each day across the Heavens in his golden chariot. As he was the only divinity who could observe what happened everywhere in the world, he kept the Olympian gods informed.

Hephaestus: god of the earth and volcanoes; his attributes were blacksmith's tools, an oval-shaped bonnet, and a mantle that left the right shoulder and arm free.

Hera: wife of Zeus, she was the protectress of matrimony. Symbolized by the nuptial veil, a sceptre and a peacock whose tail is decorated with the hundred eyes of Argus.

Heracles/Hercules: son of Zeus and Alcmene. Zeus wanted to have a child who would combine all the human virtues; to this end, he decided to seduce a modest and virtuous mortal, Alcmene, which he accomplished only by impersonating her husband. Furious with jealousy, Hera delayed the child's birth so that his cousin, Eurystheus would be born first, for Zeus had promised her that the first-born would dominate the other. Throughout his life, Heracles was pursued by Hera's unrelenting hatred: among other torments, she sent serpents into his crib which he throttled with his bare hands and afflicted him with madness so that he slew his wife and three children. To expiate his crime, the oracle at Delphi enjoined him to go to Eurystheus and obey his commands. The latter ordered him to accomplish a series of twelve superhuman feats, known as the Twelve Labours of Heracles. Having successfully surmounted his ordeals, he married Deianira. But their bliss was short lived; he was obliged to fight the centaur Nessus, who was in love with Deianira, and slayed him, only to be pursued by his curse. After many more adventures, the gods took pity on him and granted him immortality. His attributes are a club and the skin of the Nemean lion.

Hermaphroditus: son of Hermes and Aphrodite. He was bathing one day at a fountain when a nymph approached and embraced him; she begged the gods to unite them forever. The gods granted her wish and merged the two sexes into a single being.

Hermes: a multifaceted divinity, titulary god of shepherds, commerce and music. He was recognized by his hat, his winged and sandaled feet, and his caduceus.

❖

Iris: messenger goddess, servant and intimate of Hera; she fulfilled her mistress's every wish.

❖

Laocoön: a priest of Apollo, he incurred the god's wrath when he broke his vow never to take a wife. During the siege of Troy, he was the only one to warn his fellow-citizens about the Trojan Horse, which was a camouflaged fortress. But at that very moment, two serpents emerged out of the sea and strangled him and his sons. The Trojans, not knowing about Laocoön's fateful sacrilege, opened the city gates in the hope of appeasing the gods.

Lapiths: mythical people who inhabited the mountains of Thessaly; known for their battle with the Centaurs.

Leda: daughter of Thestius, the king of Aetolia, she married Tyndareos and gave him a progeny born from eggs: Castor, Pollux and Helen, actually the children of Zeus who had seduced Leda in the shape of a swan.

Leto: another of Zeus's lovers, and victim of Hera's jealousy: she suffered nine days and nine nights to bring her twins, Apollo and Artemis, into the world.

❖

Medusa: see Gorgons.

Maenads: mountain and wood nymphs who raised Dionysus. Another name for the women who celebrated the dionysiac cult (Bacchantes).

Minos: king of Crete, son of Zeus and Europa, the brother of Rhadamanthys. Renowned for his wisdom and sound judgement, he was one of the judges of Hades.

❖

Nereus: a sea god, husband of Doris, father of the fifty Nereids, beautiful composite creatures with the body of a woman and the tail of a fish.

Niobids: the seven daughters and seven sons of Niobe, who died at the hands of Artemis and Apollo after their mother boasted of her great fertility to the goddess Leto.

Nymphs: diverse female divinities who lived in the woodlands (dryads and hamadryads), in the mountains or in caves (oreads), in hot springs (naiads), and in valleys (nappeae).

❖

Oenomaüs: king of Pisa in Aelida; he challenged his daughter's suitors to chariot races which he always managed to win; Pelops was able to defeat him through a subterfuge.

Olympus: a famous mountain, said to be the dwelling-place of the gods and goddesses, protected from mortal gaze by clouds. Zeus sat there on his throne, presiding over the divine host.

❖

Pan: with his goats' feet and horns and the upper body of a man, he caused hilarity among the Olympian gods when his father, Hermes, presented him. He was venerated throughout Greece as a fertility god during the Classical period; his attribute was a reed flute.

Pandora: the Olympian gods created a woman endowed with grace, guile, audacity and strength; they called her Pandora and sent her to Earth to seduce the mortals. She wed Prometheus's brother, Epimetheus. Acting out of misguided curiosity, she opened a vessel that she had been forbidden to touch, and released evil into the world.

Paris: son of Priam, the king of Troy, and Hecuba. In accordance with the predictions of an oracle, he brought ruin to his land by abducting Helen and so causing the Trojan War.

Patroclus: the best friend of Achilles; they fought together during the siege of Troy.

Pegasus: Bellerophon's winged horse. When Bellerophon tried to ride to Olympus on Pegasus's back, the horse punished his sacrilege by making him fall to his death and arrived at Olympus alone.

Peleus: son of the king of Aegina, Aeacus; his union with the nereid Thetis brought Achilles into the world. Peleus had a harsh fate: while still young, he murdered his brother; after expiating his crime he married Antigone, only to fatally wound his father-in-law during the hunt for the boar Calydon. He expiated his crime at the court of Acastus, the king of Iolcus, but the queen spread evil rumours about him and condemned him to being eaten by the centaur Chiron on Mount Pelion.

Pelops: won the hand of Oenomaus's daughter by defeating him in a chariot race, and so became the founder of the Olympic Games.

Penthesilea: queen of the Amazons, who was forced into exile after having slain her sister. Purified of her crime by Priam, she fought against the Greeks on the side of Troy.

Persephone: daughter of Zeus and Demeter, and wife of Hades. A severe and imposing figure, she was often represented seated on a throne holding a torch, and sometimes even a poppy flower, to symbolize the annual sleep of the Earth.

Perseus: son of Zeus, who changed himself into a shower of gold to seduce Danae, the daughter of Acrisius, King of Argos. In order not to incur Zeus's wrath, Acrisius spared the lives of the mother and child, but set them adrift at sea on a frail vessel. Found by Polydectes, they lived on the island of Seriphus until the day that Polydectes, attracted to Danae, tried to dispose of Perseus by giving him the perilous mission of killing the gorgon Medusa. Perseus succeeded and wed Andromeda, whom he had saved from a monster. The head of Medusa, which still had the power to turn people to stone, enabled him to save his mother from the Temple of Athena, where she had been imprisoned as she sought to escape Polydectes' advances.

Peirithous: king of the Lapiths and friend of Theseus, with whom he descended into Hell in order to seduce Persephone, the wife of Hades. Punished for his misconduct, Peirithous was condemned to remain in the Underworld.

Poseidon: god of the waters and oceans, the brother of Zeus and Hades. He was usually represented with a trident and astride a dolphin. He is famous for having loved Demeter, Medusa and Amphitrite, who became his wife.

Pothos: one of Aphrodite's sons, the embodiment of amorous desire.

Priam: King of Troy, father of Paris and Hector.

Prometheus: one of Atlas's brothers; even Zeus was awed by his great powers. A seer and inventor, he created the first man from a block of clay mixed with water. This great benefactor of the human race was celebrated each year in Attica with religious festival called the *Prometheia*.

❖

Rhadamanthys: son of Zeus and Europa, brother of Minos. His great wisdom earned him a place among the judges of the Underworld.

❖

Satyrs: part-mortal, part-divine nature spirits similar to Pan. They are depicted holding a thyrsus or a cup, and crowned with ivy leaves and foliage.

Selene: daughter of Hyperion and Theia, sister of Helios. She symbolized the Moon. She coursed through the heavens on her chariot and each night visited her love, the shepherd Endymion, who lay plunged in an eternal sleep.

❖

Telephus: the son of Heracles. After fighting against Achilles, he helped him defeat Troy by showing him the way to the city.

Theseus: son of Ariadne and King Aegeus, legend also ascribes him a divine father, Poseidon. His successful miltary campaigns, the reforms he introduced when he was king of Athens and his notorious love affairs earned him a prestigious burial place in an Athenian temple, the Theseum.

Thetis: a nereid, the wife of Peleus and mother of Achilles.

Titans: the twelve fearsome progeny of Uranus, the god of the Heavens, and Gaea, the goddess of the Earth. Their names were: Oceanus, Coeus, Crius, Hyperion, Iapetus, Cronus, Tethys, Theia, Themis, Mnemosyne, Phoebe and Rhea.

❖

Venus: Roman goddess of Love and Beauty, identifed with the Greek Aphrodite.

❖

Zeus: king of the Olympian gods and goddesses, he presided over rain and fertility. He was alternately a vindictive and a salutary divinity. He was also worshipped as the god of all the Greek cities and territories. His attributes were a lightning-bolt, an eagle and a serpent.

Amphitheatre at Delphi

Restored in 159 BC.
Archaeological site of Delphi.

BIBLIOGRAPHY

John Boardman et al., *Greek Art and Architecture*, New York 1967

André Bonnard, *Civilisation grecque*, 3 vols. Brussels 1991

Jean Charbonneaux, *La sculpture grecque archaïque*, Lausanne 1942

Jean Charbonneaux, *La sculpture grecque classique*, 2 vols. Lausanne 1942

Jean Charbonneaux, Roland Martin, François Villard, *Grèce archaïque*, Paris 1968,
 Grèce classique, Paris 1969, *Grèce hellénistique*, Paris 1970

William B. Dinsmoor, *The Architecture of Ancient Greece*, London 1950

Henri van Effenterre, *Les Égéens*, Paris 1986

Bernard Holtzmann, *La Grèce*, Paris 1989

Pierre Levêque, *L'aventure grecque*, Paris 1990

Henri Lechat, *Le temple grec*, Paris 1902

Henri Lechat, *La sculpture grecque*, Paris 1922

Roland Martin, *Monde grec*, Freiburg 1966

Roland Martin, *L'art grec*, Paris 1994

Charles Picard, *Manuel d'archéologie grecque*, 5 vols. Paris 1935-1966

Adolphe Reinach, *Recueil Milliet*, ancient Greek and Latin texts on painting,
 rev. and ed. by A. Rouveret, Paris 1985

Gisela Richter, *Handbook of Greek Art*, London 1960

Gisela Richter, *The Sculpture and Sculptors of Greece*, New Haven 1950

Martin Robertson, *A History of Greek Art*, Cambridge 1975

Anthony M. Snodgrass, *An Archaeology of Greece*, Berkeley 1987

Jean-Pierre Vernant, *Mythe et pensée chez les Grecs*, 2 vols. Paris 1980

Christian Zervos, *L'art de la Crète néolithique et minoenne*, Paris 1956; *L'art des Cyclades*, Paris 1957;
 La civilisation hellénique, Paris 1969.